DISCARD

Hans Hofmann

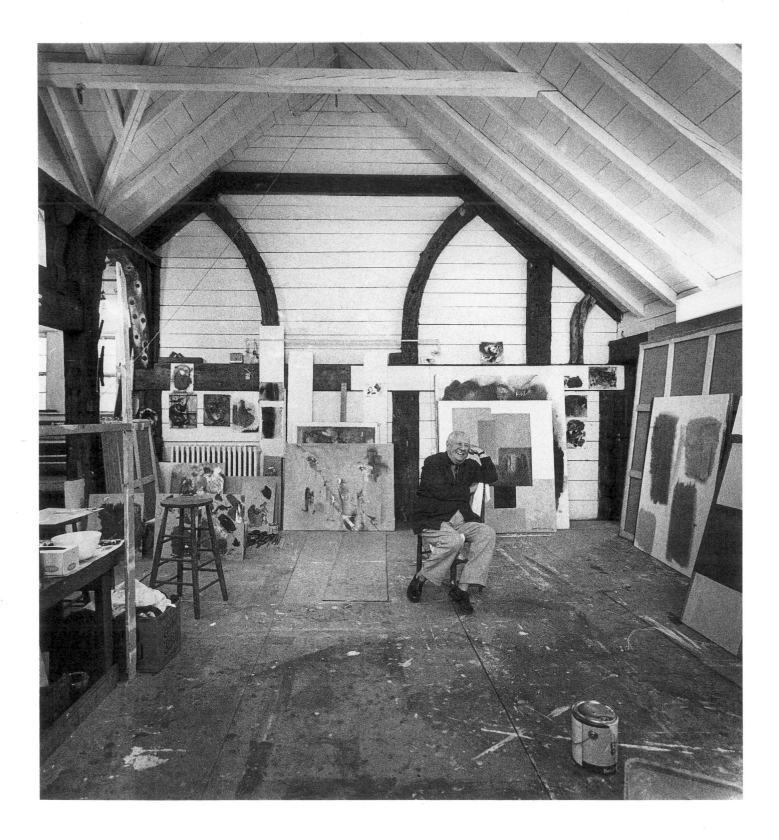

Hans Hofmann

Cynthia Goodman

with essays by
Cynthia Goodman
Irving Sandler
Clement Greenberg

Whitney Museum of American Art, New York
in association with Prestel-Verlag, Munich

Exhibition Itinerary

Whitney Museum of American Art, New York
June 20, 1990—September 16, 1990

Center for the Fine Arts, Miami
November 1990—January 1991

The Chrysler Museum, Norfolk, Virginia
February 1991—April 1991

Cover
Cap Cod — Its Eboulliency of Sumer, 1961 (Fig. 99)

Frontispiece
Hans Hofmann, 1963. Photograph by Hans Namuth

Library of Congress Cataloging-in-Publication Data
Goodman, Cynthia.
 Hans Hofmann/by Cynthia Goodman; with essays by Clement Greenberg,
 Irving Sandler.
 p. cm.
 Includes bibliographical references.
 1. Hofmann, Hans 1880-1966—Exhibitions. I. Hofmann, Hans, 1880-1966.
II. Greenberg, Clement, 1909—. III. Sandler, Irving, 1925—.
IV. Whitney Museum of American Art. V. Title. ND237.H667A4 1990
759.13—dc20 90—31104 CIP

ISBN 3-7913-1054-2 (cloth edition published by Prestel-Verlag, Munich)
ISBN 0-87427-070-7 (softcover edition)

Printed in Federal Republic of Germany

Contents

Lenders to the Exhibition

Addison Gallery of American Art, Phillips Academy, Andover, Massachusetts

Mr. and Mrs. Gerhard Andlinger

The Art Institute of Chicago

Lee and Gilbert Bachman

Richard Brown Baker

The Baltimore Museum of Art

Mrs. G. N. Bearden

Jeanne Bultman

The Cleveland Museum of Art

Mrs. Jan Cowles

Mr. and Mrs. Kenneth N. Dayton

Michael Diamond

André Emmerich Gallery, New York

Mr. and Mrs. Miles Q. Fiterman

Thomas Marc Futter

Robert and Alice Galoob

Mr. and Mrs. Jeffrey Glick

Mr. and Mrs. Graham Gund

Hirshhorn Museum and Sculpture Garden, Smithsonian Institution, Washington, D.C.

Estate of Hans Hofmann

Honolulu Academy of Arts

IBM Corporation, Armonk, New York

Dr. William C. Janss, Jr.

Mr. and Mrs. Gilbert H. Kinney

Berthe and Oscar Kolin

Beth and Steven Lever

Dr. Harold and Elaine L. Levin

Sally Sirkin Lewis and Bernard Lewis

The Metropolitan Museum of Art, New York

Modern Art Museum of Fort Worth

Museum of Fine Arts, Boston

The Museum of Fine Arts, Houston

The Museum of Modern Art, New York

Mr. and Mrs. Orin S. Neiman

New Orleans Museum of Art

Mr. and Mrs. Harold Price

Howard E. Rachofsky

Barbara and Eugene M. Schwartz

Herta and Samuel Seidman

Mr. and Mrs. Clifford M. Sobel

Frank Stella

University Art Museum, University of California, Berkeley

Marcia S. Weisman

Whitney Museum of American Art, New York

Mr. and Mrs. C. Bagley Wright

Nineteen anonymous lenders

Acknowledgments

A number of people have been instrumental in the realization of this exhibition as well as in my study of Hans Hofmann. Henry Geldzahler first awakened my interest in Hofmann while I was a Chester Dale Fellow at The Metropolitan Museum of Art. William Agee and Walter Darby Bannard invited me to be a part of the team that contributed to the Hofmann exhibition which Bannard organized at The Museum of Fine Arts, Houston, and the Hirshhorn Museum and Sculpture Garden in 1977. At the Whitney Museum, Richard Armstrong ably and thoughtfully coordinated the many aspects of the present exhibition. Patterson Sims, former Associate Curator, Permanent Collection, nurtured this exhibition in its formative stages. I am particularly indebted to Tom Armstrong for his support of the project and for inviting me to be guest curator of this long-overdue exhibition. Jennifer Russell has skillfully administrated the organizational complexities of the show. Emily Russell and Mark Bessire were especially helpful in the compilation of data for the catalogue.

André Emmerich and the entire staff of André Emmerich Gallery have cooperated enormously not only throughout the preparation of this exhibition but as well throughout my years of research on Hofmann. Jun James Yohe was instrumental in the release of new works from the Hans Hofmann Estate and in making some of Hofmann's previously unpublished writings available to me. John Sartorius of the Hans Hofmann Estate was also cooperative in the release of new material. Lisa Marks of the Emmerich Gallery provided essential assistance during the preparation of this exhibition.

As always, the realization of an exhibition is entwined with the generosity of the lenders. I am most grateful to both the private and public Hofmann collectors who have made this exhibition a reality.

Hans Hofmann has many former students and friends whose enthusiasm for him is contagious. There is no one for whom this is more true than Lillian Kiesler, who offered unpublished material on the artist that has enriched this publication and who has supported and encouraged the exhibition from its inception. The late Fritz Bultman was also an unfailing source of information about his beloved former teacher and friend. It is to Lillian and Fritz that I dedicate this publication.

Cynthia Goodman

This exhibition is supported by generous grants from Mr. and Mrs. Edwin A. Malloy, The Mnuchin Foundation, and the National Committee of the Whitney Museum of American Art.

Research for this publication was supported by income from endowments established by Henry and Elaine Kaufman, The Lauder Foundation, Mrs. William A. Marsteller, The Andrew W. Mellon Foundation, Mrs. Donald Petrie, The Primerica Foundation, The Samuel and May Rudin Foundation, The Simon Foundation, and Nancy Brown Wellin.

Foreword

Few artists participated as fully in the revolutionary changes of twentieth-century art as did Hans Hofmann. A student in Paris during the halcyon days of Fauvism and Cubism, Hofmann was caught in his native Germany when World War I broke out. In 1915, he opened his own art school in Munich. His firsthand experience with the School of Paris and German Expressionism served him well as both artist and teacher. After his move to the United States in 1931, he became a singular influence on the generations of American artists who came to the fore in the 1940s and 1950s. Hofmann's first school in New York opened in midtown in 1934, moving to West 9th Street in Greenwich Village two years later. By 1938, the school was situated on West 8th Street, on the same block as the Whitney Museum of American Art, which had opened in 1931. The two locales became counterpoints of debate and dialogue, fostering a self-assurance in the art community that resulted in an unprecedented level of creativity.

A practicing artist all his life, Hofmann achieved recognition rather late. He had his first one-artist show in New York in 1944; the following year his work was included in the Whitney Mueum's "Annual Exhibition: Contemporary American Painting." Subsequently his work was exhibited at the Museum regularly and featured in a retrospective in 1957. In the last nine years of his life, Hofmann made some of his most remarkable paintings — many of which are included in this exhibition.

We are grateful to guest curator Cynthia Goodman for guiding this project from its inception and salute Clement Greenberg and Irving Sandler for their insightful contributions to the catalogue. We are also indebted to the estate of Hans Hofmann, which provided timely assistance in organizing materials for the book. This exhibition is yet another testimony to the role the Whitney Museum has played in the narrative of twentieth-century American art and to the association between a museum and the creative genius it supported.

Jennifer Russell
Acting Director

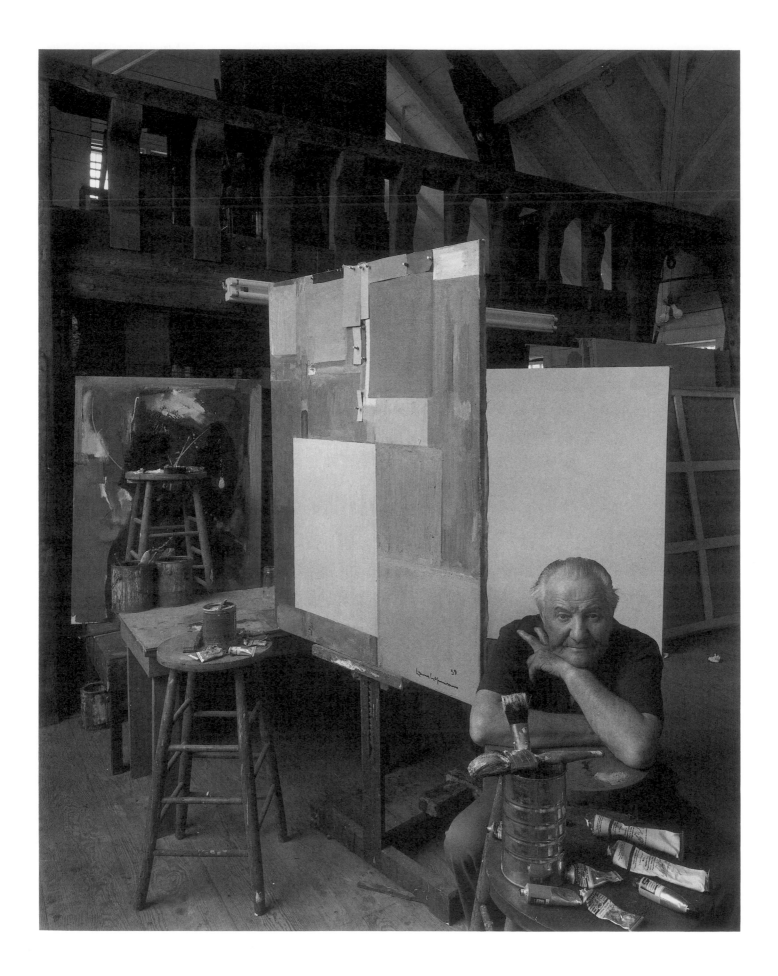

Hans Hofmann:
A Master in Search of the "Real"

Cynthia Goodman

The life-giving zeal in a work of art is deeply embedded in its qualitative substance. The spirit in a work is synonymous with its quality. The "Real" in art never dies, because its nature is predominantly spiritual. — Hans Hofmann[1]

Few have surpassed Hans Hofmann in his deep commitment to the artistic process, a commitment he nurtured over seven decades, from its beginning in prewar Europe to its successful implantation in the receptive soil of America. Hofmann's vast legacy as both artist and teacher endures.

Johann Georg Albert Hofmann was born on March 21, 1880, in Weissenburg, Germany. His family moved to Munich when he was six years old, his father having received a bureaucratic position in the government. Hans excelled in music, mathematics, and science. He also drew frequently, especially when visiting his grandparents' farm in the Bavarian countryside.

At sixteen, Hofmann left home and began working for the Director of Public Works of the State of Bavaria, a position his father had secured for him. This department was concerned with engineering and architectural projects for the government. The experience allowed Hofmann to develop his technical knowledge of mechanics, and he invented a number of devices, among them an electromagnetic compto-meter, similar in function to the accounting machine. Although he was estranged from his father, who wanted him to become a scientist, he received from the elder Hofmann a reward for his inventiveness: a gift of

Hans Hofmann, c. 1960.
Photograph by Arnold Newman.

a thousand marks. Hans used the money to enroll in Moritz Heymann's art school.

 The several dozen drawings that exist from these student days show Hofmann grappling with the human figure in a traditional manner (Figs. 1–5). There are in addition four extant paintings that show him absorbing contemporary influences — from the severe Munich School portrait style in the *Portrait of Maria Wolfegg* (Fig. 6) to the Neo-Impressionist manner of the *Still Life* on the verso of a *Self-Portrait* (Figs. 7, 8) or the portrait of an unidentified woman (Fig. 9); the last three all reveal the optical mix of small dabs of paint associated with Neo-Impressionism. In the still life, we see not only the Pointillist application of paint, remnants of which would punctuate Hofmann's canvases throughout his career, but also, for the first time, the division of the surface into the planes of color that became a standard in Hofmann's pictorial vocabulary.

 The artist's familiarity with School of Paris painting can be largely attributed to the influence of his teacher Willi Schwarz, who had brought the theories from Paris, and to the exhibitions he attended at the Secession Gallery. The Secession, which had been founded in 1892, showed both the work of then popular German painters such as Lovis Corinth and Hans von Marées, whom Hofmann admired greatly,[2] as well as the latest painting from France. Hofmann described the

1. *Untitled (Figure Study)*, c. 1898. Ink on paper, 10⅛ × 8¾ (25.7 × 22.2). Estate of the artist; courtesy André Emmerich Gallery, New York

2. *Untitled (Figure Study)*, c. 1898. Pencil on paper, 11½ × 8 (29.2 × 20.3). Estate of the artist; courtesy André Emmerich Gallery, New York

3. *Untitled (Figure Study)*, c. 1898. Pencil on paper, 11⁹⁄₁₆ × 8³⁄₁₆ (29.4 × 21). Estate of the artist; courtesy André Emmerich Gallery, New York

4. *Untitled (Figure Study)*, c. 1898. Pencil on paper, 11⁹⁄₁₆ × 8¹⁄₁₆ (29.4 × 20.5). Estate of the artist; courtesy André Emmerich Gallery, New York

Secessionist movement as "a development of Impressionism [which] later split and Neo-Secessionism was born."[3] In 1908, he exhibited with this group in the New Secession exhibition in Berlin. His work was listed simply as *Akt* (*Nude*) and his residence as Paris. Among the other artists who were included in this exhibition were Max Beckmann, Pierre Bonnard, Paul Cézanne, Corinth, Max Liebermann, Edvard Munch, Alfred Maurer, Edouard Vuillard, and Wilhelm Leibl (who was featured with forty-four works). In 1909, Hofmann again exhibited with the Secession; his entry this time was *Damenbildnis* (*Portrait of a Woman*).

Hofmann had been living in Paris since 1904, thanks to Willi Schwarz, who had introduced him to the nephew of Phillip Freudenberg, a wealthy department store owner from Berlin. Freudenberg gave him the funds to live and study in Paris. There Hofmann met and befriended many of the artists who were to shape the art of the twentieth century. According to Hofmann, during his years in Paris he had "been an intimate and integral part in the revolutionary changes that took place throughout this time in the entire field of the visual arts. It was the time of coming into being of Fauvism and Cubism in France, of Futurism in Italy, of Expressionism in Germany, etc."[4] Yet definitive evidence for his active role in these years is very sketchy, and most of it comes from various students and friends in their recollections of earlier conversations with Hofmann. The only written account of a contemporary is in the memoirs of Fernande Olivier, who recalls meeting the Hofmanns at parties she attended with Picasso at the home of art dealer Richard Goetz, where Braque and Wilhelm Uhde, another dealer, were among the guests who were lavishly entertained on some rather rowdy evenings.[5]

According to most biographers, Hofmann attended evening sketching classes at the Académie de la Grande Chaumière, where Matisse was a classmate. In one biography, Hofmann sketched "alongside Matisse," and once painted on the same balcony at the Hôtel Bisson, where Matisse created his early views of the Seine.[6] In 1908, Matisse traveled to Berlin for an exhibition of his work then on display at the gallery of Paul Cassirer. On this trip, Matisse is said to have visited Freudenberg and seen the collection of Hofmann paintings he had received as one of the conditions of his continued patronage; Matisse's "enthusiasm had the convenient effect of encouraging Hofmann's patron to continue his support."[7] More significant than the precise details of the interchange between Matisse and Hofmann is the lifelong influence that the French artist exerted on his American colleague. Hofmann absorbed Matisse's color lessons so successfully that Clement Greenberg later claimed "that in America in the 1930's one could learn Matisse's color lessons better from Hofmann than from Matisse himself."[8]

5. *Untitled (Standing Youth)*, c. 1898. Pencil on paper, 6⅜ × 4¹⁄₁₆ (16.2 × 10.3). Estate of the artist; courtesy André Emmerich Gallery, New York

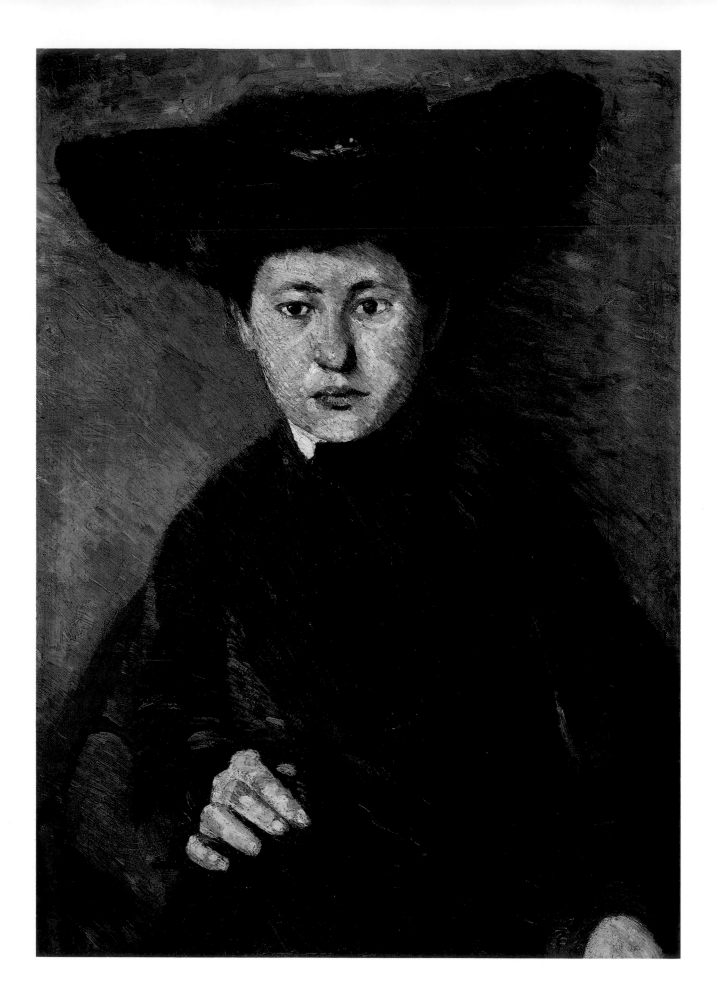

Accounts of the actual nature of Hofmann's friendship with Delaunay are as variable as those of his relationships with Picasso and Matisse. One early student recounted his belief that Delaunay "was a roommate to Hofmann."[9] Fritz Bultman and Lillian Kiesler, two other former students, recall the Hofmanns telling them about how they painted neckties, scarves, and hats with the Delaunays in Sonia's workshop.[10] Bultman, who boarded with Miz Hofmann in the Hofmanns' Munich apartment in 1936–37, also remembered visiting Sonia Delaunay when he went to Paris with Miz in 1937. One of many letters in Sonia Delaunay's archives from Miz Hofmann written between 1949 and 1952 relates how happy Sonia's recent letter had made her, because "it is always a pleasure to hear from old friends of whom only a few are left."[11] Perhaps what is most fascinating about Hofmann's friendship with Delaunay is the probability of their mutual influence. Hofmann had told William Seitz that it was he who had made Delaunay "aware of Seurat," and Seitz credits him with the transformation in Delaunay's palette from "its earlier sobriety to the brilliant hues for which he is known."[12]

Unfortunately, not even one of the paintings Hofmann made in Paris still exists. He was home in Germany when World War I broke out, and all the work he had left in Paris disappeared during the war. Virtually the only knowledge of his work between 1902 and 1914 comes from his own recollections and those of his acquaintances and later students who saw the few works he had brought from Paris to Munich. The painter Vaclav Vytlacil, who studied with Hofmann in Munich, described the drawings his teacher had shown him from his Paris days as examples of early Cubism. Hofmann recounted to Frederick Wight that his work in Paris had consisted of still lifes, figures, and landscapes in the Luxembourg Gardens.[13] Lamentably, however, he did not describe the work stylistically.

A few works on paper have survived from the period shortly after Hofmann's return to Germany in 1914. Among these are several bright Expressionist landscapes (Fig. 11), evocative of Kandinsky's Murnau scenes, that depict the area of the Ammersee where Hofmann and Miz were summering when war broke out. Bultman, who later became close to Hans as well as Miz, has perceptively commented that these watercolors were an exception in Hofmann's work at this time "of upset and economic readjustment [when] Hans turned to drawing and to nature as a major means of expression, to the fundamentals. It was not to be the last time."[14] In fact, until the early 1950s, when Hofmann claimed he "no longer [had] the patience to work with pen, pencil, or crayons,"[15] he drew prolifically.

6. *Untitled (Portrait of Maria Wolfegg)*, c. 1901. Oil on academy board mounted on masonite, 27½ × 19½ (69.9 × 49.5). Estate of the artist; courtesy André Emmerich Gallery, New York

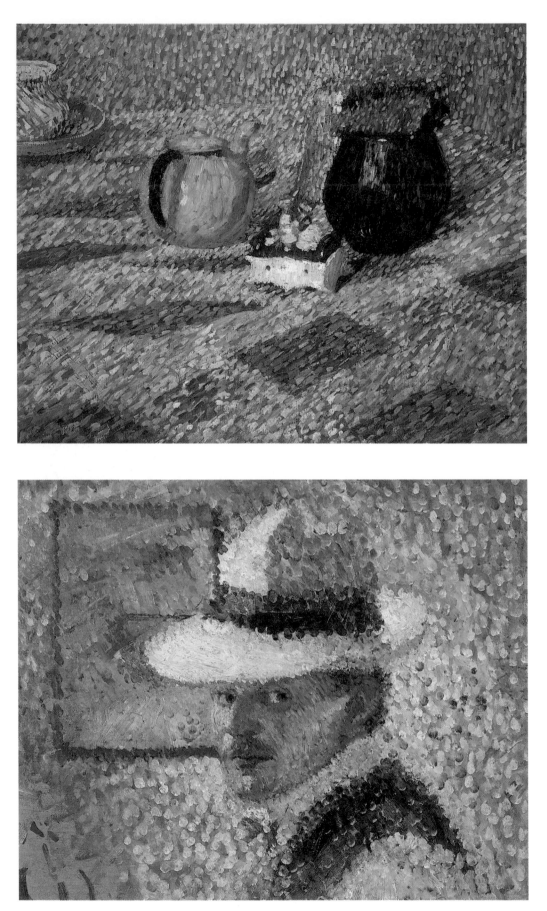

7. *Untitled (Still Life)*, 1902 (verso of Fig. 8). Oil on composition board, 16½ × 20½ (41.9 × 51.4). Estate of the artist; courtesy André Emmerich Gallery, New York

8. *Self-Portrait*, 1902 (recto of Fig. 7). Oil on composition board, 16½ × 20¼ (41.9 × 51.4). Estate of the artist; courtesy André Emmerich Gallery, New York

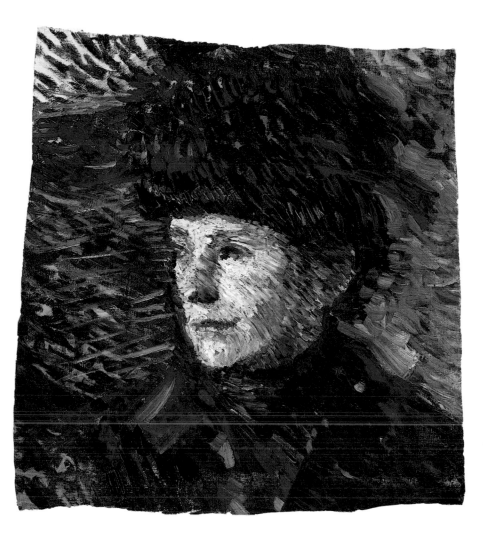

9. *Untitled (Portrait of a Woman)*, 1902. Oil on canvas mounted on canvas, 16 × 15 (40.6 × 38.1). Estate of the artist; courtesy André Emmerich Gallery, New York

There are also several cityscapes from the mid-teens (Fig. 12) similar to those Oskar Kokoschka was painting about 1910, and a ceiling design of a group of nude females for a now unknown commission (Fig. 15). In the latter, Hofmann seems to have made separate studies of some of the figures and moved them about before deciding on their final placement, a practice he continued both in teaching and in planning the compositions of his later rectangle paintings. Cézanne's bathing scenes were the likely source for the female nudes. The thirty-three Cézanne paintings on display in the Salon d'Automne when Hofmann first arrived in Paris represented one of the most widely acclaimed art world events. Cézanne, whose work was shown regularly in the Salons of the ensuing years, continued to be a significant influence on Hofmann both philosophically and pictorially. In Hofmann's major unpublished manuscript, "Creation in Form and Color: A Textbook for Instruction in Art," he repeats Cézanne's often quoted state-

10. *Untitled (Landscape)*, c. 1914. Watercolor and pencil on paper, 8 × 10½ (20.3 × 26.7). Estate of the artist; courtesy André Emmerich Gallery, New York

11. *Untitled (Landscape)*, c. 1914. Watercolor on paper, 8 × 10½ (20.3 × 26.7). Estate of the artist; courtesy André Emmerich Gallery, New York

12. *Untitled (Cityscape)*, c. 1914. Watercolor on paper, 8¼ × 10½ (21 × 26.7). Estate of the artist; courtesy André Emmerich Gallery, New York

ment that "In nature you see everything that is in perspective in relation to the cylinder, the sphere, and the cone in such a way that each side — each surface of the object — moves in depth in relation to a central point," and declares it the "starting point for an entirely new conceptual orientation in painting."[16] This concept was one he was to follow for the rest of his life.

In 1915, having lost the support of his patron and in need of supporting himself, Hofmann, disqualified from military service because of a lung condition, opened the Hans Hofmann Schule für Bildende Kunst in the Bohemian district of Munich known as Schwabing. The classroom schedule was divided into three sections: mornings for life and head studies; afternoons for head and costume studies; evenings for the life class with either a single model or a group.

Hofmann's teachings were infused with both French and German doctrines. Hegel, Wölfflin, and Goethe, whom he quoted often, were as much a part of the classroom atmosphere as the French Cubists and Fauves. Hofmann was also aware of contemporary German art philosophy, that is, Der Sturm, Die Brücke, and the Bauhaus.[17] His instruction, like his thinking and writing, was never confined to the art of one century or the style of one movement. Rather, it was an amalgam of the theories of artists and philosophers whom he admired. He gathered and distilled sources as disparate as Whistler, Lorenzo Lotto, and Gauguin, and found in their work substantiation for his own hybrid

13. *Untitled (Landscape)*, c. 1914. Watercolor and pencil on paper, 6¾ × 8¾ (17.1 × 22.2). Estate of the artist; courtesy André Emmerich Gallery, New York

14. *Untitled (Landscape)*, 1917. Watercolor and pastel on paper, 8 × 10 (20.3 × 25.4). New Orleans Museum of Art; The Muriel Bultman Francis Collection

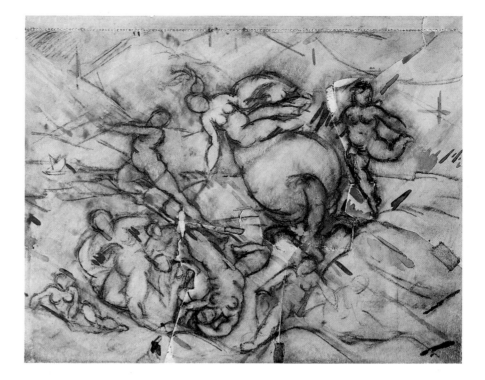

15. *Untitled (Study for Ceiling Design)*, c. 1914. Pencil, watercolor, and tape on paper, 8¼ × 10¾ (21 × 27.3). Estate of the artist; courtesy André Emmerich Gallery, New York

philosophy. Hofmann illustrated his Munich lectures, as he did later ones, with diagrams of composition and movement inspired by the works of Rembrandt, Piero della Francesca, Giotto, and other master-pieces in the Alte Pinakothek, which he visited regularly on Sundays, often accompanied by students.[18] He also used reproductions or photographs of works in other collections, among them one of Rembrandt's *Sophonisba Receiving the Poisoned Cup* (then known as *Queen Arte-misia*) in the Prado. On this photograph, he diagrammed the bodies of the women as a series of cubes. He drew arrows from one mass of cubes to another as well as from the cubes into the surrounding space to illustrate his dictum that volumes operate against each other to produce an energy-filled space. Although he exemplified his theories with modern as well as Old Master paintings, he admitted that he favored the Old Masters, because people generally found them more convincing.[19]

During the war, Hofmann did not have many students, but in the postwar years his international reputation quickly grew, and numerous Americans as well as students from other countries flocked to his classes. Among the many who studied with him in Europe and who later became prominent on their own were Vaclav Vytlacil, Louise Nevelson, Alfred Jensen, Wolfgang Paalen, Ludwig Sander, Carl Holty, and Cameron Booth.

Each summer, beginning in 1918, Hofmann also conducted courses at various European resorts. These summer locations included picturesque spots in the Alps such as Murnau and Herrsching as well as

Ragusa, Capri, and St. Tropez. In Europe, as later in the United States, Hofmann's Parisian affiliations acted as a magnet that brought students to the school. Among the five published descriptions of the school that announced the summer 1929 session at St. Tropez, four mentioned his Parisian experiences.

Despite growing attendance, conditions at the school were still rather penurious through the late twenties. Glenn Wessels, who traveled from the University of California at Berkeley to study with Hofmann in Munich, recalls that early in the morning he and Hofmann huddled in still-life draperies to keep warm, while he tutored Hofmann in English.[20] It seems that Hofmann painted little during his early years as a teacher in Munich, partly because of the rigors of running a school and the seeming futility of painting in the midst of a world war. In fact, the only painting known to have survived from all the years of his Munich school is a 1921 still life called *Green Bottle* (Fig. 16). This rather conservative Cubist composition of a bottle, glass, palette, and teapot on a table incorporates a painting of a section from the German periodical *Der Querschnitt*, as if following the collage tradition of Picasso and Braque.

Green Bottle, the few surviving paintings already mentioned, and some portfolios of drawings are, somewhat inexplicably, the only works that Miz Hofmann, who stayed in Munich and maintained their apartment and Hofmann's school for many years, brought from Europe with her in 1939. Hofmann had carried some drawings from Europe himself, and several portfolios were brought back in 1937 by Bultman, who has conjectured that Miz's selection may well have been motivated by her regard for Hofmann "primarily as a draughtsman." Lamenting the decision, Bultman recalled Hofmann's Munich paintings as a "remarkable painterly step, fusing French and German influences with a surface that was deeply pitted and highly built up by overpainting and overpainting—color was an important element."[21]

A number of drawings do exist from the later twenties, for Hofmann drew the figures and portrait studies he assigned to students in his school. *Student with Spectacles* of c. 1926 (Fig. 17) has an agitated line that attempts to balance the activation of the negative and positive areas of the composition, which he believed were of equal pictorial significance, as much as render a representational likeness of the subject. For Hofmann, "A head is a plastic form. ... This plastic form is not only an exterior form. There are plastic dimensions." Thus he saw portraiture as an opportunity to create a likeness in "a plastic sense, not in a photographic one. You can show how you experience the planes."[22] An untitled portrait study of 1930 (Fig. 18) uses the same convention as *Student with Spectacles*, along with Cubist collage, to depict a multi-profiled subject. Carl Holty, who studied with Hofmann at about the

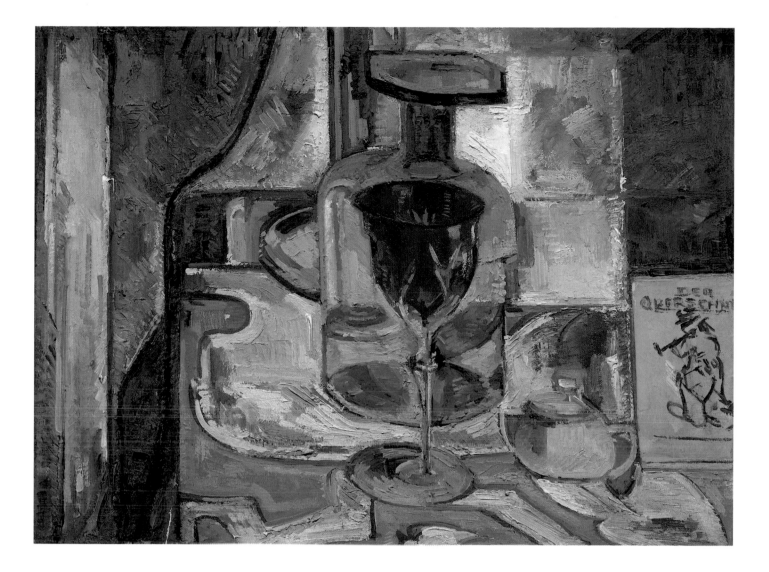

16. *Green Bottle*, 1921. Oil on canvas, 17¾ × 22¾ (45.1 × 57.8). Museum of Fine Arts, Boston; Gift of William H. and Saundra B. Lane

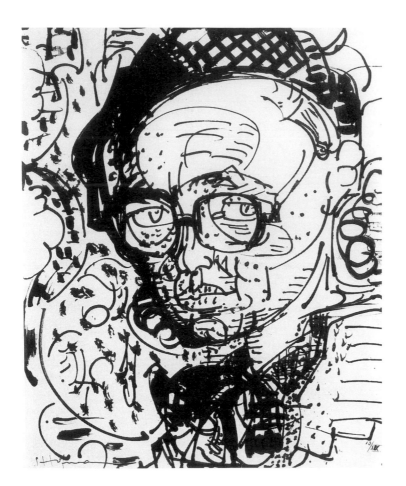

17. *Student with Spectacles,* c. 1926. Ink on paper,
13¾ × 11 (34.9 × 27.9). Estate of the artist; courtesy
André Emmerich Gallery, New York

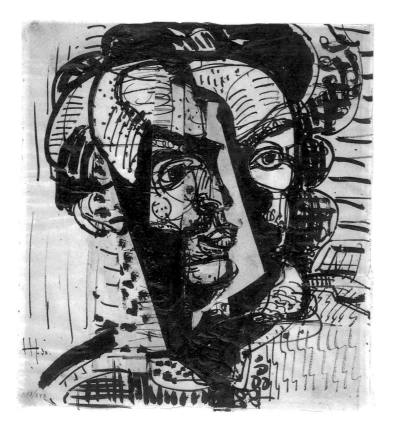

18. *Untitled (Portrait Study),* 1930. Ink and collage
on paper, 15 × 12½ (38.1 × 31.8). Collection of
Jeanne Bultman

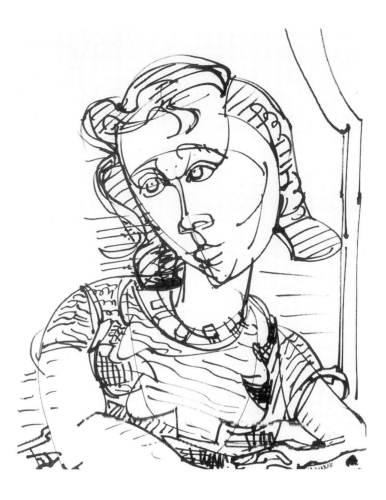

19. *Untitled (Portrait of a Woman)*, c. 1929. Ink on paper, 13¹⁵/₁₆ × 10¹⁵/₁₆ (35.4 × 27.8). Estate of the artist; courtesy André Emmerich Gallery, New York

time these portraits were executed, has commented that most of Hofmann's models "appeared commonplace and uninteresting. ...This choice of models was by design. Hofmann demonstrated ably enough that any human head in all its 'plastic' complexity was interesting and remarkable and his likeness drawings were always clear, telling, and exact."[23] Hofmann, who rarely ventured into the realm of printmaking, translated a group of portrait heads, including *Student with Spectacles*, into a series of prints using a process called *Lichtdrucke*, a photographic technique similar to xerography.

A number of extant drawings from these years are studies of the Mediterranean resort of St. Tropez, where his classes were held in the summers of 1928 and 1929 (Figs. 20–23). As Hofmann was to do later in the United States in drawings of Cape Cod, he selected one particular view and drew it time and again in varying degrees of detail. Although some sheets show a heavier and more forceful line than others, all were tightly constructed depictions in which various patterns differentiated landscape from seascape and one building from another. Curvilinear forms distinguished mountains and trees from the more angular architectural elements.

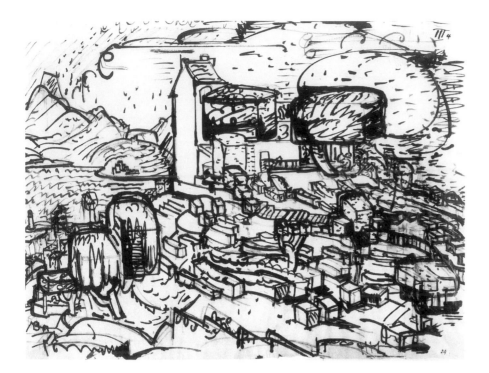

20. *St. Tropez vue sur les montagnes de St. Raphael,* 1929. Ink and pencil on paper, 10½ × 13⅞ (26.7 × 35.2). Estate of the artist; courtesy André Emmerich Gallery, New York

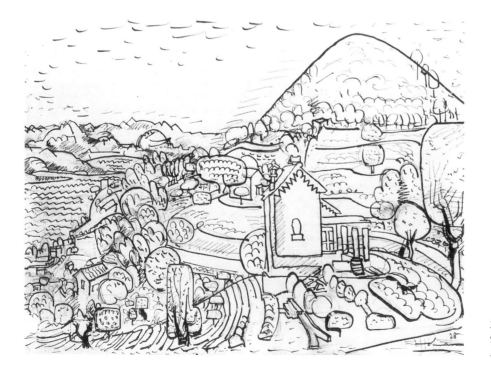

21. *Untitled (St. Tropez),* 1928. Ink on paper, 9 × 12 (22.9 × 30.5). Estate of the artist; courtesy André Emmerich Gallery, New York

Hofmann first visited the United States when his former Munich student Worth Ryder invited him to teach at the University of California at Berkeley during the 1930 summer session. After returning to Munich to teach the winter 1930–31 session at his school, he came once again to the United States in 1931 to teach in the spring at the Chouinard School of Art, Los Angeles, and in the summer at Berkeley. In the autumn of 1932, he accepted an invitation to become a faculty member at the Art Students League in New York City. In this unanticipated manner, Hofmann joined the growing number of artists and intellectuals seeking refuge in America from the increasingly hostile atmosphere in Europe before World War II. Although he was not confronted daily by the oppressive European environment, its specter was omnipresent in his psyche. In late September 1937, for example, after a hurricane in Provincetown, he wished that "the whole of Europe would have such a hurricane, that it would calm the disturbed minds."[24] When war first broke out, he was unable to work: "And now we have the war. This upsets me very much. Humanity is hopeless. My nerves have not found the necessary balance to do good work. But I think I will find back to myself soon."[25]

And so he did. Less than a year later, despite his continued anguish, he was resolute that "art must be kept alive and one cannot be too much absorbed from all these strange happenings."[26] As was his custom, he took solace in his work. Although reconciled to the fact that a "few good paintings is perhaps the best which such a time can produce," he thought it was "worthwile to try to do some good work" and prayed "may inspiration be with me."[27] For Hofmann, art always provided an antidote to adverse situations, whether global or personal.

Vaclav Vytlacil, who had spread news of Hofmann's prowess as a teacher before the Berkeley sessions, did so again at the Art Students League, where he was then teaching. Once more, Hofmann's arrival was gleefully anticipated and his classes well attended from the beginning. Burgoyne Diller, Ray Eames, Lillian Kiesler, Mercedes Carles Matter, Louise Nevelson, and Irene Rice Pereira were among his first eager students. Throughout the thirties, the Regionalism of Thomas Hart Benton, John Steuart Curry, and Grant Wood dominated the American aesthetic vision. When Hofmann arrived at the Art Students League, it was still a stronghold of conservatism. But he was warmly welcomed by those students anxious to learn about modern art and seeking an alternative to the teaching of Benton and John Sloan, who controlled the academic direction of the school. For many of his new students, Hofmann, with his European charm and impenetrably thick accent, personified the modern European masters, many of whom he referred to with impressive familiarity in his lectures and writings.

The only other artist in New York at that time who had had similar experiences was the elusive John Graham. Hofmann literally brought the School of Paris to life through his firsthand accounts. As one student commented, "Hans Hofmann embodied a focal point for the School of Paris in America."[28] For the same student, Hofmann's Art Students League class was a "marvelous atmosphere to get sucked into Cubism! It was the only school in the U.S. at that time which established clearly the lineage of Cézanne in painting and drawing in depth."[29] Cubism remained the mainstay of the school, and Hofmann frequently illustrated his lessons by drawing small Cubist diagrams in the margin of students' work, sometimes to their dismay but often to their enlightenment.

Hofmann stayed at the Art Students League until 1933, when he left to found his own school at 444 Madison Avenue. After several moves, the Hans Hofmann School of Fine Arts settled in 1938 at 52 West 8th Street in Greenwich Village, where it was to remain until Hofmann stopped teaching in 1958. Following his European practice, he taught in the summer as well. In 1933 and 1934, he held summer classes at the school of Ernest Thurn, another former student, in Gloucester, Massachusetts. In 1935, he established his own summer school in Provincetown, Massachusetts, a resort long popular with artists. Hofmann found the glorious Cape Cod beaches, crested with sand dunes unparalleled in scale on the eastern coast of the United States, intriguing as subject matter year after year.

In California, Hofmann had been limited to illustrating his lectures with diagrams and reproductions of paintings, but in New York he turned the rich collections of the city's museums and galleries into an extended classroom. He frequently took students to The Museum of Living Art at New York University, which housed the Albert E. Gallatin Collection until 1943 and was only a few blocks away from Hofmann's school. This fine collection, formed to show the evolution of modern art with works by Seurat, Braque, Picasso, Miró, Léger, and Delaunay, was ideal for Hofmann's instructional purposes. A particular favorite of his was Picasso's *Three Musicians* of 1921, a masterpiece of Synthetic Cubism, a style that exerted a dominant influence on Hofmann until the end of his life. On the announcement for the 1935–36 school year, he even included a list of what he considered to be the year's outstanding exhibitions in museums and commercial galleries, an indication of how he thought of these shows as an integral part of his curriculum. Among those he listed were the Léger, Van Gogh, and "Cubism and Abstract Art" exhibitions at The Museum of Modern Art, as well as gallery shows of works by Giorgio De Chirico, Jacques Lipchitz, Jean Hélion, Alexander Calder, Arthur B. Carles, Arshile Gorky, Wassily Kandinsky, and Chaim Soutine. Thanks to this approach, Hofmann's students

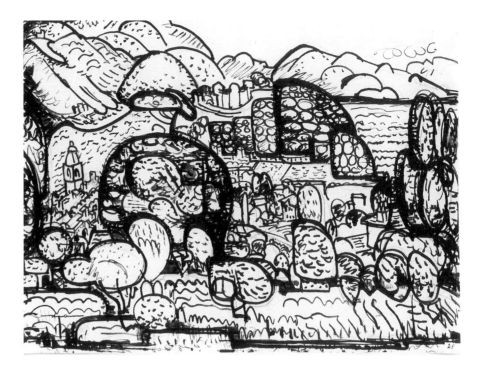

22. *Untitled (St. Tropez)*, 1928. Ink on paper,
9¾ × 12⅞ (24.8 × 32.7). Estate of the artist;
courtesy André Emmerich Gallery, New York

23. *Untitled (St. Tropez)*, 1929. Ink on paper,
10½ × 13½ (26.7 × 34.3). Estate of the artist;
courtesy André Emmerich Gallery, New York

appreciated modernist European masters before other American artists. Many of the watercolors in Miró's 1937 New York exhibition at the Pierre Matisse Gallery, for example, were bought by Hofmann's students, who paid a minimal amount for them since Miró was not yet generally recognized in the States.

Hofmann's European experiences distinguished him not only from his students but also from the Abstract Expressionists with whom he was later grouped. Robert Hobbs has described the "generalized and incomplete understanding of European developments," which most members of this group had in the early 1940s. "One might say that before the second half of the forties they had excellent renditions of the opera constituting modern painting but only fragmentary copies of the libretto."[30] Hans Hofmann already knew this libretto by heart. He had lived with the modern art movements and even in New York was surrounded by the works of those masters he had been fortunate enough to acquire. When Miz Hofmann finally arrived from Munich in 1939, she also brought with her paintings by Léger, Miró, and Braque, as well as a few pieces of Biedermeier furniture and a number of her beloved paintings by the French primitive master Louis Vivin, which she had purchased from Wilhelm Uhde (p. 188).

Just what was it that Hofmann taught? In the briefest synopsis, the essence of his teaching was based on the determination of the artistic process by "three absolutely different factors: first, nature which works upon us by its laws; second, the artist who creates a spiritual contact with nature and his materials; third, the medium of expression through which the artist translates his inner world."[31] For students as well as for himself, Hofmann maintained nature as the starting point for even the most seemingly abstract compositions. His pictorial message was focused on a quest for "plasticity," which he defined as "the transference of three-dimensional experience to two dimensions. A work of art is plastic when its pictorial message is integrated with the picture plane and when nature is embodied in terms of the qualities of the 'expression medium [the medium of expression].'"[32] In order to achieve this plasticity, the picture plane must be animated by the counterbalancing forces that Hofmann called "push and pull." For many, this term became synonymous with his way of painting. Whenever the picture plane is activated in one location, this stimulus causes a counterreaction. As he most frequently phrased it, "'Push' answers with 'Pull' and 'Pull' with 'Push.'"[33] In order to make this activation more patent, he compared it to the impact of pushing a gas-filled balloon first from one side and then from the other.

Hofmann's pictorial universe was linked intimately with his experience of both the natural and spiritual worlds. The push and pull of the picture surface was akin to the negative and positive occurrences in one's life. He expressed this relationship clearly in a letter written in the summer of 1938. Already fifty-eight years old, he lamented his inability to devote himself to what he saw as his foremost mission in life, that is, to paint: "I cannot understand why nature does not free one in a certain advanced stage of life so one may be open for great and undisturbed work. But every dream passes like an illusion in the movies and the waking finds us back in reality. It may be what seems an experience … which appears negative is a precondition for the positive which we must accomplish in life."[34]

His lectures and writings of all periods sound as if he had been creating the paintings of his last decade virtually all his life. In 1938–39, he gave a well-attended series of lectures at his 8th Street school.[35] He began the first by talking about the "Law of the Picture Plane." For Hofmann, "plastic creation" was a lifelong pursuit, and he exactingly positioned each element of the composition in order to achieve it. He constantly admonished students about the pictorial significance of moving a compositional element even a millimeter, for such a slight shift gave it an entirely new meaning. He frequently punctuated lectures with diagrammatic illustrations about planar construction and the differing "tensions" or "distance between two planes."[36] In these classroom drawings, the tensions between planes were drawn as brackets; the larger the bracket, the greater the tension (Fig. 24).

Planes have the ability to move on the picture plane "to the right or to the left … up or down, or into space and out of space."[37] The minute an arrangement is drawn, a "spatial effect" is created, and by shifting one element "the whole spatial effect is changed."[38] Hofmann demonstrated this effect with a grouping of three overlapping rectangles, which he labeled 1, 2, and 3, in order to indicate their spatial order. According to his philosophy, the "overlapping of planes creates a spatial illusion in the sense which you experience it outside."[39] This was "fundamental" to "every plastic creation."[40] Planes in themselves are "static but when in proper relation express a certain plastic tension. …"[41] This tension exists not only between the planes themselves but between the planes and the four sides of the paper.

Hofmann proclaimed: "I want the fullness of myself realized through color,"[42] and each of his paintings was a struggle to find a perfect balance of form and color, which he saw as interdependent and indissolubly linked: "Form only exists through color and color only exists through form."[43] Like forms, colors had tensions between them, and the meaning of each color was dependent on its location on the

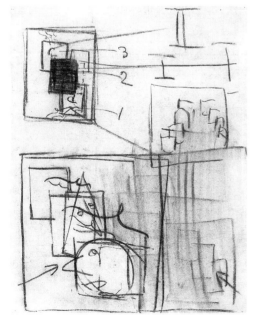

24. *Untitled (lecture demonstration drawing)*, c. 1942. Charcoal on paper, 25 × 18⅞ (63.5 × 47.9). The Metropolitan Museum of Art, New York; Gift of Jermone Burns, 1978

picture plane. According to Hofmann, the color development of the composition should lead from one color scale to another, and developing the scales was one of the most important things in painting. In the "pure painting" he sought, the pattern of color movement is from one scale to the next across the picture surface; intervals express the relations between colors in the same way that tensions function for planes. He achieved "plasticity" with color as well as with form and the achievement "gives the plane transparency ... [which] gives the color the possibility to express a movement of light in the depth of the picture and out of the depth of the picture."[44] He compared this light effect to that of a jewel or precious stone, such as a diamond or sapphire, which both absorbs and reflects light. Hofmann made this analogy even more comprehensible to his audience by showing a reproduction of a Renoir as an illustration of a painting that gives "the illusion that the light goes into the picture and that it flows back out of the picture."[45]

Until the mid-forties, Hofmann painted and drew the same three categories of subjects he assigned to students in his school: portraits and figure studies; landscapes; interior scenes and still lifes. A group of ink on paper drawings of the California landscape were done during his first few years in the United States. Not only are many of these dated but a number of them can be identified by the unmistakable forms of the oil derricks that fascinated him in the Richmond area outside San Francisco (Figs. 25, 26). Hofmann's early years in America had an astonishingly liberating influence on his drawing style. The compact, apparently precise manner in which he had frequently recorded the European landscape in the twenties almost immediately gave way to much less carefully delineated renditions of the American terrain. Recurrent in many of his California landscapes is the steering wheel of the Packard that he bought there and cherished. Haley, his former student in Munich and friend in California, recalled how Hofmann came over from Germany with the idea, derived from watching American movies, that the Packard was "the car" in America. Hofmann, who proclaimed that he "loved to drive in California," terrorized his friends by insisting on driving in the center of the city streets and, on the highway, stopping suddenly whenever the scenery appealed to him.[46]

It was not until the mid-thirties that Hofmann began painting regularly again. Once more, the demands of the school and the effort of acclimatizing to an entirely new life-style seemed to inhibit his artistic achievement. In fact, as late as 1952 he was regretting that his "own work suffered slightly through the weight of the school. ... As a European of birth, I still have not acquired the American elasticity of constant changes."[47]

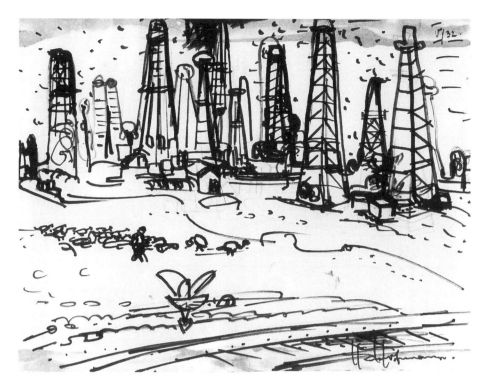

25. *Untitled (California Oil Field)*, c. 1930. Ink on paper, 8¹⁵⁄₁₆ × 10⅞ (22.7 × 27.6). Estate of the artist; courtesy André Emmerich Gallery, New York

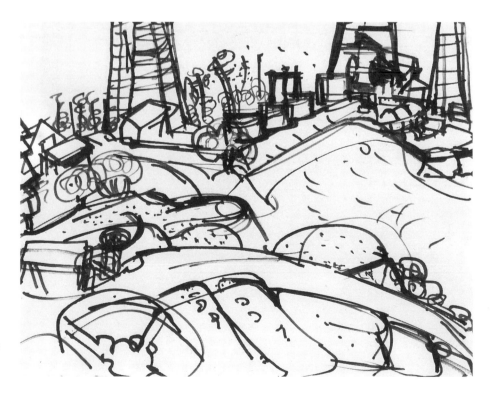

26. *Untitled (California Oil Field)*, c. 1930. Ink on paper, 8⁷⁄₁₆ × 10¹⁵⁄₁₆ (21.4 × 27.8). Estate of the artist; courtesy André Emmerich Gallery, New York

27. *Reclining Nude*, 1935. Ink on paper, 8½ × 11 (21.6 × 27.9). The Museum of Modern Art, New York; Gift of Philip Isles

Although from the beginning Hofmann drew from the model and still lifes in his New York classroom as he had done in Europe and California, a definitive chronology is impossible because few of the thousands of figure studies in ink on paper are dated. Hofmann's treatment of the human body was as varied as his treatment of other subject matter (Figs. 27, 28). Sometimes he was more concerned with the figure as a series of volumes; at other times, he was preoccupied with it as a linear form. Some of his figure drawings verge on the representational; others are akin to Picasso in their distortion and liberties with the human shape. Once again, however, the key to the composition was the movement of the planes and their relationship to the picture plane. As he told students: "Think about planes in relation to a figure. When I move this plane out it perhaps expresses that there is a greater spatial tension between the forehead and chest."[48]

Hofmann's enormously diverse depictive styles — which have engendered criticism and hindered a full appreciation of his work — are actually entirely consistent with his pictorial approach. His preeminent concern was the interaction between a subject and the space around it. As composition changed, so might the manner of portrayal. Glenn Wessels explained his former teacher's practice:

> His system of using the model was to arrange an environment, and the student had to draw not only the figure but the figure in relation to other things because Hofmann kept saying, 'Things exist only in relation.' This same pose in another environment

would become a different compositional problem and so forth.... This was rather unusual in those days because the traditional way to use the model was simply to stand the model on the podium in the middle of the room and you just drew the figure in a closed form; you did not relate it to anything. The idea that forms exist in relation was not part of the formal art instruction in the typical school of the time. I never had it before Hofmann and I don't think that a great many people did either.[49]

Whether figure, still life, or interior scene, Hofmann's goal was an activated space full of "contrasts" that enlivened the composition. The idea of contrast is key to an understanding of the paradoxical manner in which Hans Hofmann both lived and worked. Bultman remembers that Miz called her husband "a 'Widerspruchsgeist'—the embodiment of contradiction, and it was by paradox and duality that he developed his work. His work from the beginning to the end is a dialogue of the abstract and the observed (even when this observation became the relationship of planes of color to other planes of color). He refused to produce in conformation with any previous findings—any previous image. Each painting was a new beginning in which he tried to resolve the duality of color and form, space and flatness, volume and the two-dimensionality of the prime surface."[50]

When Hofmann began teaching at the Art Students League in 1932, he lived at the Barbizon Hotel. Lillian Kiesler, who was in his first class, recalls that he took a studio somewhere in the west twenties, on the top floor of an office building, accessible only by stairs. In this modest space, he began working once again in watercolor as well as paint. Among the first works produced there were a delicately painted arrangement of flowers in a vase (Fig. 29) and a more colorful and strongly painted bouquet of flowers, perched somewhat ambiguously on a small table in front of a chair, with some outlines delineated in black and others with the telltale black dots that Hofmann was often to use (Fig. 30).

The tightly structured arrangement of *Apples* (Fig. 32) and a second brightly and thickly painted still life (Fig. 31), also done in the same studio about 1932, attest to the continuing influence of Cézanne. The dablike application of paint manifests as well the lingering effect of Impressionism and a continuation of the heavily painted surfaces of many of the Munich paintings. Hofmann's lively surfaces reflected as well his Germanic inclination to animate the inanimate. In his words: "Think of an apple. An apple is not only a dead form. An apple is life, and you have to feel this life. ... An apple is the result of a long process of growing. The form has inner tension. The form in other words stops not

28. *Untitled (Figure Study)*, c. 1935. Ink on paper, 11 × 8½ (27.9 × 21.6). Estate of the artist; courtesy André Emmerich Gallery, New York

on the surface, but under the surface you feel all this power which has created the apple."[51] Both *Apples* and the untitled still life are related compositionally to the interiors and still lifes Hofmann was to paint until the mid-1940s in which the tilted tabletop was a recurrent device. However, the surfaces of his subsequent compositions were generally distinguished by the translucency of highly saturated color rather than by a thick application of paint. Thus, in terms of paint application, these two still lifes look both backward to his Munich paintings as well as forward to the animated surfaces of his mid-fifties works, many of which achieved a dense, mosaiclike effect.

An opulently laden table such as that in *Table with Fruit and Coffeepot* of 1936 (Fig. 33) was frequently the point of departure for Hofmann's interior compositions. This table also appears repeatedly, sometimes yellow as here and in *Untitled (Yellow Table on Green)* (Fig. 34), sometimes pink, sometimes blue, and sometimes green. Many of these compositions recall Matisse's great interior scenes such as the 1911 *The Red Studio* and *The Pink Studio*. Like Matisse, Hofmann often incorporated one of his own "compositions within a composition." The paintings on the walls in the backgrounds of his interiors are probably based on those in his own studio at the time. Again like Matisse, in *Interior No. 1 — Pink Table, Yellow Tulips* (Fig. 35), he covered the floors and walls with a single color that served as a backdrop for the objects in front of them. Wessels also remembers the painstaking care with which his teacher arranged all the objects in the room. Before class time, Hofmann went

> around with huge sheets of colored paper and illuminating the shadows so that one could look into them and see something. Then killing the glare of white walls by darkening them with sheets of paper and so forth. So when you looked around the room, you got an alternation of dark and light that was kind of alive.[52]

Color permeated Hofmann's work and life. For many who visited the Hofmanns in their Provincetown home, the lingering impression was of how the brightly colored walls, floors, and furniture, all painted by Miz, echoed the cadmium reds, ultraviolets, and cobalt blues in her husband's paintings. The Hofmanns referred to one room as a "Matisse room" and another as a "Mondrian room,"[53] names that not only reflected the color scheme but also Hofmann's admiration for the two masters.

Portraiture and self-portraiture are also recurrent themes. *Jeannette Carles* (Fig. 38) is recognizably the likeness of Mercedes Carles, one of Hofmann's students, a frequent companion, and the daughter of Arthur B. Carles, whom Hofmann knew from his years in Paris and

29. *Still Life*, c. 1932. Oil on board, 25 × 30 (63.5 × 76.2). Collection of Michael Diamond

30. *Untitled (Still Life)*, c. 1932. Watercolor on paper, 19½ × 24½ (49.5 × 62.2). Private collection

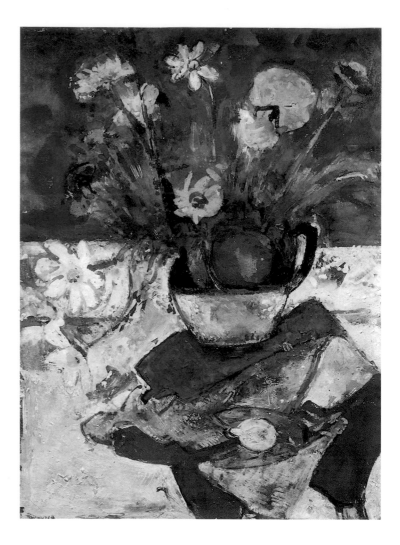

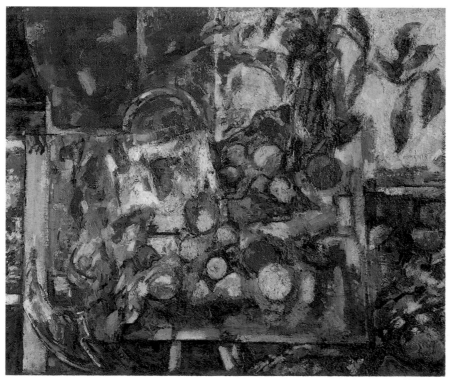

31. *Bouquet*, c. 1932. Gouache on paper,
15¾ × 11½ (40 × 29.2). Private collection

32. *Apples*, c. 1932. Oil on composition board,
25 × 30 (63.5 × 76.2). Private collection

33. *Table with Fruit and Coffeepot*, 1936.
Oil and casein on panel, 59¾ × 47¾.
(151.8 × 121.3). University Art Museum,
University of California, Berkeley; Gift of the artist

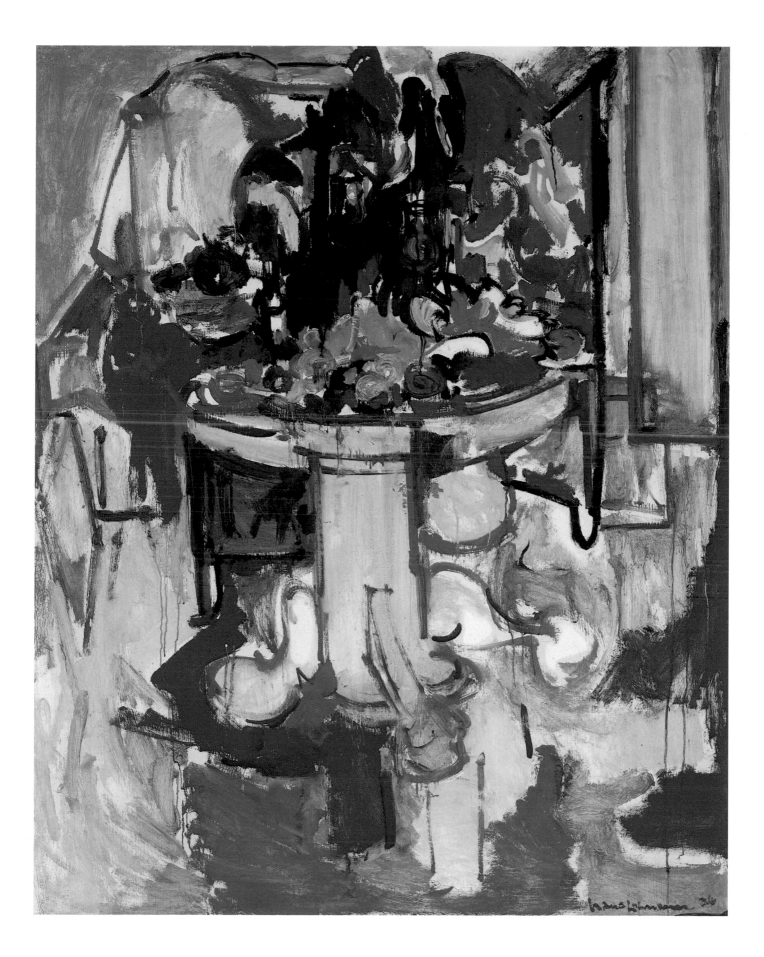

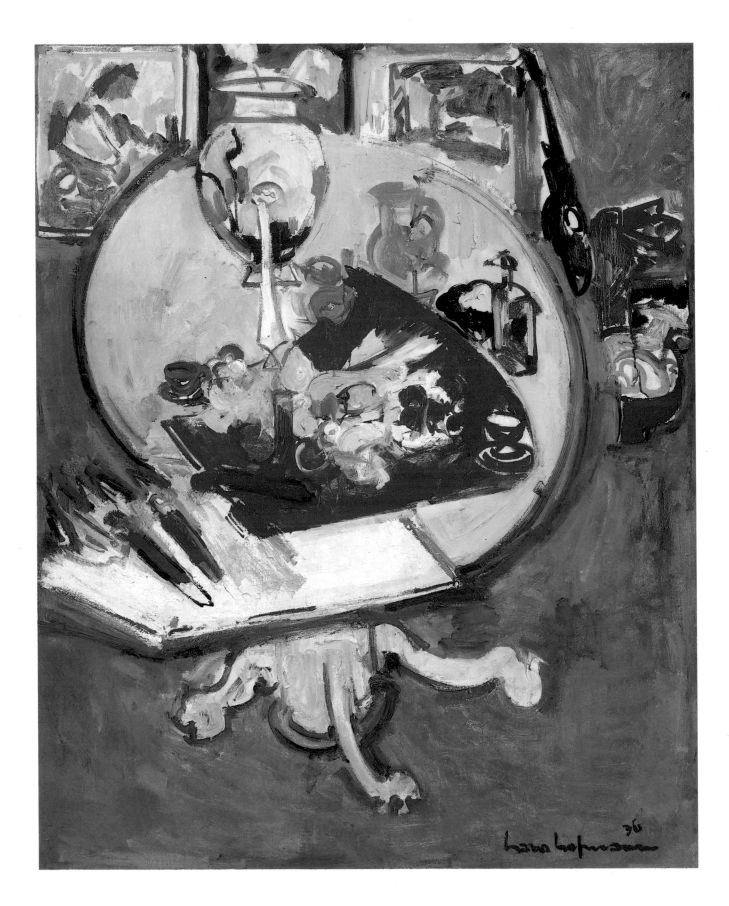

34. *Untitled (Yellow Table on Green)*, 1936. Oil on board, 60 × 44½ (152.4 × 113). Collection of Howard E. Rachofsky

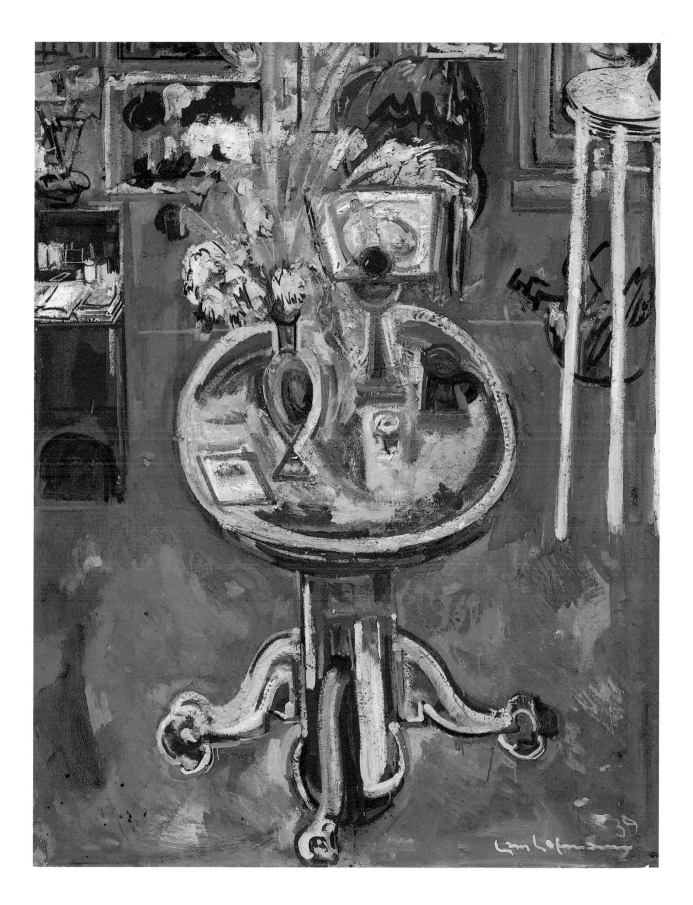

35. *Interior No. 1 – Pink Table, Yellow Tulips*, 1937. Oil on board, 58½ × 44½ (148.6 × 113). Collection of Mr. and Mrs. Preston Robert Tisch

36. *Untitled*, 1939. Watercolor on paper, 17¾ × 24 (45.1 × 61). Private collection

37. *Untitled (Still Life)*, c. 1940. Ink on paper, 8¼ × 10¾ (21 × 27.3). Estate of the artist; courtesy André Emmerich Gallery, New York

respected greatly. The identity of many other sitters in his portraits, however, is unknown, although one assumes that once again he used the school models. Frequently, he turned to himself as subject. As in *Self-Portrait with Brushes* of 1942 (Fig. 39), the likeness is often unmistakable. At other times, as in a series of progressively more abstract self-portraits (Figs. 40–42), one unfamiliar with Hofmann's manner of self-depiction would have great difficulty in recognizing him and, in the most abstract of the three in this exhibition, even in recognizing the image as a portrait.

During summers, the focus of Hofmann's work was the landscape and seascape of Cape Cod, which he depicted in ink, watercolor, crayon, and paint (Figs. 43–47). His portrayal of these subjects was also stylistically diverse, ranging from the strictly representational with specific details of locale to swirling crests of paint only occasionally punctuated by recognizable elements to cascades of colorful planes that foretell the compositional device which was to become the hallmark of his mature style (Figs. 48, 49). A recurrent silhouette in these landscapes is that of "the house on the hill" (Fig. 50), the large frame house that formerly belonged to painter Charles Hawthorne and was adjacent to the barnlike building in which Hofmann's Provincetown school was located from 1935 until 1945.

The house was but a pretext for Hofmann's true motivation in landscape painting — to celebrate nature. He relished June, for example, as "a month where 'green' has a holiday. In an ocean of green a

38. *Jeannette Carles (Mercedes Carles Matter)*, 1934. Oil on plywood, 54½ × 40½ (138.2 × 102.9). Collection of Mr. and Mrs. Jeffrey Glick

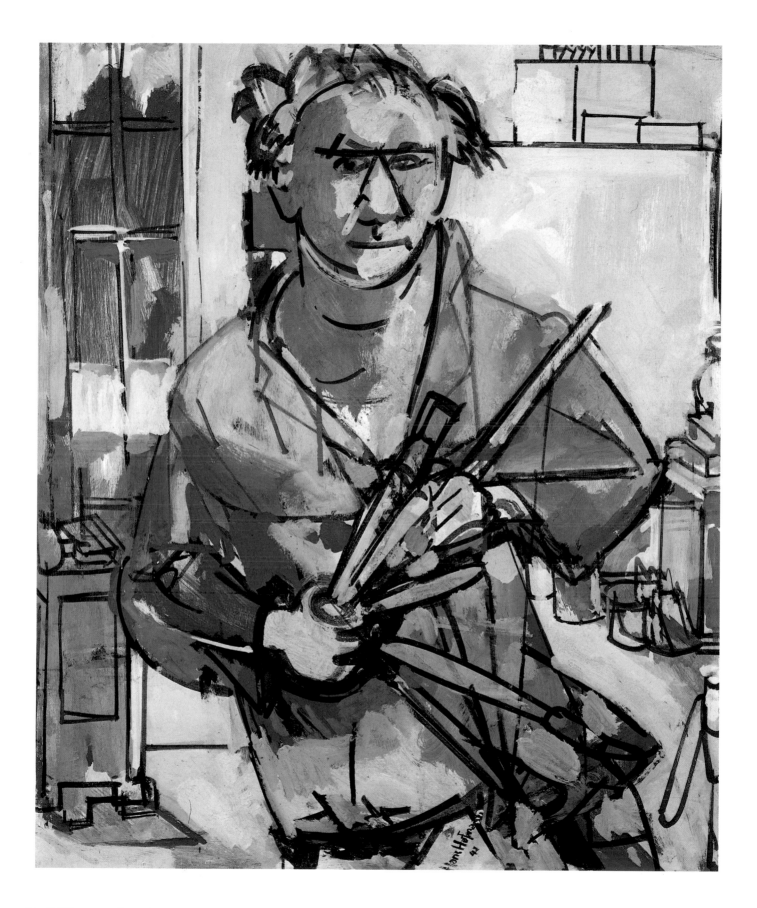

39. *Self-Portrait with Brushes*, 1942. Casein on plywood, 30 × 25 (76.2 × 63.5). Estate of the artist; courtesy André Emmerich Gallery, New York

40. *Untitled (Self-Portrait)*, c. 1942. Oil and ink on paper, 10¹⁵⁄₁₆ × 8½ (27.8 × 21.6). Estate of the artist; courtesy André Emmerich Gallery, New York

41. *Untitled (Self-Portrait)*, c. 1942. Oil and ink on paper, 10¹⁵⁄₁₆ × 8⅝ (27.8 × 21.9). Collection of Dr. Harold and Elaine L. Levin

42. *Untitled (Self-Portrait)*, c. 1942. Oil and ink on paper, 10¹⁵/₁₆ × 8½ (27.8 × 21.6). Estate of the artist; courtesy André Emmerich Gallery, New York

multicolored green of a billion variations."[54] Hofmann wanted to be always in a state of preparedness so that he could take advantage of "every paintable occasion."[55] He worked daily from nature, weather permitting, and was often spotted on the dunes with bottles of water and turpentine suspended from his easel to weigh it down against the wind. Sometimes he drove everyday to paint in Wellfleet or Truro; although he admitted that he was "having difficulties with the landscape," he likened it nevertheless to "heaven ... a landscape like [the] Toledo of Greco."[56]

Despite the numerous landscape paintings that survive, Hofmann's letters reveal that it was not always easy for him to work in paint, and he frequently turned to drawing either as a respite or more often as a preliminary exercise somewhat comparable to a dancer limbering up before beginning a formal practice routine. Sometimes hundreds of drawings preceded a composition in paint. In the summer of 1941, he wrote that he felt "a very deep need to draw and I have already made a quite great number. They are most of them color drawings. ... I color with oil crayon so I am somewhat back on the way to oil. It is quite

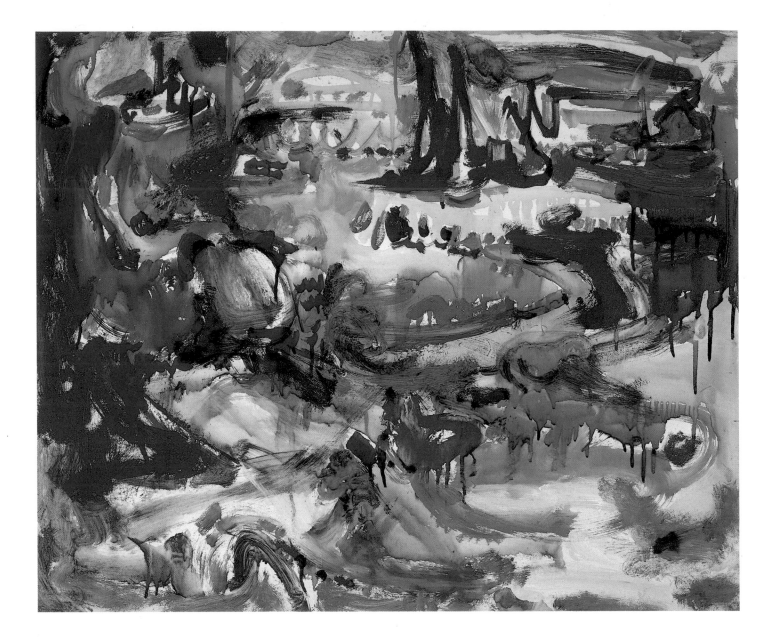

43. *Landscape*, 1935. Casein on plywood, 25 × 30 (63.5 × 76.2). Private collection

44. *Untitled (Provincetown Seascape)*, c. 1935. Ink on paper, 8½ × 11 (21.6 × 27.9). Estate of the artist; courtesy André Emmerich Gallery, New York

a wonder what one can do with reduced means."[57] Drawing in color was crucial to Hofmann's artistic development. It helped free him from the need to begin a composition by sketching in the forms with black outlines and then filling in the color. Putting pen or pencil to paper had been so ingrained in his manner of working that only in the mid-forties did the black outlines with which he frequently began paintings as well as drawings for the most part disappear.

Hofmann was aware of this revolution in his work. In the same 1941 letter he also claimed with his usual mix of confidence and reticence: "I think I am on the way to a new orientation with amazing results ... so I hope." And several months later he wrote again about the new developments in his work: "My work comes along in rather an experimental period which I find myself on the way to highest freedom. My concept has enlarged tremendously. Yet I don't quite realize what it is ... I am looking for it but it is on the way."[58] Even before he relinquished his practice of delineating forms, the landscape had manifested a spontaneity and painterly abandon unequaled in the more structured studio still lifes and portraits he painted during the winter months. Thus at an early stage two diverse styles of painting coexisted in his work, and they continued to do so.

Hofmann had had several exhibitions in California in 1931 as well as a one-man exhibition at the Isaac Delgado Museum in New Orleans ten years later. He had exhibited in a group show at the Art Students League in 1943, but his first solo show in New York was at

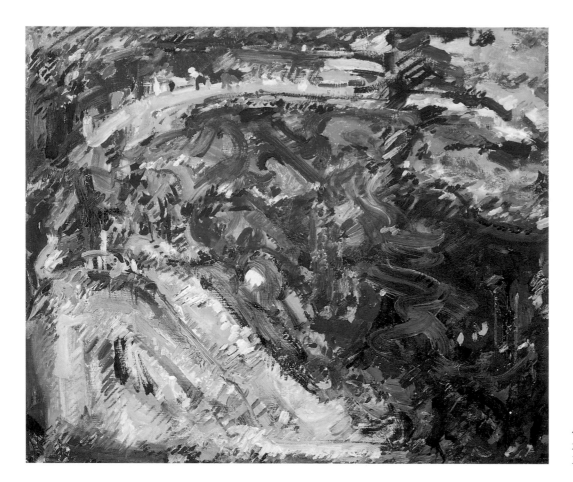

45. *Pilgrim Hights Vue*, 1936. Oil on board,
25 × 30 (63.5 × 76.2). Collection of Mr. and Mrs.
Miles Q. Fiterman

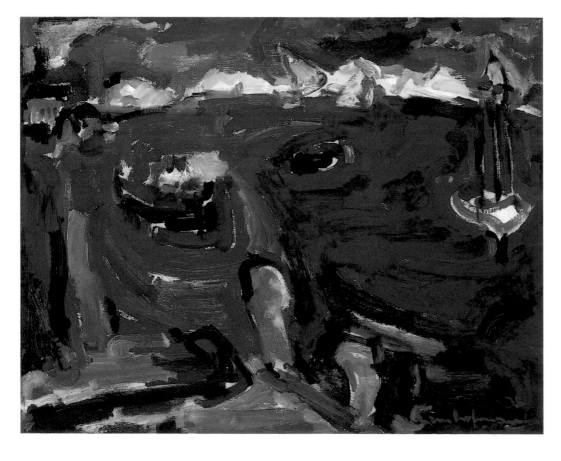

46. *Truro, Evening in the Harbor*, 1938. Oil on
board, 24 × 30 (61 × 76.2). Private collection

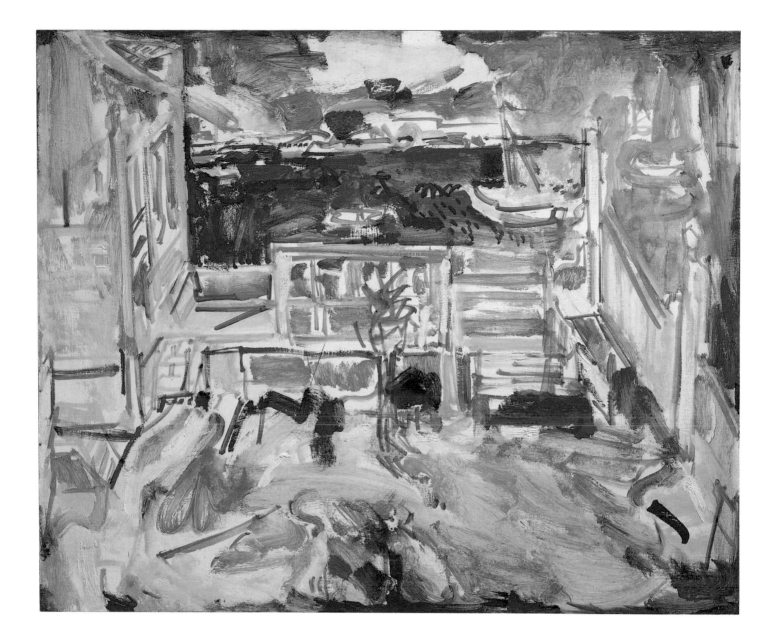

47. *Landscape*, c. 1936. Oil on board, 30 × 36 (76.2 × 91.4). Collection of Mr. and Mrs. Kenneth N. Dayton

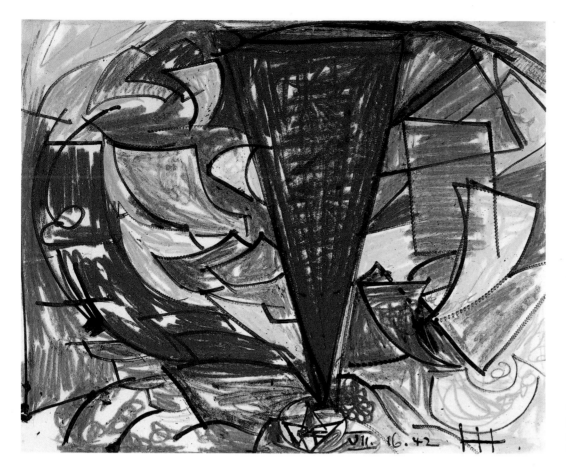

48. *Untitled, VII. 16.42,* 1942. Ink and crayon on paper, 14 × 16¹⁵⁄₁₆ (35.6 × 43). Hirshhorn Museum and Sculpture Garden, Smithsonian Institution, Washington, D.C.; Museum Purchase, 1977

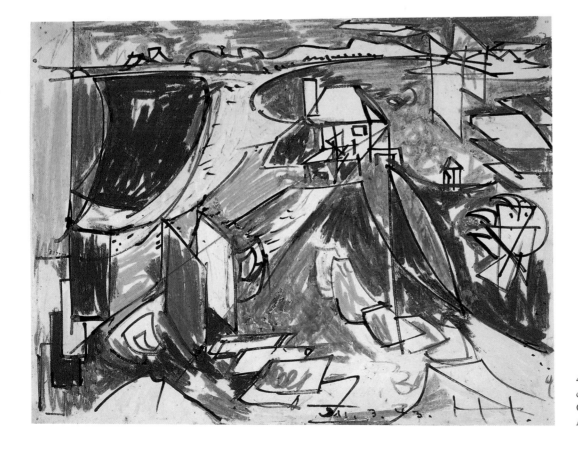

49. *Color Intervals at Provincetown,* 1943. Ink and crayon on paper, 17½ × 24 (44.5 × 61). Addison Gallery of American Art, Phillips Academy, Andover, Massachusetts

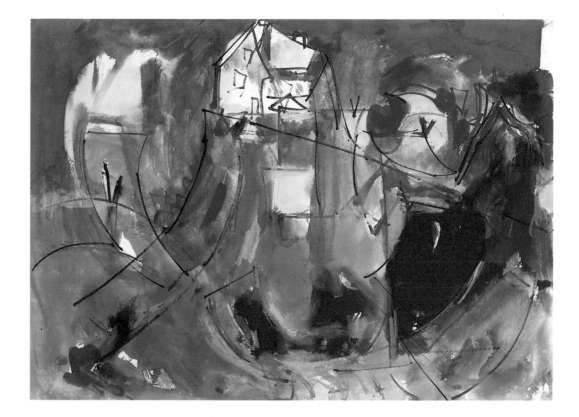

50. *Untitled*, 1943. Gouache on paper, 17½ × 24
(44.5 × 61). Collection of Mr. and Mrs. Orin
S. Neiman

Peggy Guggenheim's Art of This Century Gallery in 1944. It was here
that most people in the New York art world, even those who had sat in
his classroom or listened to his lectures, saw Hofmann's paintings for
the first time. Until this exhibition, Hofmann's awareness of the still
experimental nature of much of his work and his coincident frustration
that he was unable to devote himself fully to his art made him reticent
about showing his work to all but a few friends. His inhibition must also
have been motivated by the understandable fear of putting his own work
up for examination and critical evaluation in a manner not unlike that
which he practiced daily on students.

Guggenheim's gallery was the center of Surrealist activity
for European artists who had sought refuge in America during World
War II. Guggenheim also showed many of the emerging American
vanguard, including Jackson Pollock (who had encouraged her to give
Hofmann a show and whom Hofmann supported, in turn, by purchasing
two of his works), Robert Motherwell, William Baziotes, and Clyfford
Still. Despite the Surrealistic tenor of the gallery's activities, according to
one contemporary review many of the works that Hofmann exhibited
were variations on the theme of his Provincetown house and thus must
have looked fairly conservative in comparison to those of the other
artists who were affiliated with Art of This Century.

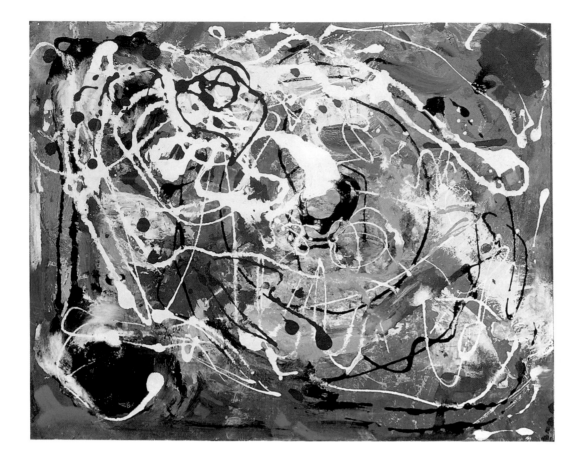

Nineteen forty-four was a signal year in Hofmann's development. A hernia operation prevented him from painting out-of-doors because he could no longer carry the heavy easel and painting supplies; landscape thus ceased to be a major theme. His compositions became increasingly abstract and involved with mythic as well as primitive imagery, partly in response to the work being done by Art of This Century painters. The titles of his new works reflected these concerns — *Flow of Life*, *Life Coming into Being*, *The Secret Source*, and *Idolatress I* of 1944 (Fig. 74). The latter painting was indebted to Hofmann's understanding of both Picasso and Miró as well as a reference to paintings by Jackson Pollock such as *Moon Woman* (1942) and *Moon Woman Cuts the Circle* (1943), which had been exhibited in Pollock's 1943 exhibition at Art of This Century. (A catalogue from that show was found among Hofmann's papers at the time of his death.)[59]

Although it has been claimed that Hans Hofmann initiated the drip technique before Jackson Pollock, there is much to suggest that Hofmann's linear compositions such as *Spring* (Fig. 51), *The Wind* (Fig. 52), and *Fantasia* (Fig. 65) were not painted before 1944, although they bear earlier dates.[60] The most convincing evidence is Sidney Janis'

51. *Spring*, 1944–45 (dated 1940). Oil on panel, 11¼ × 14⅛ (28.6 × 35.9). The Museum of Modern Art, New York; Gift of Mr. and Mrs. Peter A. Rübel

52. *The Wind*, c. 1944 (dated 1942). Oil, Duco paint, gouache, and ink on poster board, 43⅞ × 27¾ (111.4 × 70.5). University Art Museum, University of California, Berkeley; Gift of the artist

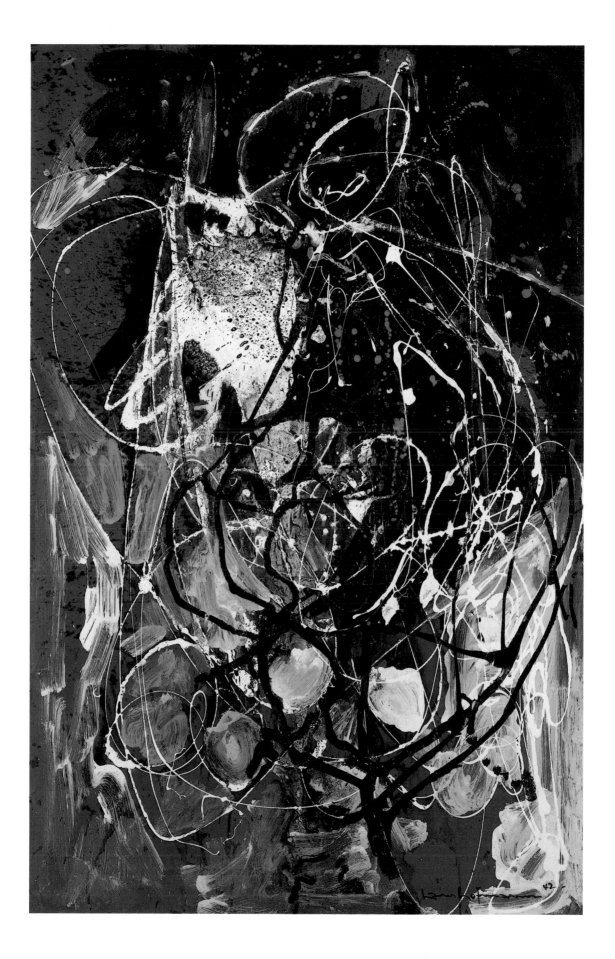

recollection of visiting Hofmann's studio sometime in mid-1943 in search of a work for inclusion in the "Abstract and Surrealist Art in the United States" exhibition he was organizing. Although Hofmann showed him virtually every painting in the studio, Janis left empty-handed. Approximately six months after this visit, Miz Hofmann called Janis to tell him that Hofmann had just completed a painting, now called *Idolatress I*, which qualified for inclusion in his show. Certainly if Hofmann had already painted *Spring, The Wind,* or *Fantasia* — in all of which skeins of paint drip and puddle across the surface seemingly without reference to any recognizable imagery — he would have shown them to Janis rather than the far more conservative mythic figure of *Idolatress*. Additional evidence is provided by the dating of *Fantasia* to 1945 – 46 in the catalogue for Hofmann's large exhibition at the Addison Gallery of American Art in 1948, which Miz Hofmann closely supervised.

In the mid-forties, Hofmann also turned with fervor to working in mixed media on paper. Among the most outstanding achievements of the next several years was a series of gouaches, including *Midnight Glow* (Fig. 53), and two untitled sheets (Figs. 75, 77), which are among his most successful works. Opulently colored, inhabited by whimsical, somewhat mythic creatures, and frequently punctuated by Miróesque doodles, they signaled a distinctive development in Hofmann's work, which he acknowledged by referring to them as "free creations."[61]

In exploring automatism, the incorporation of mythic, primitive, and underwater imagery, during the 1940s, Hofmann was responding to many of the same sources as his American colleagues. Unlike them, however, he had had direct experience with these sources much earlier. He had known the impact of primitive art on the Cubists when he had lived in Paris some thirty years before. In 1930, he had returned to Munich from his first trip to California with an Ivory Coast female initiation mask that he had bought in San Francisco.[62]

As the 1940s progressed, there was a growing recognition of a new, yet evasively undefinable style of painting. Robert Coates tackled the problem in *The New Yorker* in 1944:

> There's a style of painting gaining ground in this country which is neither Abstract nor Surrealist, though it has suggestions of both, whilst the way the paint is applied — usually in a pretty freeswinging, spattery fashion, with only vague hints at subject matter — is suggestive of the methods of Expressionism.[63]

In 1945, Howard Putzel attempted to define the new movement by organizing an exhibition at his gallery called "A Problem for Critics." Among the artists included were Arp, Gorky, Gottlieb, André Masson,

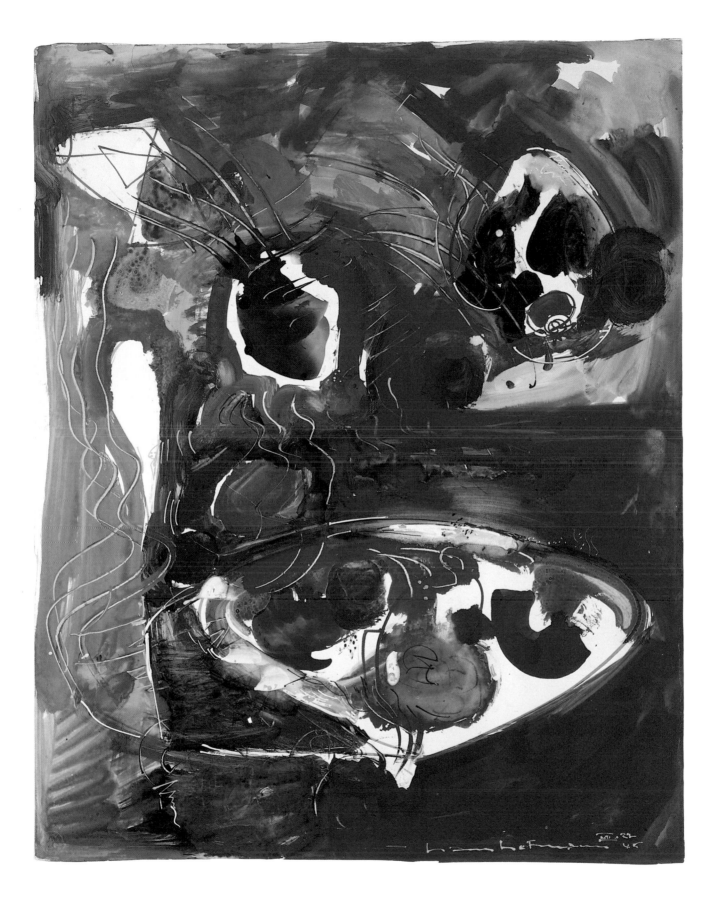

53. *Midnight Glow*, 1945. Gouache on paper, 28⅞ × 22⅞ (73.3 × 58.1). Collection of Mrs. G. N. Bearden

Miró, Rothko, Pollock—and Hofmann. The first time that the term "abstract expressionism" was applied to the new painting was in a review of Hofmann's one-man exhibition at the Mortimer Brandt Gallery in New York in 1946. Coates wrote: "[he] is certainly one of the most uncompromising representatives of what some people call the spatter-and-daub school of painting and I, more politely, have christened abstract Expressionism."[64]

After Hofmann's exhibition at Art of This Century, he had yearly one-man shows and was included regularly in prestigious group exhibitions, among them "The Ideographic Picture" at the Betty Parsons Gallery in 1945, organized by Barnett Newman and exhibiting work by Newman as well as Pietro Lazzari, Boris Margo, Ad Reinhardt, Rothko, Stamos, and Still. Hofmann's work was also shown in the "Intra-subjectives" exhibition co-organized by Harold Rosenberg and Sam Kootz in 1949. In 1947, Hofmann had become affiliated with Kootz's gallery, where he showed regularly until his death in 1966. His solo exhibition at the Addison Gallery of American Art in 1948 was the first one-man exhibition given to any of the Abstract Expressionists.

Many of Hofmann's American colleagues tried to break from European influences in the later forties. Their attitude toward the European modern masters was somewhat ambiguous: both indebted to and stimulated by them, they also fiercely fought to maintain their independence. Hofmann, on the other hand, continued to proclaim his European loyalties. In a 1945 interview, he identified Arp, Miró, Kandinsky, and Mondrian as the greatest innovators in modern art.[65]

As the decade closed, Hofmann reiterated his predilection for the School of Paris. At a panel discussion in 1950, he asserted the superiority of the French heritage in the arts: "Yes, it seems to me all the time that there is a question of heritage. ... French pictures have a cultural heritage. ... The French have it easier. They have it in the beginning."[66] This attitude helps explain why, like Picasso and Matisse and unlike his New York School contemporaries, even Hofmann's most abstract compositions were rooted in the object—and also why he came to abstraction so late in life. Thus even a seemingly non-objective composition such as the jubilantly colored *Gestation* of 1947 (Fig. 54) is based on one of his earlier interior scenes. At first unrecognizable, the familiar table and still-life objects have been abstracted to their most elemental forms and the background depicted as simple planes of color.

Whereas *Gestation* is exuberant in both color and form, a number of Hofmann's compositions from the mid- to the late forties appeared restrained in both color and line; sometimes one large, frequently white, form would be silhouetted in black against a solid ground of blue, orange, or black; at others, the palette was richer,

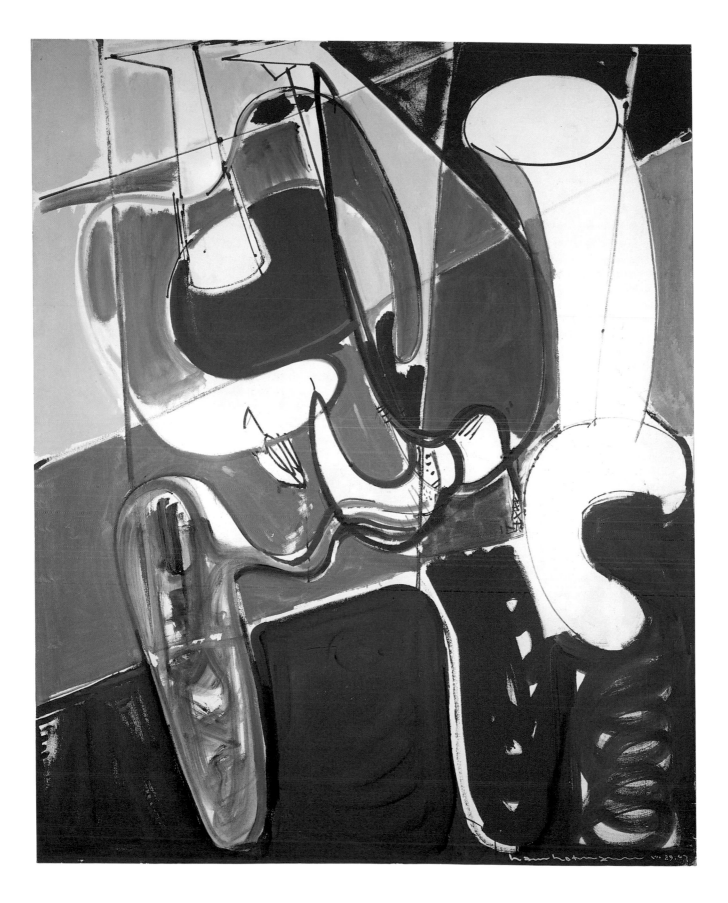

54. *Gestation*, 1947. Oil on canvas, 60 × 48 (152.4 × 121.9). Collection of Frank Stella

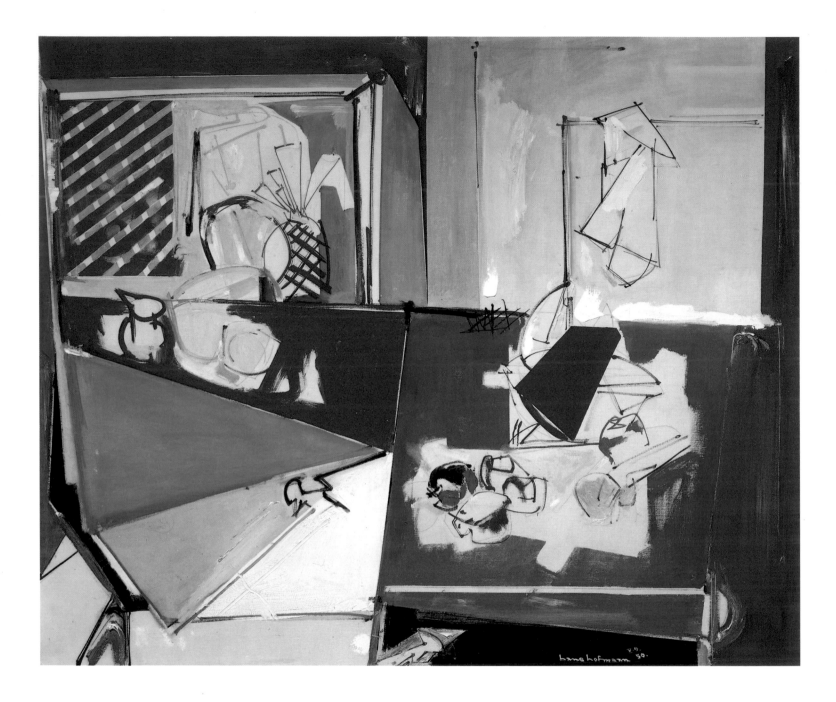

55. *Magenta and Blue*, 1950. Oil on canvas, 48 × 58 (121.9 × 147.3). Whitney Museum of American Art, New York; Purchase 50.20

although the paint was still thinly applied. New and sometimes seemingly aggressive and mysterious shapes appear in Hofmann's pictorial vocabulary at this time. Yet, as always, his source was close at hand. The repeated inspiration for many of these compositions was a piece of driftwood that he kept in his Provincetown studio (p. 190).

In the early 1950s, Hofmann's surfaces once again became denser, more tactile, and more activated. From this time until his death in 1966, he often applied the oil paint lavishly as he built up a painting layer by layer with thick swaths of paint. Tony Rockwell, a conservator at the San Francisco Museum of Modern Art who has closely studied Hofmann's working methods, observed: "Once applied, the still wet paint, or perhaps with thin dried skin, might be scratched, scraped or pushed around with a spatula, palette knife or brush."[67]

"We hear, smell, and touch space,"[68] Hofmann proclaimed in his unpublished textbook on art. Painting was for him a sensory experience that called into play not simply vision but all the senses. His predilection for lustily applied surfaces is amply demonstrated by the exquisite small painting *Persian Phantasy* of 1953 (Fig. 79), which is several inches thick in numerous places. Crests and mounds of pigment heave and surge, many applied directly from the tube and then manipulated by fingers and sticks as well as by brush. To *Liebesbaum* of 1954 (Fig. 80), he applied the swirling crests of thick red and green paint with such force and conviction that the viewer both feels a part of the growth process of this "tree of love" and shares the exuberance with which it was created. These surfaces typify those of the gesture painters — including Willem de Kooning and Franz Kline — for whom the primary pictorial intent was the animation of the surface with fluid, expressive gestures.

Yet not all Hofmann's pictures explore the painterly direction in Abstract Expressionism. The thinly painted, highly saturated *Magenta and Blue* of 1950 (Fig. 55) links him with the Color Field painters Mark Rothko and Barnett Newman. This work also refers with a surprising directness to Hofmann's great still lifes and interiors of the previous decade, for he never relinquished these themes, although they were usually better disguised. With *Magenta and Blue*, therefore, he seems to have momentarily abandoned the direction he had been pursuing in compositions of the late forties such as *Gestation*. In these, only a vestige of earlier still lifes was visible, with bowls and pieces of fruit reduced to curvilinear outlines often tilted askew. But in the still life on a table arrangement in *Magenta and Blue*, the striated forms of a pineapple, a small pitcher, and several large pieces of yellow fruit are among the clearly discernible objects, and the reference to Matisse is once again unmistakable.

The same year Hofmann painted *Magenta and Blue*, Elaine de Kooning documented his painting technique in her illuminating article for *Art News* entitled "Hans Hofmann Paints a Picture." In preparation, she had watched Hofmann painting *Fruit Bowl Transubstantiation No. 1* (1950), an arrangement of three apples and an ashtray against a background of silver wrapping paper. Rudolph Burckhardt took a series of photographs for the article, several of which show *Fruit Bowl* (p. 190). One can imagine that the point of departure for *Magenta and Blue* was similar — a relatively modest arrangement of objects including some fruit and a small pitcher on a table. Whereas the coloration of *Fruit Bowl* is both fairly monochromatic and subdued, the colorful background of *Magenta and Blue* makes one believe that Hofmann probably used large sheets of colored paper for his backdrop rather than aluminum foil.

Landscape also remained a permanent part of Hofmann's vocabulary. A painting such as the heavily impastoed, jewel-like *A Lovely Day* of 1955 (Fig. 56) is a remembered compilation of many such days. This process is in keeping with the explanation Glenn Wessels gave of the evolution of his teacher's pictorial process. According to Wessels, in earlier years Hofmann portrayed a particular sunset directly from nature but later distilled the essence of "many sunsets" in his studio.[69]

By 1956, the full-bodied rectangle had emerged as a major compositional element in Hofmann's work. *Circles* (Fig. 82) clearly reveals the evolution of this form as well as how Hofmann experimented with it. Rather than commit himself to the incorporation of rectangles into this otherwise curvilinear composition, he probably moved the hand-painted pieces of colored paper across the surface until he found the right location and then stapled them on, leaving open the possibility of their removal. Two paintings, *Color Study I* and *Color Study II*, painted just one year before, offer further proof of the "newness" of this form. Although related to *Circles* in format, gesture, and color scheme, they are entirely devoid of even a hint of rectangular elements.

Hofmann continued to test the placement of color rectangles before painting them. Photographs of works in progress in his studio in the late 1950s and 1960s show numerous rectangles of various colors and sizes tacked to his paintings. If one examines the surface of his late rectangle paintings closely, many still show the imprints left by thumbtacks. This practice was once again a continuation of a technique he had devised long ago, as in his 1914 ceiling commission (Fig. 15). For his advanced still-life class in Munich he had developed one of his most inventive methods of teaching color: he instructed the students to test the color tensions in their compositions by pinning and adjusting pieces

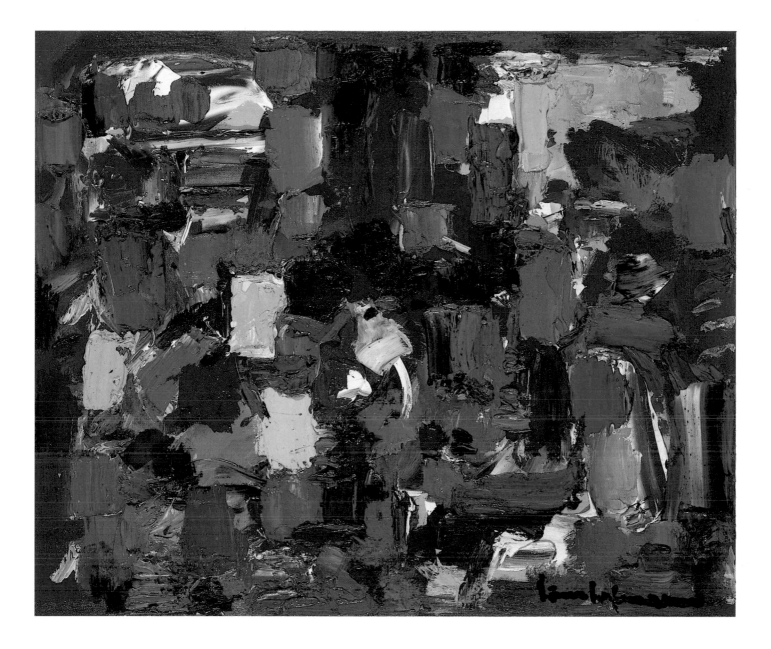

56. *A Lovely Day*, 1955. Oil on canvas, 20 × 24 (50.8 × 61). Private collection

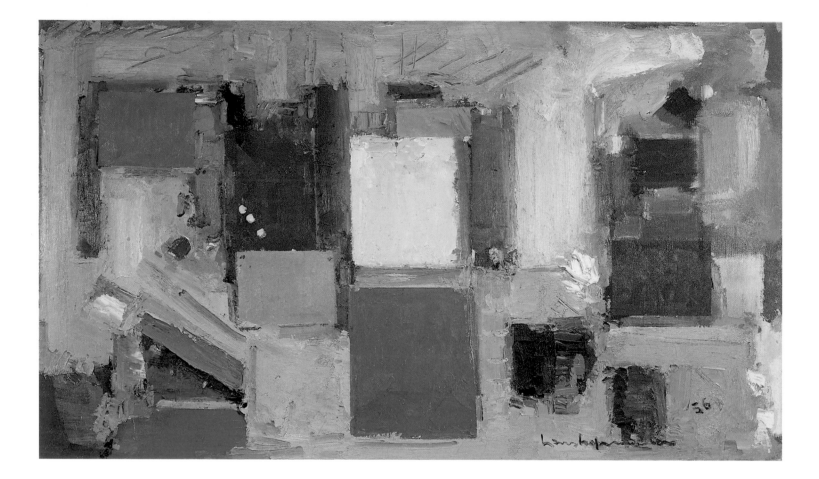

57. *Blue on Gray*, 1956. Oil on canvas, 50 × 84 (127 × 213.4). Collection of Mr. and Mrs. Clifford M. Sobel

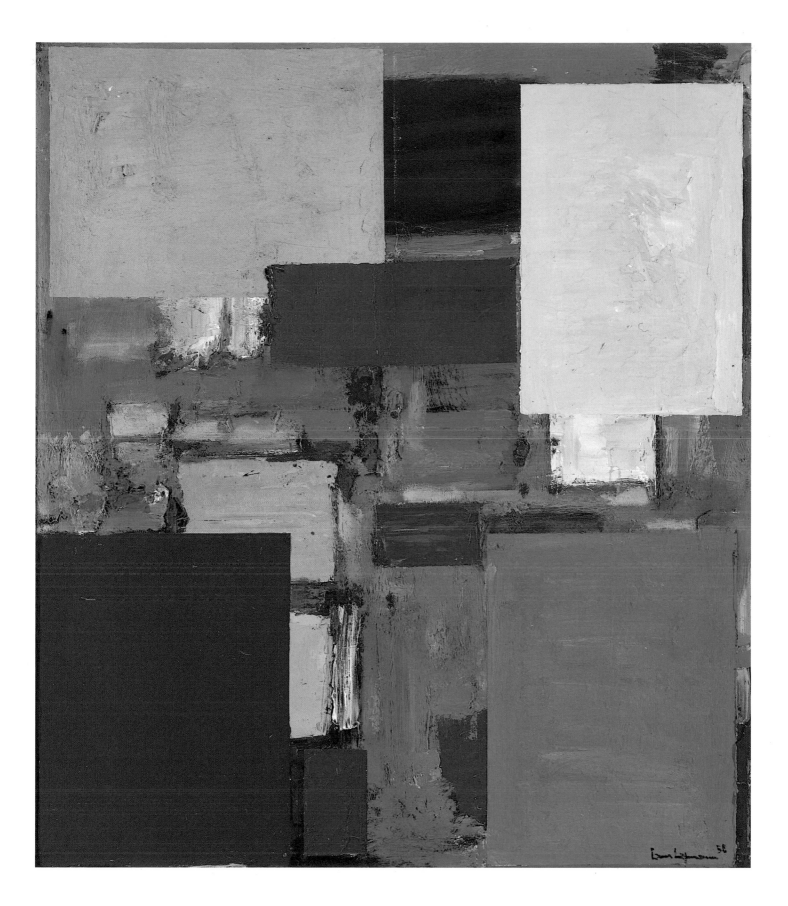

58. *Equipoise*, 1958. Oil on canvas, 60 × 52 (121.9 × 132.1). Collection of Marcia S. Weisman

of colored paper on the painting surface. In Carl Holty's humorous recollection, "The idea was that once the colors were adjusted, the bits of paper would be painted into the vacant spot. Actually there were so many bits of paper pinned into the canvas that the reverse side resembled the flattened out hide of a porcupine."[70]

The primarily red, yellow, and blue rectangles in *Blue on Gray* of 1956 (Fig. 57), a pronouncedly horizontal composition — a format with which Hofmann was experimenting at this time — appear to both emerge from and be superimposed on a dense bed of gray paint. The painting is punctuated as well by scored lines and variously sized dots of paint, such as the three yellow spots on the red rectangle in the upper right quadrant. As is true in all Hofmann's compositions with rectangular planes of color, the planes differ enormously in size, shape, regularity, application of paint, and hue. Issues such as these occupied him for most of the remaining twelve years of his life.

Equipoise (Fig. 58) and *Towering Clouds* (Fig. 59), both of 1958, exemplify the two major directions that coexisted in Hofmann's pictorial vocabulary: architectonic compositions such as *Equipoise* in which the rectangle is the primary element; and non-geometric pictures such as *Towering Clouds* in which painterly bravura and gesture dominate. Sometimes the naturalistic reference is obvious. At other times, as in the 1958 *Pond* (Fig. 71), the title is the only indication that the large expanse of green in the center of the painting might be a body of water. Yet those who knew Hofmann's activities on the Cape could even identify the pond to which he frequently drove in Wellfleet as the subject of this painting as well as numerous others, including *Image of Cape Cod: The Pond Country, Wellfleet* of 1961 (Fig. 102). A comparison of *The Pond* and *Image of Cape Cod,* similar in subject matter but different in depictive style, reveals even more about Hofmann's artistic process than *Equipoise* and *Towering Clouds.* In certain areas both paintings of the pond are enlivened by the thick application of irregularly bounded areas of varicolored paint, and one familiar with Hofmann's pictorial vocabulary might reasonably argue that in these areas the form of the rectangle is implied. In *Image of Cape Cod*, however, the rectangle is unmistakable. Not only is there the pronounced single cobalt plane, but also the half dozen or so others which, although partially obscured by paint or abruptly truncated by the border of the composition, remain an important presence. As if in counterpoint to the large color blocks, several thin vertical slivers of paint have been inserted both within and at the borders of the large area of cool green that once again may represent the "pond."

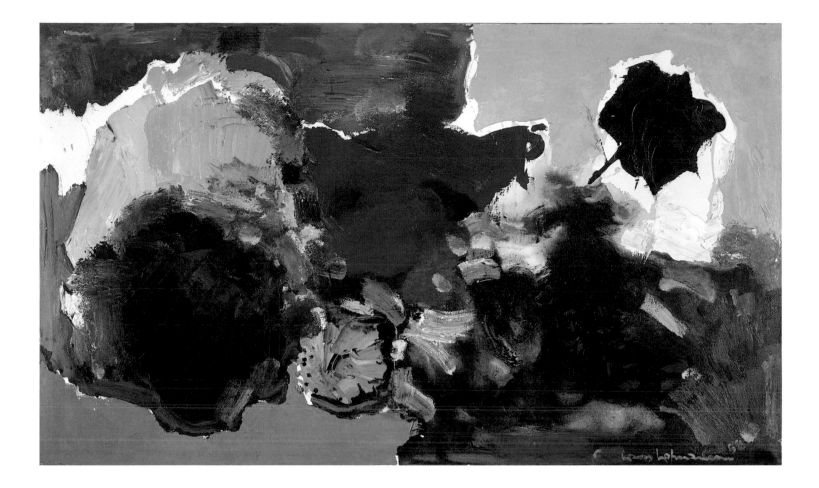

59. *Towering Clouds*, 1958. Oil on canvas, 50 × 84 (127 × 213.4). Private collection

In 1958, after forty-three consecutive years of teaching both winter and summer, Hofmann finally closed his schools and for the rest of his life devoted himself to his own painting. At this time, he was recognized as the foremost art teacher in America. Nearly thirty years before, his immigration to America had had an almost immediate impact on his painting style; now freedom from the responsibilities of running a school exerted a similarly liberating effect on his work. At seventy-eight, Hofmann turned to his art with a vigor and enthusiasm that belied his age, painting not only some of his greatest works but also some that rank with the greatest achievements in twentieth-century art.

 Pompeii of 1959 (Fig. 60) is among these paintings. Hofmann was often able to recreate a mood, an occurrence, or a recollection merely through color. The brilliant reds in this painting are surely a reference to the volcanic eruption of Mount Vesuvius that in 79 A.D. spread a lethal layer of volcanic ash upon the ancient city. The much less structured bed of aqua perhaps refers to the azure water of the Mediterranean, which at the time of the eruption lapped at the walls of Pompeii as it appears to "lap" at the structural "walls" of red in the painting. Although at first glance the magenta, ocher, yellow, and green rectangles seem to be superimposed on a fairly monochromatic bed of paint, this red is also divided into rectangular components barely differentiated at their edges by lines in which the underlayer of color, with which Hofmann frequently began a composition, is allowed to peek through. As often in Hofmann's work, a sad occasion becomes the point of departure for an exuberant and seemingly gleeful delectation of paint. Similarly, the highly saturated magentas and blues of *To Miz — Pax Vobiscum* of 1964 (Fig. 61) seem to celebrate his companion of over sixty years rather than express his painful bereavement over her death.

 Sometimes, as in *Rising Moon* of 1965 (Fig. 62), Hofmann inserted an explicit naturalistic reference, as if to reassert his pictorial heritage in what otherwise seems to be a non-objective composition; and he did it with an uncanny sense of rightness. He saw the functioning of his compositional universe as parallel to that of the natural world. The frequent appearance of both the sun and the moon in these late works thus seems appropriate. As the sun and the moon illuminate the world of nature, they metaphorically illuminate his paintings. Yet Hofmann was careful to distinguish between the two different kinds of illumination: "In nature, light creates color; in painting, color creates light."[71]

 For Hofmann, who claimed that "My ideal is to form and to paint as Schubert sings his songs and as Beethoven creates a world in sounds,"[72] the worlds of art and music were also interrelated. He frequently compared the two forms: "The plastic artist is concerned with music-like relationships of plastic units just as the musical artist is

60. *Pompeii*, 1959. Oil on canvas, 84¼ × 52 (214 × 132.1). The Tate Gallery, London

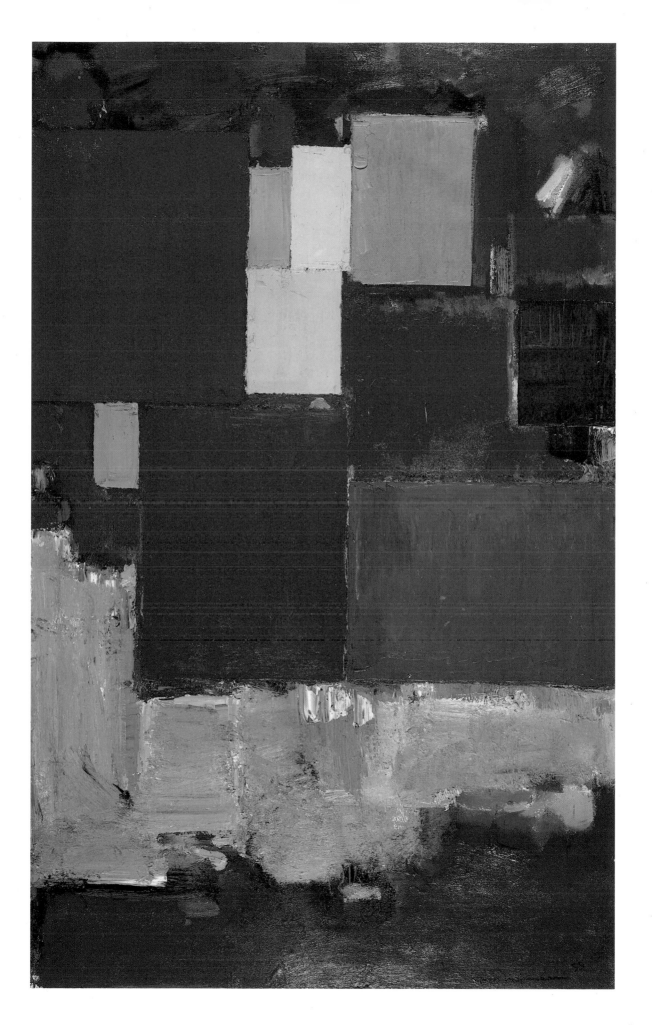

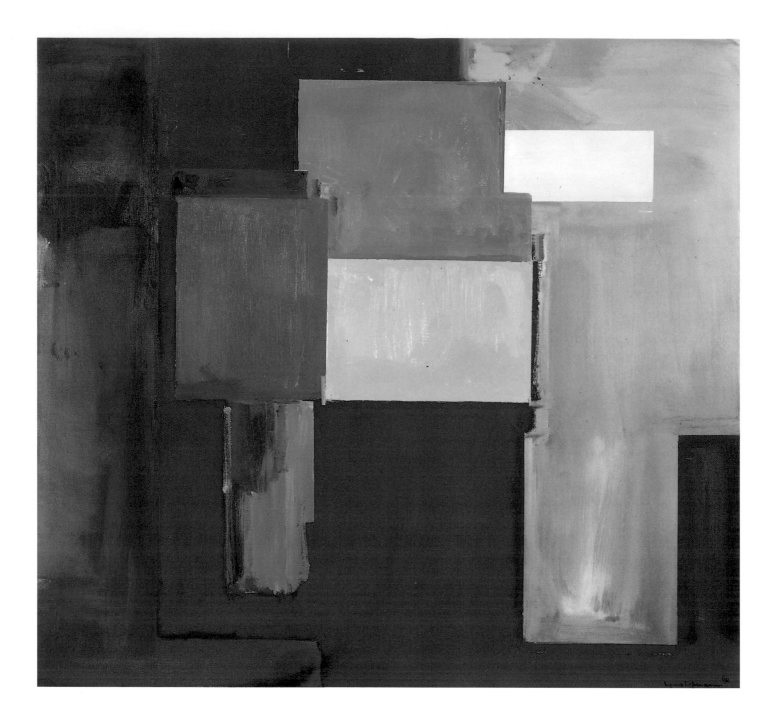

61. *To Miz – Pax Vobiscum*, 1964. Oil on canvas, 78 × 84 (198.1 × 213.4). Modern Art Museum of Fort Worth; Museum Purchase

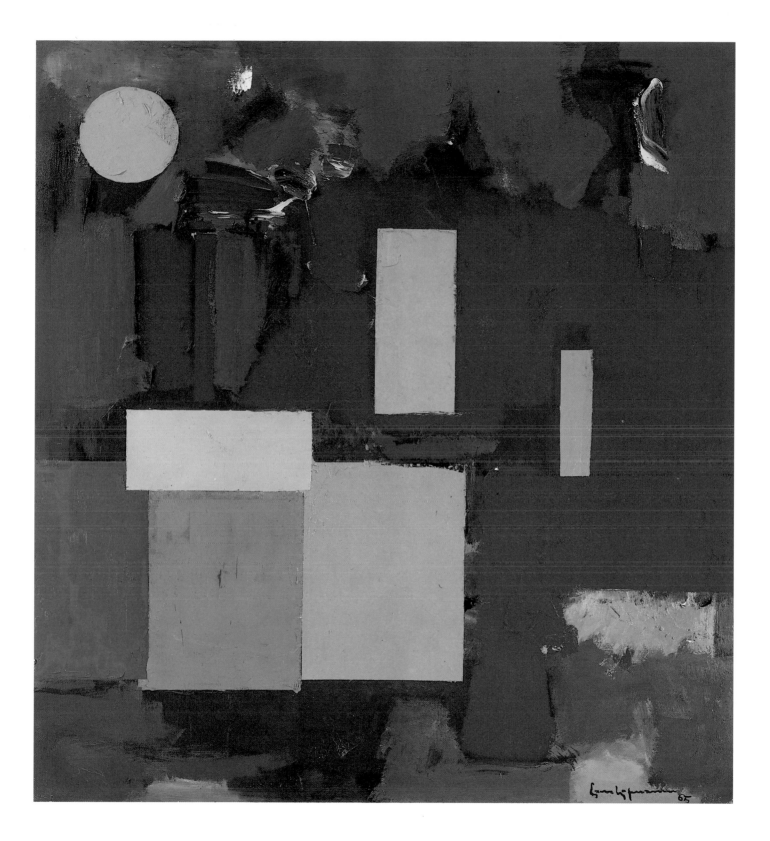

62. *Rising Moon*, 1965. Oil on canvas, 84 × 78 (213.4 × 198.1). Private collection

concerned with the harmonic relationships of musical units."[73] He went so far in his analogy as to liken a picture with "its sequence of planes" to an "instrument" that he could play, and the realization of a work of art to the swelling of an orchestra.[74] *Moonshine Sonata* (Fig. 63), probably named, as was his custom, after the painting was completed, is one of many titles that reflects his intertwining of music and art.

Hofmann continued painting in an extraordinarily wide range of styles until the end of his life. Some compositions are structured entirely of rectangles — at times compactly arranged, at others with only one or two color planes. Some are dense with enormously varied pigment. In others, such as *Joy Sparks of the Gods* (Fig. 70), the rectangles are thinly applied and some areas of color are lightly stained. Whereas paintings such as *Elyseum II* (Fig. 64), with its configuration of tightly interlocking planes, seem informed by an indisputable logic, in others there is not even the merest trace of the planar form, and the sheer glee of flinging paint seems the only possible explanation for a painting. Hofmann's work remains impossible to categorize. Yet within this elusiveness lies much of the greatness of his art and his profound contribution to the art of this century.

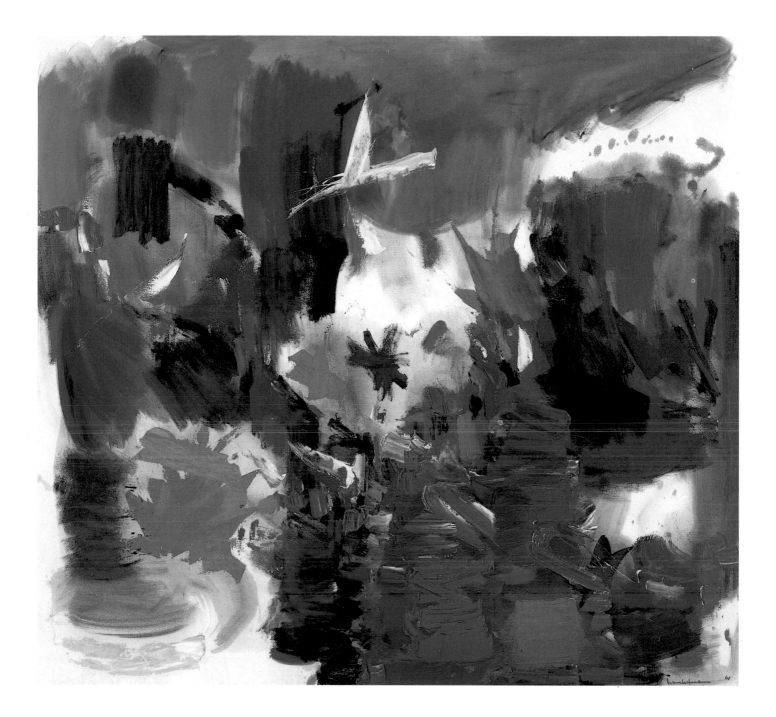

63. *Moonshine Sonata*, 1961. Oil on canvas, 78⅛ × 84⅛ (198.4 × 213.7). IBM Corporation, Armonk, New York

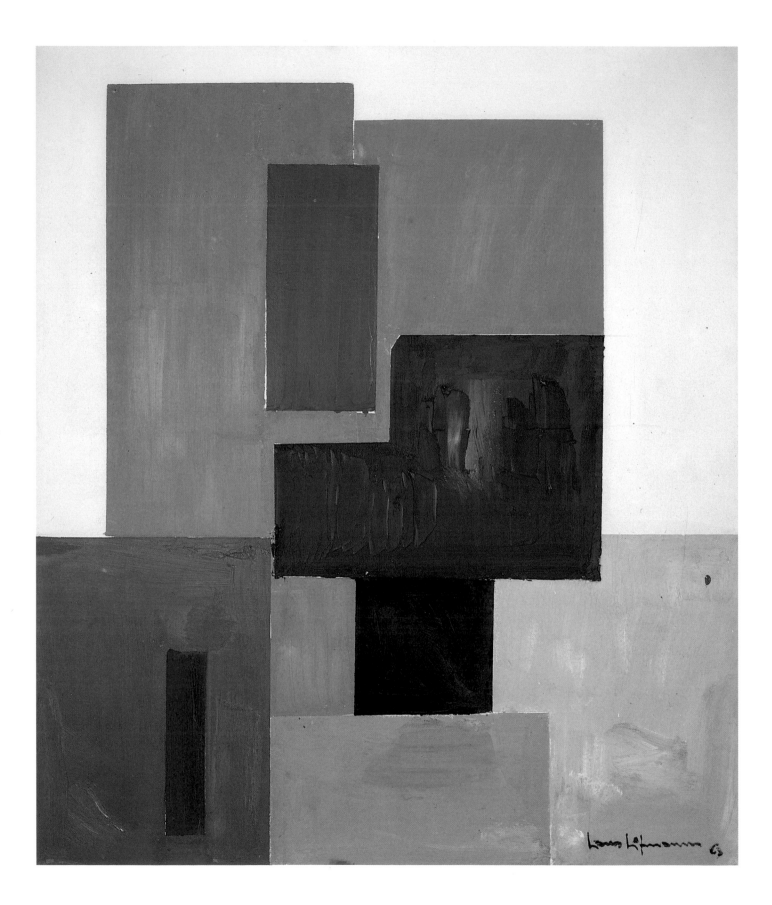

64. *Elyseum II*, 1963. Oil on canvas, 60 × 52 (152.4 × 132.1). Collection of Mr. and Mrs. C. Bagley Wright

74

Notes

1. Hans Hofmann, "The Search for the Real in the Visual Arts," in *The Search for the Real and Other Essays,* eds. Bartlett H. Hayes, Jr., and Sara T. Weeks (Cambridge, Massachusetts: The MIT Press, 1967), p. 54.

2. Fritz Bultman, "Hans Hofmann," lecture, Parsons School of Design, New York, December 11, 1980, typescript, estate of the artist.

3. Quoted in Ben Wolf, "The Digest Interviews Hans Hofmann," *The Art Digest,* 19 (April 1, 1945), p. 52.

4. Quoted in "Hans Hofmann as Teacher," in "Selected Writings on Art," typescript compiled by William Seitz, 1963, Library, The Museum of Modern Art, New York, p. 2.

5. Fernande Olivier, *Picasso and His Friends* (New York: Appleton Century, 1955), pp. 121–22.

6. Frederick S. Wight, *Hans Hofmann,* exhibition catalogue (New York: Whitney Museum of American Art; Los Angeles: Art Galleries of the University of California, 1957), p. 30.

7. Ibid., pp. 30–31.

8. Clement Greenberg, "The Later Thirties in New York," in *Art and Culture* (Boston: Beacon Press, 1961), p. 232.

9. Glenn Wessels, quoted in Suzanne B. Reiss, "Glenn Wessels: Education of an Artist," unpublished interview, 1967, Bancroft Library, University of California, Berkeley, appendix, p. 111.

10. Lillian Kiesler, interview with the author, October 18, 1976.

11. Miz Hofmann to Sonia Delaunay, March 3, 1952; letter seen by the author in Delaunay's apartment, June 1977, when Delaunay recalled that Miz Hofmann was her "best friend," although she could not remember any details about Hans Hofmann's friendship with her late husband.

12. William Seitz, *Hans Hofmann,* exhibition catalogue (New York: The Museum of Modern Art, 1963), p. 7. According to Fritz Bultman, "Hans Hofmann," lecture, Hofmann was part owner with Richard Goetz of a Seurat painting before World War I.

13. Wight, *Hans Hofmann,* p. 30. Wight relates (p. 29) that Hofmann had become "absorbed in Cubism" in Paris, and thus one assumes that Hofmann's Parisian works were primarily Cubist once the style was formulated.

14. Bultman, "Hans Hofmann," lecture, p. 2.

15. Elaine de Kooning, "Hans Hofmann Paints a Picture," *Art News,* 48 (February 1950), p. 40.

16. Hans Hofmann, "Creation in Form and Color: A Textbook for Instruction in Art," typescript, 1931, estate of the artist, p. 1.

17. Wessels in Reiss, "Glenn Wessels," appendix, p. 111.

18. Harry Brown, interview with the author, July 10, 1978.

19. Hofmann, 1938–39 lecture series, typescript, estate of the artist, lecture IX, p. 2.

20. Wessels in Reiss, "Glenn Wessels," p. 106.

21. Bultman, "Hans Hofmann," lecture, p. 3.

22. Hofmann, 1938–39 lecture series, I, p. 4.

23. Carl Holty, in "Hans Hofmann Students' Dossier," compiled by William Seitz, 1963, Library, The Museum of Modern Art, New York.

24. Hofmann to Alice Hodges, September 27, 1938, private collection.

25. Hofmann to Hodges, September 29, 1938, private collection.

26. Hofmann to Lillian Kiesler, June 30, 1941, private collection.

27. Ibid.

28. Peter Busa, "The Art of Hofmann's Teaching," typescript, n.d., estate of the artist, p. 1.

29. Ibid.

30. Robert C. Hobbs, "Early Abstract Expressionism: A Concern with the Unknown Within," in *Abstract Expressionism: The Formative Years,* exhibition catalogue (New York: Whitney Museum of American Art; Ithaca: Herbert F. Johnson Museum of Art, 1978), p. 15.

31. Hofmann, "Painting and Culture," in *The Search for the Real,* p. 55.

32. Hofmann, "Terms," ibid., p. 72.

33. Hofmann, "The Search for the Real in the Visual Arts," in *The Search for the Real,* p. 44.

34. Hofmann to Hodges and Kiesler, August 16, 1938, private collection.

35. Lillian Kiesler, interview with the author, January 16, 1990.

36. Hofmann, 1938–39 lecture series, II, p. 2.

37. Ibid., I, p. 2.

38. Ibid., p. 1.

39. Ibid., III, p. 1.

40. Ibid.

41. Ibid.

42. Hofmann to Hodges and Kiesler, August 28, 1940, private collection.

43. Hofmann, "Creation in Form and Color," preface.

44. Hofmann, 1938–39 lecture series, VII, p. 1.

45. Ibid.

46. John Haley, interview with Lawrence Dinnean, 1973, typescript, Bancroft Library, University of California, Berkeley, p. 2.

47. Hofmann to Hodges and Kiesler, August 1953, private collection.

48. Hofmann, 1938–39 lecture series, III, p. 2.

49. Wessels in Reiss, "Glenn Wessels," p. 135.

50. Bultman, "Hans Hofmann," lecture, p. 5.

51. Hofmann, 1938–39 lecture series, I, p. 4.

52. Wessels in Reiss, "Glenn Wessels," p. 134.

53. Hofmann to Hodges and Kiesler, July 3, 1940, private collection.

54. Hofmann to Hodges and Kiesler, June 18, 1943, private collection.

55. Hofmann to Hodges and Kiesler, July 30, 1943, private collection.

56. Hofmann to Hodges and Kiesler, October 1, 1938, private collection.

57. Hofmann to Hodges and Kiesler, July 14, 1941, private collection.

58. Hofmann to Hodges and Kiesler, September 5, 1941, private collection.

59. For Hofmann and Pollock, see Cynthia Goodman, *Hans Hofmann* (New York: Abbeville Press, 1986), pp. 49–52.

60. Ibid., pp. 44–45.

61. Bultman, "Hans Hofmann," lecture, p. 7.

62. Bultman, interview with the author, January 1977.

63. Robert Coates, "Assorted Moderns," *The New Yorker,* December 23, 1944, p. 51.

64. Robert Coates, "The Art Galleries Abroad and at Home," *The New Yorker,* March 30, 1946, p. 83.

65. Hofmann, in Wolf, "The Digest Interviews Hans Hofmann," p. 52.

66. Quoted in "'Artists' Sessions at Studio 35," in *Modern Artists in America,* eds. Robert Motherwell and Ad Reinhardt (New York: George Wittenborn, 1951), p. 121.

67. Tony Rockwell, "Conservation Problems Present in Paintings by Hans Hofmann," typescript, n.d., Bancroft Library, University of California, Berkeley, p. 7.

68. Hofmann, "Creation in Form and Color," p. 13.

69. Wessels in Reiss, "Glenn Wessels," p. 107.

70. Carl Holty in "Hans Hofmann Students' Dossier."

71. Hofmann, "Excerpts from the Teaching of Hans Hofmann," in *The Search for the Real,* p. 59.

72. Hofmann, *Hans Hofmann,* reprinted, p. 163, below.

73. Hofmann, "Painting and Culture," in *The Search for the Real,* p. 58.

74. Hofmann, 1938–39 lecture series, IV, p. 5.

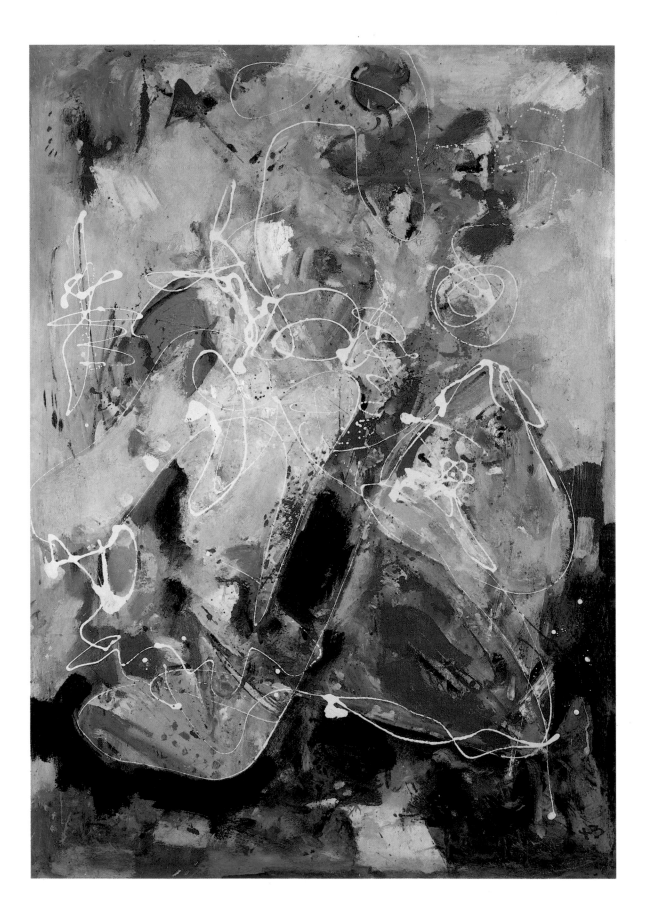

Hans Hofmann: The Dialectical Master

Irving Sandler

After a lifelong struggle Cézanne made the following aesthetical statement: "All lies in the contrast." — Hans Hofmann, 1950.[1]

The universe, Hans Hofmann believed, "worked" according to the "laws" of dialectics — the synthesis of dualities. The goal of painting was to represent this "cosmology," as he called it. Each canvas was to be an arena in which opposites vied: nature and abstraction; the material and the transmaterial or spiritual; the preconceived and the impulsive; and the romantically free and the classically ordered or disciplined. Hofmann also pitted intuition or the "creative" (a favorite word of his) against formal problem-solving; tradition against modernist innovation; and the Apollonian against the Dionysian.

To Hofmann, the central dialectical process in art was the synthesis of the three-dimensionality of natural phenomena and the two-dimensionality of painting, a synthesis achieved in the improvisational process or experience of painting. The artist had to take into account at one and the same time three interacting factors: nature and its laws; the painting as a medium with its inherent abstract qualities; and the artist's own psychological, spiritual, intuitive, and imaginative "feeling into" both nature and painting. Hofmann generally began a painting with some reference to visual reality, but the subject was not to be dumbly copied: "There are bigger things to be seen in nature than the object."[2] The next step was to translate the volumes and voids of things seen into planes of color in accordance with the two-dimensional nature of the

65. *Fantasia*, c. 1944. Oil, Duco paint, and casein on panel, 51½ × 36⅝ (130.8 × 93). University Art Museum, University of California, Berkeley; Gift of the artist

picture surface. And then, the crucial action was to structure these planes into "complexes," every element of which had to be related to every other — part-to-part-to-whole — creating an organic entity. At the same time, this entity had to be made "plastic," that is, reinvested with a sense of the third dimension, of depth or volume, without sacrificing physical flatness. This "law" of painting constituted the basis of both Hofmann's art and his teaching.

Hofmann was temperamentally inclined to speculate about natural and artistic laws. As a teenager, he had been drawn to science and had demonstrated a remarkable aptitude for it. In the late 1890s, he invented and had his mother patent — he was underage — an electromagnetic comptometer and a signaling device for alerting ships to unseen dangers. He also experimented with a new kind of electric bulb and a portable freezing unit. But when his father gave him money to continue his scientific enterprises, he used it to go to art school. It is not surprising that Hofmann should have done so. He thought of art and science as related; he wrote in a textbook on art some three decades later that "creative science is art and creative art is science."[3] It is also not surprising then that as an art student he should have studied the science of perception.

Hofmann's cosmology was shaped by the German philosophy he had read as a youth, along with most educated Germans of his generation. The key text for him was Adolph von Hildebrand's *Problem of Form in the Visual Arts,* first published in 1893. Hofmann was so impressed by von Hildebrand's book that he assigned it to generations of his students.[4] The problem that von Hildebrand posed was: how is the sense of the third dimension derived from images that are assumed to be two-dimensional? This art-theoretical issue was important in German metaphysics, as Michael Podro has written, because there was "a firm tradition which saw in painting and sculpture, or at least in the perceptual power of the artist, the highest development of human perception. Here perception reached its greatest clarity and greatest completeness. [This] completeness and clarity became very closely identified with clarity in the perception of the third dimension."[5]

Hofmann learned from von Hildebrand that volume could be constructed through overlapping planes parallel to the picture plane — which also turned out to be a device employed by Cézanne and the Cubists — and he later taught this to his students. Hofmann also demonstrated that mass and space could be created through the interaction of color. Although he had first learned this from Cézanne and the Fauve Matisse, he developed the theory and practice of making color volumetric to such an extent that they constituted his own original artistic and pedagogical contribution. Through the overlapping of planes

and the interaction of color, Hofmann avoided modeling and perspectival systems, the academic means of forming solids and voids, because they dissolved the picture surface. He would not relinquish the sense of depth — the vestige of humanist space — but he insisted on articulating the flat surface — a modernist approach. Indeed, Hofmann managed to be at once traditionalist and radical; as a former student, Allan Kaprow, remarked, he had "a sense of a living past and involvement with the moment," with "the New."[6]

The suggestion of the third dimension was not just a formal issue for Hofmann. It was the primary visual manifestation of his cosmology. Formulating a cosmology and the means whereby it would find its fullest pictorial expression was so critical to Hofmann that it took precedence over painting from 1915 to roughly 1936, that is, from his thirty-fifth to his fifty-sixth year. During those two decades, motivated by the need to explain not only to himself but to others, Hofmann was primarily a teacher. It appears in retrospect that he had to be clear about what he would create as an artist before doing it. As Frederick Wight observed: "There are painters who feel the need of accounting for what they have done. Hofmann, on the contrary, appears as a man who first needed the accounting, who had first to convince himself. Subsequently... he had to paint his concepts."[7]

Pictorial depth was of such vital concern to Hofmann that it took on a quasi-religious dimension. It was created through the interaction of material planes of color, tangible pigment on canvas, but depth itself was not a physical pictorial property. Instead, it was transmaterial, and thus suggestive of the spiritual. With Hegel's dialectic in mind, Hofmann wrote that the "relation of two given realities always produces a higher, a purely spiritual third. The spiritual third manifests itself as a pure effect. ... The quality of the work originates in this transposition of reality into the purely spiritual."[8]

To synthesize two- and three-dimensionality, Hofmann formulated a dialectical process of painting, what he called the technique of "push and pull," an improvisational orchestration of areas of vivid colors conceived of as opposing forces, each force answered by a counter-force. He observed that any change in one area of color produced a change in every other color, causing some to recede, others to project. The problem was to adjust high-keyed color-shapes, pushing and pulling them, as it were, so as to achieve an equilibrium and all-over intensity.

If Hofmann's cosmology was an intellectual formulation, his method of expressing it pictorially was largely impulsive and emotional, dictated by "inner necessity," as Kandinsky said painting ought to be. But even in unpremeditated improvisation, rigorous visual thinking had to be brought to bear. Dionysian vitality and ecstasy had to be combined

with Apollonian clarity and harmony.[9] There was the need to realize a simultaneous two- and three-dimensionality which, after all, was fundamental. Kaprow summed it up: "This, we found out, was not easy at all ... so this part-to-whole problem occupied the class continually and further broke down into a study of special particulars of all painting; color, that is, hue, tone, chroma, intensity, its advancing and receding properties, its expansiveness or contractiveness, its weight, temperature, and so forth; and in the area of so-called form, the way in which these act together in points, lines, planes, and volumes."[10] And the same time, Hofmann insisted that art was essentially intuitive; it had to surpass "the limit of construction and calculation."[11] As Greenberg remarked, for Hofmann "science and discipline which have not become instinct are cramping rather than enabling factors."[12]

Hofmann was not alone in wanting to paint improvisationally and freely and yet create coherent pictures. His younger colleagues, soon to be labeled Abstract Expressionists, also faced this challenge in the early and middle 1940s. At first they turned to Surrealist psychic automatism (not the academic variant of a Dali but the radical technique that shaped the imagery of Miró, Masson, Matta, and Arshile Gorky) and then to painterly or gestural or action painting, which was more to their liking because it involved conscious choice.[13] Improvisational painting allowed Hofmann to give rein both to his psychic urgencies and fertile imagination, and inventiveness was one of his strongest traits.

Push and pull also created a sense of movement in the picture, in and out thrusts and counterthrusts contributing to the suggestion of depth. (Von Hildebrand had noted that motion helps construct the third dimension.) This sense of movement was a metaphor for life itself — more lifelike than the imitation of nature. As Hofmann remarked, it created "space [which] is dynamic, [which] vibrates and resounds [with] the rhythm of life. ... Movement is the expression of life."[14]

In addition, push and pull also enabled Hofmann to reveal his metaphysical vision of nature. He conceived of weighty paint forces and counterforces in interaction as metaphors for the inner workings of nature. His former student Richard Stankiewicz conveyed the sense of this when he described Hofmann's "concept of composition as a created universe, in which all forms and forces find their complementary and opposite movement to establish in that universe an equilibrium, an active and dynamic complex of forces which balance each other out to zero."[15]

One dialectical problem that occupied Hofmann almost from the very start of his career was to synthesize explosive Fauvist color and paint handling and compacted Cubist drawing and composition. Hofmann

had lived in Paris from 1904 to 1914, the heroic decade of twentieth-century art. He knew Picasso and Braque and worked beside Matisse at the Académie de la Grande Chaumière. He also was friendly with many avant-garde artists, notably Delaunay, whose formulation of a coloristic Cubism influenced him. Thus, he witnessed at firsthand — indeed, participated in — the origins of Fauvism and Cubism and their early and crucial development. This was the catalytic experience of his life. The impact of two revolutions of such historic dimensions as Fauvism and Cubism continued to shape his painting for the rest of his life. In embracing these movements as early as he did, Hofmann was avant-garde, but his attempt at a grand synthesis was oddly conservative or "old-fashioned," as Greenberg termed it.[16] This was particularly true after about 1936, when Hofmann began to paint seriously, since by that time Fauvism and Cubism were established in avant-garde circles as the two mainstreams of modern art. And yet, Hofmann's abstraction and wild color as well as his impetuous painting — although he always strove for a well-painted surface — seemed anything but conservative.

Hofmann's paintings are distinguished by — and esteemed most of all for — their ebullient color and vigorous brush handling. His obvious delight in the orchestration of brilliant hues and the direct manipulation of paint matter calls to mind Fauvism and, to a lesser degree, Expressionism, suggesting that it is within this romanticist stream of modern art that Hofmann belongs. Yet, as I have written elsewhere, classicizing Cubist design of cleanly edged planes was as important as color and facture, and he never abandoned it.[17] Greenberg has questioned whether Hofmann needed the Cubist component, whether he indeed suffered from a "Cubist trauma," that is, an excessive attachment to drawing that caused him to impose it on painterly and chromatic conceptions that were already complete in themselves.[18] Hofmann himself had discovered two radically new ways of bypassing Cubism. One was to compose abstractions from splashed and dribbled pools of pigment whose running edges looked random and uncontrolled — this as early as 1944, as in *Fantasia* (Fig. 65), completed three years before Jackson Pollock began his poured pictures. Hofmann's other approach, beginning in 1946, was to pack his abstractions with freewheeling swaths and open areas of heavy paint, sometimes squeezed directly from the tube (*Bacchanale*, Fig. 66). Neither kind of impulsive painting bore much relation to Cubist designing and design. Although Hofmann continued to develop both approaches until the end of his life, he never relinquished the Cubist component. Evidently the dialectician in him needed Cubism as a foil for Fauvism. Or more likely, his ambition was to advance the Cubist tradition — beyond the limits of what he had inherited — by introducing extravagant color and

facture, the likes of which had been unknown in Cubist painting. He may also have sensed that retaining a base in Cubism would lead him to major and original paintings.

Hofmann's conception of color was related to Cubist design. Both were derived from Cézanne, whom Hofmann venerated. Unlike the Cubists, who looked to Cézanne primarily for their principles of form, Hofmann was inspired by his color as well. He learned that a painting of a landscape, figure, or still life could be structured through the contrast of color, color conceived as volume, as "plastic." Hofmann carried "forming with color" a step further, into abstraction. As the Cubists designed their pictures by relating forms, so Hofmann designed his by relating colors. But it must be stressed that the interaction of color, the building of structure with color, was primary. Hofmann spurned the filling in of linear diagrams with color, which would produce what Kaprow once called a "bright Cubism," where color was subordinate to drawing.[19]

Hofmann's opulent palette distinguished his work from that of Willem de Kooning, Franz Kline, Philip Guston, and other artists who have also been labeled variously gesture painters, action painters, or painterly painters. Indeed, Hofmann was *the* colorist of this group of Abstract Expressionists. But he was also different from those Abstract Expressionists who were primarily colorists, such as Clyfford Still, Mark Rothko, and notably Barnett Newman, because their approach to color bypassed Cézanne and Cubism entirely. Inspired by the post-Fauve Matisse and Milton Avery, Newman simplified drawing, gesture, and surface incident, enlarged the size of his canvases, and painted each with a thin, almost even coat of a single color, energized and given scale by a few vertical bands of other colors. Newman went beyond Matisse and Avery into non-objectivity. His aim was to create an overwhelming visual and emotional impact with the field color. Because there were no horizontals crisscrossing the verticals to create relational structures, Newman's design is not reminiscent of Cubism but of late Impressionism. Each of his abstractions is perceived as an open field, graspable immediately and in its entirety. The thinly applied pigment adds to the openness; disembodied, it appeals to the eye rather than to the touch. It is optical instead of tactile or plastic.

In contrast to this color-*field* abstraction, Hofmann's relational, volumetric painting might be termed color-*form* abstraction. His concern with the tactility of color allowed him to use rich pigmentation. Greenberg remarked on the "weight and density of his paint — attributes it has even when it is not thickly impastoed." "Hofmann has come to require his color to be saturated corporeally as well as optically." Moreover: "It was he — not Pollock or Dubuffet — who launched the 'heavy' surface in abstract art, [a] fat, heavy, and eloquent surface."[20]

82

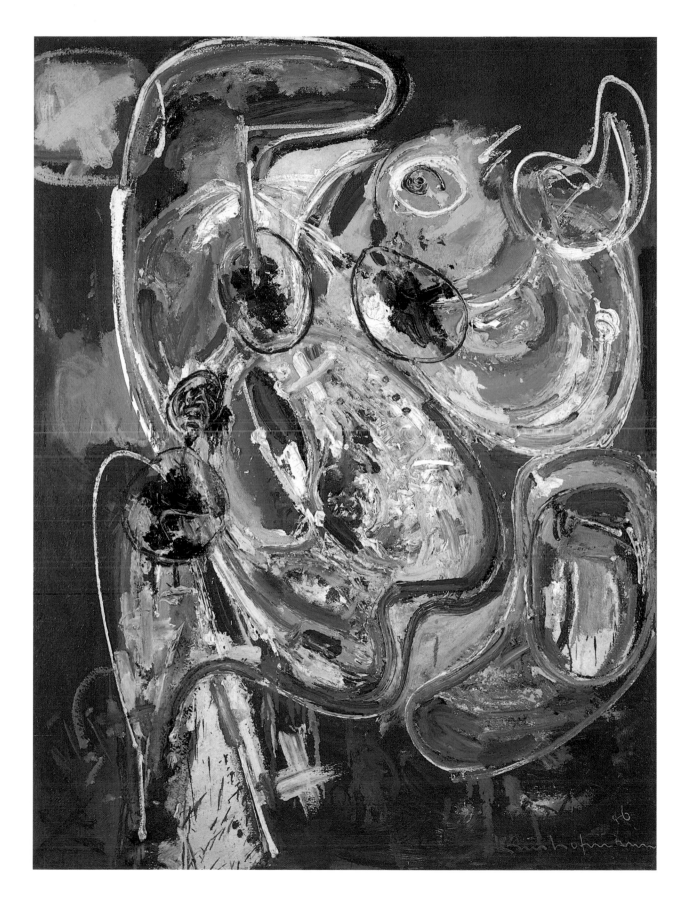

66. *Bacchanale*, 1946. Oil on composition board, 64 × 48 (162.6 × 121.9). Collection of Robert and Alice Galoob

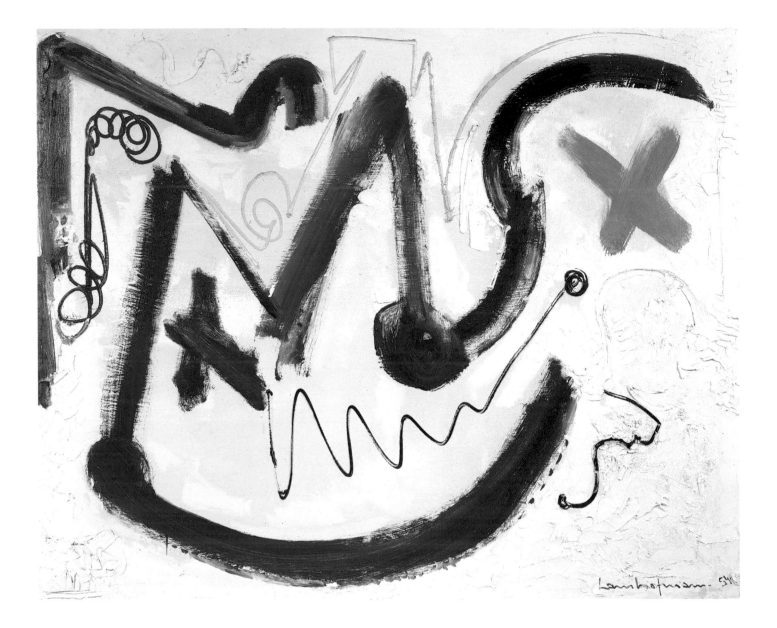

67. *Red and Blue Rhythm*, 1954. Oil on canvas, 48 × 58 (121.9 × 147.3). Private collection

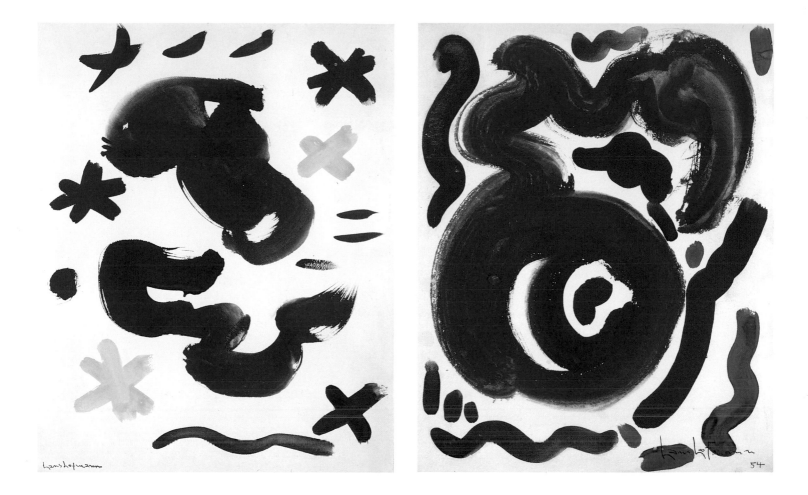

68. *Untitled*, 1954. Gouache on paper, 13¾ × 10¾
(34.9 × 27.3). Collection of Haik Zarian

69. *Untitled*, 1954. Gouache on paper, 12 × 14½
(30.5 × 36.8). Estate of the artist; courtesy André
Emmerich Gallery, New York

The attempt to fuse Cubist drawing and Fauve color and
facture can be viewed as only one of Hofmann's many approaches,
because his painting was extremely diverse. "I hate to repeat myself," he
once said.[21] Hofmann also vehemently denied that he had a "style,"
which he equated with mannerism,[22] although his pictures are clearly
recognizable as Hofmann's. However, the synthesis of Cubism and
Fauvism was more than just one of his approaches. It informed all the
others, becoming a kind of stabilizer that kept the changeable Hofmann
from veering off into eccentricity. And most of his digressions seem
motivated by the desire to explore one or another component or to give
free rein to one or another impulse. With regard to vibrant color, for
example, he brushed it spontaneously (*Red and Blue Rhythm*, Fig. 67) or
stained it (*Joy Sparks of the Gods*, Fig. 70) or applied it directly from the
tube, in freely drawn lines or mounds (*The Pond*, Fig. 71), or confined
color in rectangular compartments (*Combinable Wall, I and II*, Fig. 72).

But though Hofmann worked in a variety of directions at any one time, he always returned to the synthesis of Cubism and Fauvism. This was central in his work, notably during the years 1936—44, 1947—52, and 1955 to 1966, the year of his death. In most of his work from 1936 to roughly 1944, Hofmann's subjects are recognizable landscapes or still lifes, but as in *Yellow Table on Green* (Fig. 34) they are at once brilliantly colored and schematized in a Synthetic Cubist manner. Paintings from 1947 to 1952 on the whole are increasingly abstract, their development inadvertently following his teaching that art begins with nature and progresses toward abstraction. From 1955 on, and particularly after 1958, Hofmann translated the freer, varied areas of his earlier works into rectangles — they often cover the entire surface — reminiscent of Mondrian's compositions and calling to mind the Dutch Neoplasticist's quest for spirituality.[23] It was as if he had recapitulated Mondrian's movement from Synthetic Cubism into Neoplasticism. But as Hofmann's structure became geometric, his surfaces remained physical, scored and overpainted, and his color became even more high-keyed, so much so that it is barely contained within the rectangles (*The Golden Wall,* Fig. 73). Unlike Mondrian's work, in which color helps balance the design, Hofmann's paint-loaded brush and exuberant hues threaten to explode the stable right-angled grid. It is in these pictures — a number of them among his greatest — that Hofmann achieved a lifelong ambition: an original and grand synthesis in a non-objective manner of Cubist-inspired geometry and Fauve color and texture and, metaphorically, of the intellectual and the emotional, and of the spiritual and the sensual.

Hofmann was the greatest art teacher of the twentieth century, that is, if a teacher's stature is measured by the number of students who achieve national and international renown in their own right. He had the strongest influence on two generations of advanced American artists, the geometric abstractionists of the 1930s and the younger painters of the New York School who matured in the 1950s. Oddly enough, his influence was, unintentionally, dialectical; each generation was drawn to an opposite pole of his teaching. The artists of the thirties, avant-gardist in disposition, were inspired by Hofmann's emphasis on abstraction as well as on rational drawing. The artists of the fifties, inclined to be conservative, responded to his love of nature and his demand that it be the stimulus for painting as well as to his predilection for sensuous color.

The earlier generation's need was to join the mainstream of modern art by mastering Cubism and the other modern isms. Hofmann could teach them how to make a modern picture — the basics — and articulate a convincing rationale for doing so. Stressing the self-

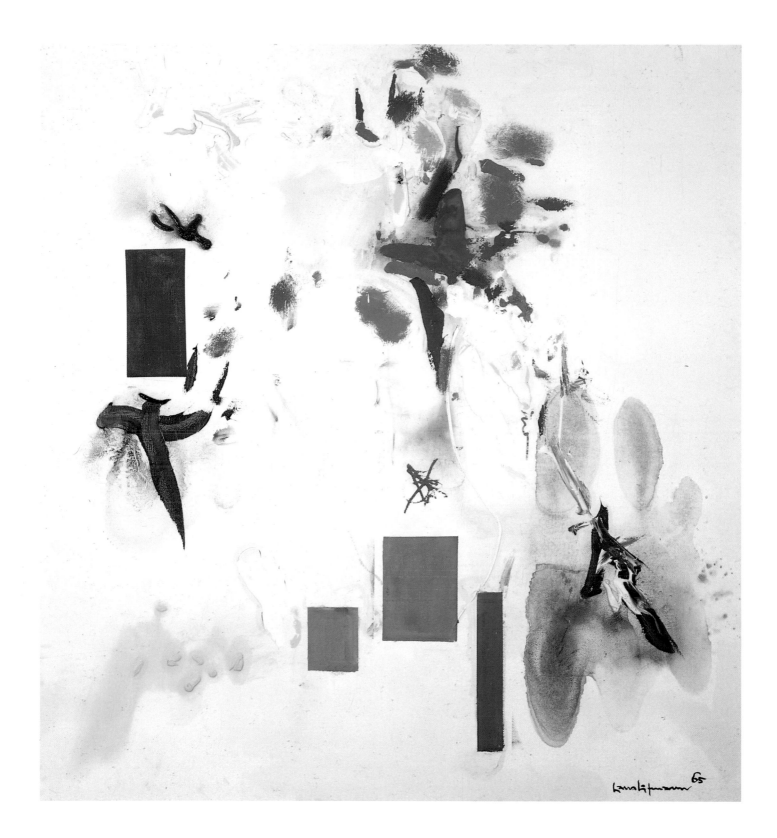

70. *Joy Sparks of the Gods*, 1965. Oil on canvas, 84 × 78 (213.4 × 198.1). Estate of the artist; courtesy André Emmerich Gallery, New York

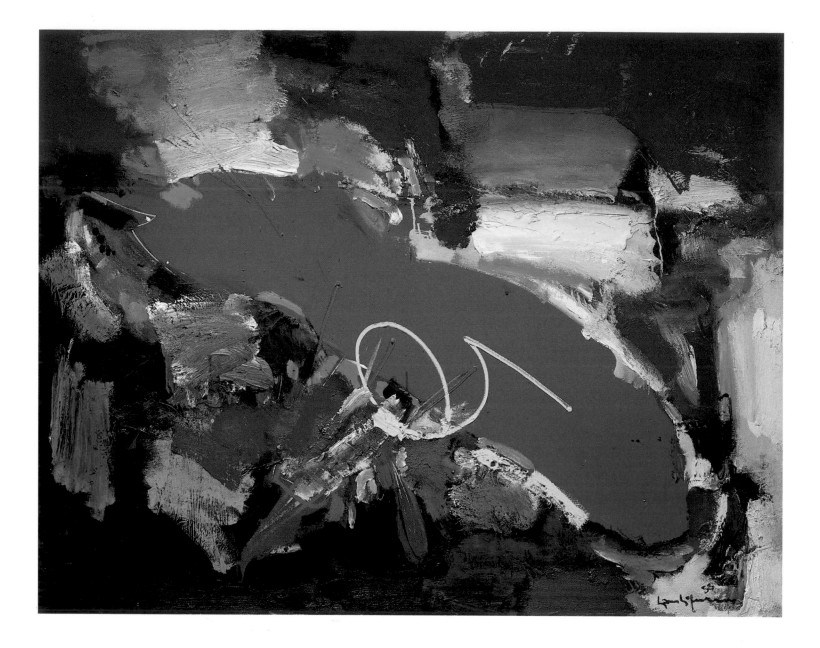

71. *The Pond*, 1958. Oil on canvas, 40 × 50 (101.6 × 127). Collection of Richard Brown Baker

sufficiency (indeed, the sanctity) of art while claiming that it could illuminate the working of the universe, his theorizing — conveyed with powerful conviction — was most attractive to the ideology-prone artists of the Great Depression who wanted to justify abstract art in the face of the prevailing Marxist and nationalistic rhetoric that condemned it as either ivory-tower escapism or un-American. Almost half of the charter members of the American Abstract Artists, comprising virtually the entire avant-garde in the 1930s, had studied with Hofmann. Although he himself was unsympathetic to geometric abstraction, his former students embraced it in part because of his emphasis on Cubist drawing, which was its forerunner.[24] Moreover, geometry was favored by avant-garde artists in Paris, which, as Hofmann drummed into them, was the center of world art.[25]

The innovators of Abstract Expressionism who began to exhibit their work in the early forties at roughly the same time as Hofmann had not studied with him. Although he was their colleague, he did not participate actively in their social life; his age — he was two decades older — his poor English and his faulty hearing made socializing at their hangouts — the noisy Cedar Street Tavern or The Club — difficult. Moreover, his systematic and theoretical discourse was at odds with their existential art talk. But Hofmann was always counted in, because of his stature and because his improvisational or gestural pictures were related to de Kooning's and Pollock's. In the middle 1940s, he was a member of Peggy Guggenheim's Art of This Century Gallery, along with William Baziotes, Jackson Pollock, Mark Rothko, Clyfford Still, and Robert Motherwell, and later of the Kootz Gallery, with Baziotes, Adolph Gottlieb, and Motherwell. He was included in important group shows, such as "The Ideographic Picture," organized by Barnett Newman at the Betty Parsons Gallery in 1947, the "Instrasubjectives," arranged by Harold Rosenberg and Samuel Kootz at the Kootz Gallery in 1949, and the "Ninth Street Show" in 1951, organized by the Abstract Expressionists themselves with the help of Leo Castelli. Moreover, Hofmann was one of the notorious Irascible Eighteen who protested against a show organized in 1950 by the Metropolitan Museum, which the group believed would discriminate against modernist art, although he was unable to pose for their now-famous group photograph in *Life* magazine.

It is not clear whether Hofmann influenced the gesture painters of his generation or was himself influenced; most likely there was a kind of mutual feedback. They all relied on the process of painting for inspiration and revealed the signs of that process in their completed pictures. Greenberg suggested that it was Hofmann who showed the way, by insisting on totally activating the picture surface, addressing it "as a

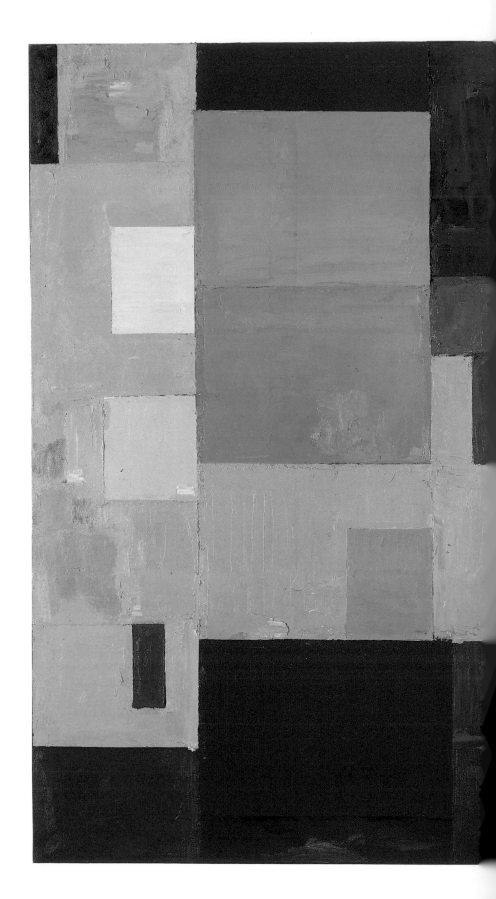

72. *Combinable Wall, I and II*, 1961. Oil on canvas, 84½ × 112½ (214.6 × 285.6) overall. University

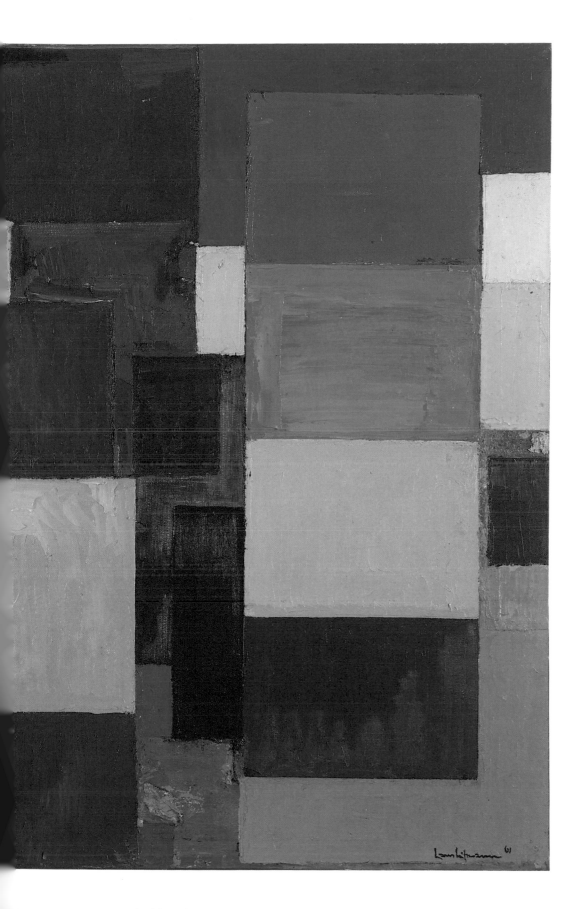

f California, Berkeley; Gift of the artist

responsive rather than inert object, and painting itself as an affair of prodding and pushing, scoring and marking, rather than of simply inscribing or covering. ... And it is thanks in part to Hofmann that the 'new' American painting in general is distinguished by a new liveness of surface."[26]

Younger New York School artists who emerged in the 1950s, most of them alumni of the Hofmann School, were intent on consolidating the innovations of their elders. They were attracted to Hofmann's claim that "there is such a thing as the Good Painting." As Thomas B. Hess remarked, "a novice's efforts should aspire to it. ... In the best meaning of the term, the Hofmann School is an Academy — a temple in which mysteries and standards are preserved."[27] Hofmann's *joie de vivre* also appealed to aspiring young artists. It was conveyed in his teaching by a growing emphasis on the interaction of sumptuous color and by his requirement that his students draw from nature. Indeed, there was a widespread turn toward painterly "realism," inspired by both de Kooning's and Pollock's "return to the figure" around 1951 and Hofmann's instruction. Hess noted in 1954 that "with descending age comes an increasing interest in figurative elements."[28] Hofmann's students were also influenced by his admiration of French painting, and they were instrumental in the rehabilitation of such hedonistic and sensuous modern masters as Bonnard, Vuillard, and Renoir (a favorite of Hofmann's).

If Hofmann's influence on his generation of Abstract Expressionists is problematic, his ideas had a strong effect on its major critics, Clement Greenberg and Harold Rosenberg, who acted to a degree as spokesmen. Greenberg's and Rosenberg's approaches were in fact antithetical, the one formalist, the other existentialist. Greenberg wrote in 1945: "Hans Hofmann is in all probability the most important art teacher of our time. [His] insights into modern art ... have gone deeper than those of any other contemporary. He has, at least in my opinion, grasped the issues at stake better than did Roger Fry and better than Mondrian, Kandinsky, Lhote, Ozenfant, and all the others who tried to 'explicate' the recent revolution in painting." Greenberg went on to say that he "owes more to the initial illumination received from Hofmann's lectures than to any other source."[29] Indeed, Greenberg's central thesis was anticipated by Hofmann's insistence that "the difference between the arts arises because of the difference in the mediums of expression, and in the emphasis induced by the nature of each medium [which] has its own order of being."[30] Greenberg also remarked: "I find the same quality in Hofmann's painting that I find in his words — both are completely relevant. His painting is all painting ... asserting that painting exists first of all in its medium and must there resolve itself before going on to do anything else."[31]

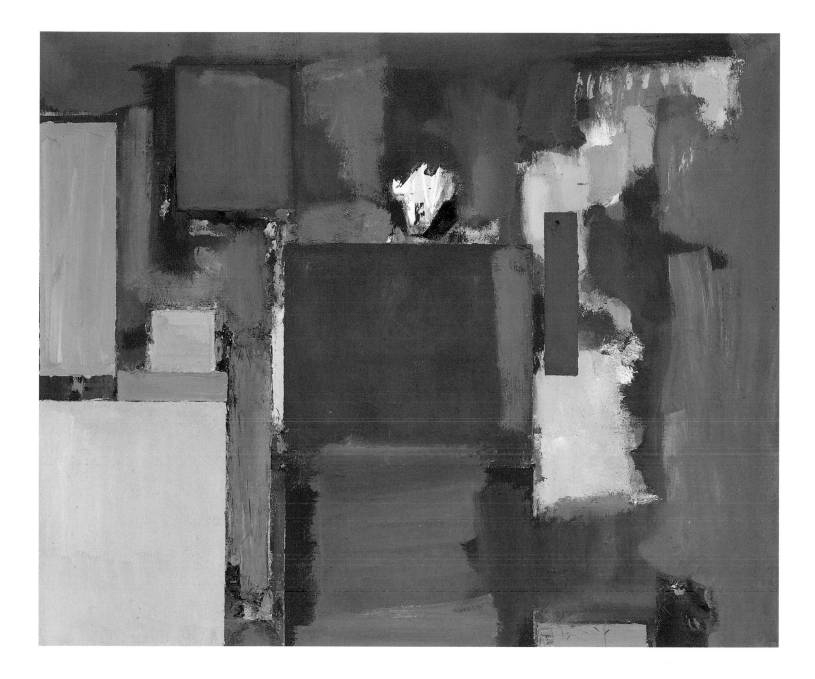

73. *The Golden Wall*, 1961. Oil on canvas, 60 × 72 (152.4 × 182.9). The Art Institute of Chicago; Mr. and Mrs. Frank G. Logan Prize Fund, 1962

Rosenberg held Hofmann's painting in just as high esteem as Greenberg but focused on its process and the existential signification of that process. Rosenberg's central thesis, formulated in a widely discussed article of 1952, "The American Action Painters," had its roots in Hofmann's conception of painting as push and pull. Concerning the inception of Abstract Expressionism, Rosenberg wrote: "The big moment came when it was decided to paint.... just TO PAINT." The unpremeditated "gesturing with materials" represented "a 'moment' in the adulterated mixture of [the artist's] life.... The act-painting is of the same metaphysical substance as the artist's existence." Rosenberg believed that Action Painting enabled the artist to "encounter" an image of his or her authentic being, and that was its purpose.[32]

Until recently, Hofmann's stature as a painter was often called into question. Responsible in part was the diversity of his pictures, as Greenberg observed, a diversity that raised doubts about the singleness of Hofmann's vision, purpose, and conviction.[33] His detractors claimed that his works were primarily facile exercises in problem solving, over-intellectualized despite their look of spontaneity;[34] they were the pictures of an art teacher whose function it was to conceptualize rather than those of a "genuine" artist. Hofmann's role as a teacher was often used to demean his role as an artist.

But there were other reasons for the dismissal of Hofmann. He strongly professed his belief in the continuing hegemony of contemporary French painting at just the moment when his Abstract Expressionist colleagues were asserting their artistic independence. Still and Newman were the most vociferous in the cause of the American vanguard, but de Kooning, who considered himself the heir of French modernism as much as Hofmann did, agreed with them about its decline. Hofmann, on the other hand, proclaimed: "The master[s] of Paris give undiminished proof of Strength/Tenacity and/Courage in a/continued struggle for inward development/Paris is not the soul of France alone/it is the hearth of the world/it is the spiritual center."[35]

What hurt Hofmann's reputation more than such statements was that much of his work looked "French," which, as the Americans interpreted it, meant beautifully crafted but sterile. As Walter Darby Bannard commented: "Many of Hofmann's pictures look like certain kinds of bad art, the soft, painterly bad art of the later School of Paris, puffy, crusty colorful pictures, lazily dependent on Cubism."[36] Bannard stressed that it was Hofmann's poorer work that looked "decorative," and moreover that Hofmann was an uneven painter, but until the 1960s that distinction was rarely taken into account.

Vanguardists denigrated Hofmann's paintings because of their references to nature, pictorial depth, Cubist design, and painterly finesse, and indeed, they did not look as radical as the abstractions of Pollock, Still, Rothko, and Newman. But then, neither did de Kooning's, which had the same traditional components as Hofmann's, and de Kooning was the most widely admired and influential Abstract Expressionist in the fifties. De Kooning's painting had a restless, raw, and violent edge, however, and an oppressive look that seemed to exemplify a "crisis mentality" that gripped many New York artists in the 1950s. His lack of "finish" looked radically different from School of Paris "cuisine"—the distinction was deemed crucial—and was believed to be peculiarly American rather than French.[37] In contrast, Hofmann's painting often struck his fellow artists as "overfinished," as Hess claimed.[38] Moreover, it evoked a *joie de vivre* associated with School of Paris painting. "Throughout his long career as a painter, teacher, and theorist," William Seitz wrote, "one would be hard pressed to find a stroke or word that is melancholy, bitter, ironic, or disenchanted."[39]

Abstract Expressionist painting generally became increasingly lyrical and rooted in nature as the fifties progressed, so much so that the label Abstract Impressionism was coined to distinguish it from Abstract Expressionism. Hofmann's former students played an important part in this change, and one would have supposed that they would have acknowledged his inspiration. But too many who esteemed him as a teacher questioned his abilities as a painter. Erle Loran, who was devoted to Hofmann, remarked on "a surprising range of quality in his work. . . . Those who are antagonistic have only to point to the less realized works to make a disparaging evaluation."[40] Indeed, the alumni of his school preferred de Kooning, Kline, and Guston to their own teacher, and they reflected an opinion generally held by artists. Alfred H. Barr, Jr., the director of collections at The Museum of Modern Art and the most influential tastemaker of his time, agreed. So did Barr's associate, Dorothy C. Miller, who omitted Hofmann from her important "The New American Painting" exhibition, which toured Europe in 1958–59 and was shown at MoMA upon its return.

Art critics, notably Greenberg, Rosenberg, and Hess, were more favorable to Hofmann, but their opinion did not offset that of most artists as well as Barr and Miller. Thus Greenberg could claim with justification in 1958 that "the magnitude of Hofmann's achievement" had not been sufficiently reckoned with.[41] But that changed in the early sixties. In 1963, The Museum of Modern Art atoned for its earlier neglect by giving Hofmann a full-scale retrospective, organized by William Seitz. Hofmann's reputation was also advanced by a new generation of artists who had not studied with him but knew only his work. They esteemed

his painting primarily because of its quality. Thus Bannard, who curated the 1976 Hofmann retrospective at the Hirshhorn Museum and The Museum of Fine Arts, Houston, wrote in his catalogue introduction that "Hofmann was one of the great geniuses of painting in our time."[42] Bannard's opinion has became the prevailing one.

Given the condition of the world during the cold war, it was not surprising that "most art," as *Newsweek's* art critic wrote in 1963, "appears to be a cardiographic report from the Age of Anxiety."[43] But Hofmann would have none of that — in his life or in his art. He was utterly convinced that the universe "works." As its metaphor, painting could be made to "work," and thus reveal physical and spiritual reality. And he exulted in that knowledge, and his painting conveys that unabashed exultation. On the whole, it is distinguished by an extravagant physicality, expressed by his energetic brush and bold palette. Yet much as his colors are opulent, they are also strong, dissonant, and juxtaposed in jarring combinations — to avoid decoration and challenge taste — but they are rarely tragic. Indeed, Hofmann is *the* hedonist of Abstract Expressionism, robust and generous.

Notes

1. Hans Hofmann, unpublished talk given at the Provincetown Art Association, August 28, 1950; quoted in Cynthia Goodman, *Hans Hofmann* (New York: Abbeville Press, 1986), p. 110.

2. Hans Hofmann, quoted in Frederick S. Wight, *Hans Hofmann,* exhibition catalogue (New York: Whitney Museum of American Art; Los Angeles: Art Galleries of the University of California, 1957), p. 23.

3. Hans Hofmann, "Creation in Form and Color: A Textbook for Instruction in Art," typescript, 1931, p. 1; quoted in Goodman, *Hans Hofmann,* p. 15.

4. Harry Holtzman, who was a monitor in Hans Hofmann's school in the middle 1930s, told me that Hofmann had recommended von Hildebrand's book and had discussed it with him.

5. Michael Podro, *The Manifold in Perception* (Oxford: Oxford University Press, 1972), p. 81.

6. Allan Kaprow, "Hans Hofmann" (obituary), *The Village Voice,* February 24, 1966, p. 2.

7. Wight, *Hans Hofmann,* p. 14.

8. Hans Hofmann, "Plastic Creation," *League,* 5 (Winter 1932–33), p. 14, reprinted in Sam Hunter, *Hans Hofmann* (New York: Harry N. Abrams, 1963). The metaphysically disposed Hofmann was influenced not only by von Hildebrand and Hegel but by Wilhelm Worringer's defense of Expressionism in *Abstraction and Empathy* (1908), and Goethe's part-scientific, part-mystical writings on color; see Goodman, *Hans Hofmann,* p. 15.

9. Ivo Frenzel, "Prophet, Pioneer, Seducer: Friedrich Nietzsche's Influence on Art, Literature and Philosophy in Germany," in Christos M. Joachimides, Norman Rosenthal, and Wieland Schmied, eds., *German Art in the 20th Century,* exhibition catalogue (London: Royal Academy of Arts, 1985), p. 75. As Frenzel pointed out, Nietzsche was much discussed in German artistic circles around the turn of the century, and Hofmann probably read his works.

10. Kaprow, "Hans Hofmann," p. 2.

11. Hans Hofmann, address, 1941; see p. 166, below.

12. Clement Greenberg, "Hans Hofmann: Grand Old Rebel," *Art News,* 57 (January 1959), p. 29.

13. Hofmann disliked Surrealism, although he greatly admired Miró. He was, however, interested in automatism. It is noteworthy that two of his former students, Peter Busa and Gerome Kamrowski, along with Jackson Pollock, Robert Motherwell, and William Baziotes, were among the Americans who, in the early 1940s, joined Matta in experimenting with the technique. Pollock was Hofmann's next-door neighbor, and he and his wife, Lee Krasner, a former student of Hofmann, occasionally visited him.

14. Hans Hofmann, "Plastic Creation" (1932–33), in Hunter, *Hans Hofmann,* p. 38.

15. Richard Stankiewicz, in "Hans Hofmann Students' Dossier," compiled by William Seitz, 1963, Library, The Museum of Modern Art, New York.

16. Greenberg, *Hans Hofmann,* reprinted, p. 128, below.

17. See Irving Sandler, *Hans Hofmann: The Years 1947–1952,* exhibition catalogue (New York: André Emmerich Gallery, 1976).

18. Greenberg, *Hans Hofmann,* reprinted, pp. 125–26, below.

19. Allan Kaprow, interviewed by Dorothy Seckler, New York, September 10, 1968, transcript in the Archives of American Art.

20. Greenberg, *Hans Hofmann,* reprinted, pp. 132, 134, below.

21. Hans Hofmann, statement, in *Hans Hofmann: New Paintings,* exhibition catalogue (New York: Kootz Gallery, 1957), n.p.

22. Hunter, *Hans Hofmann,* p. 24.

23. Hofmann's use of rectangles also derived from the pieces of colored construction paper he affixed to his students' canvases to demonstrate the mechanics of push and pull.

24. In the 1920s and 1930s, Hofmann denigrated non-objective art; see Carl Holty, "Studying with Hofmann," *Art in America,* 51 (May–June 1973), p. 56. In the 1940s, Hofmann allowed that Kandinsky, Miró, Arp, and Mondrian were the greatest innovators of modern art; see Ben Wolf, "The Digest Interviews Hans Hofmann," *The Art Digest,* 19 (April 1, 1945), p. 52, quoted in Goodman, *Hans Hofmann,* pp. 55–56.

25. In contrast to his avant-gardist students of the 1930s, Hofmann painted recognizable subjects in a Synthetic Cubism manner but with heightened colors reminiscent of Fauvism. He did not show this work, and few of his students saw it. Some two decades later, Hofmann would create his own unique variant of geometric abstraction.

26. Greenberg, *Hans Hofmann,* reprinted, p. 129, below.

27. Thomas B. Hess, "U.S. Painting: Some Recent Directions," *Art News Annual,* 25 (1956), pp. 92–93.

28. Thomas B. Hess, "New York Salon," *Art News,* 52 (February 1954), p. 57.

29. Clement Greenberg, "Art," *The Nation,* April 21, 1945, p. 469.

30. Hans Hofmann, "Painting and Culture," in Hans Hofmann, *The Search for the Real and other Essays,* eds. Bartlett H. Hayes, Jr., and Sara T. Weeks (Cambridge, Massachusetts: The MIT Press, 1967), p. 57.

31. Greenberg, "Art," p. 469.

32. Harold Rosenberg, "The American Action Painters," *Art News,* 51 (December 1952), pp. 22–23.

33. Greenberg, *Hans Hofmann,* reprinted, pp. 123–24, below.

34. See Thomas B. Hess, *Abstract Painting* (New York: The Viking Press, 1951), p. 131. Hess was an admirer of Hofmann and so was Sam Hunter, who also faulted him as a problem solver. In his lavish monograph of 1963, Hunter wrote that "too often his [Hofmann's] work has seemed a simplistic demonstration of the dynamics of space relation" (p. 16).

35. Hans Hofmann, "Reply to Questionnaire and Comments in a Recent Exhibition," *Arts and Architecture,* 66 (November 1949), p. 23.

36. Walter Darby Bannard, *Hans Hofmann: A Retrospective Exhibition,* exhibition catalogue (Washington, D.C.: Hirshhorn Museum and Sculpture Garden, Smithsonian Institution; Houston: The Museum of Fine Arts, 1976), p. 13.

37. Willem de Kooning, in "Artists' Sessions at Studio 35 (1950)," in Robert Motherwell and Ad Reinhardt, eds., *Modern Artists in America* (New York: Wittenborn Schultz, 1952), p. 13, said "that the French artists have some 'touch' in making an object … that makes [it] look like a 'finished' painting. They have a touch which I am glad not to have."

38. Hess, *Abstract Painting,* p. 131.

39. William Seitz, *Hans Hofmann,* exhibition catalogue (New York: The Museum of Modern Art, 1963), p. 7.

40. Erle Loran, "Hans Hofmann and His Work," in *Recent Gifts and Loans of Paintings by Hans Hofmann: Hans Hofmann and His Work,* exhibition catalogue (Berkeley: University of California, Worth Ryder Art Gallery, 1964), p. 15.

41. Clement Greenberg, "Hofmann's Early Abstract Paintings," in *Hans Hofmann,* exhibition catalogue (New York: Kootz Gallery, 1958), n.p.

42. Bannard, *Hans Hofmann,* p. 9.

43. [Jack Kroll], "Old Man Crazy About Painting," *Newsweek,* September 16, 1963, p. 88.

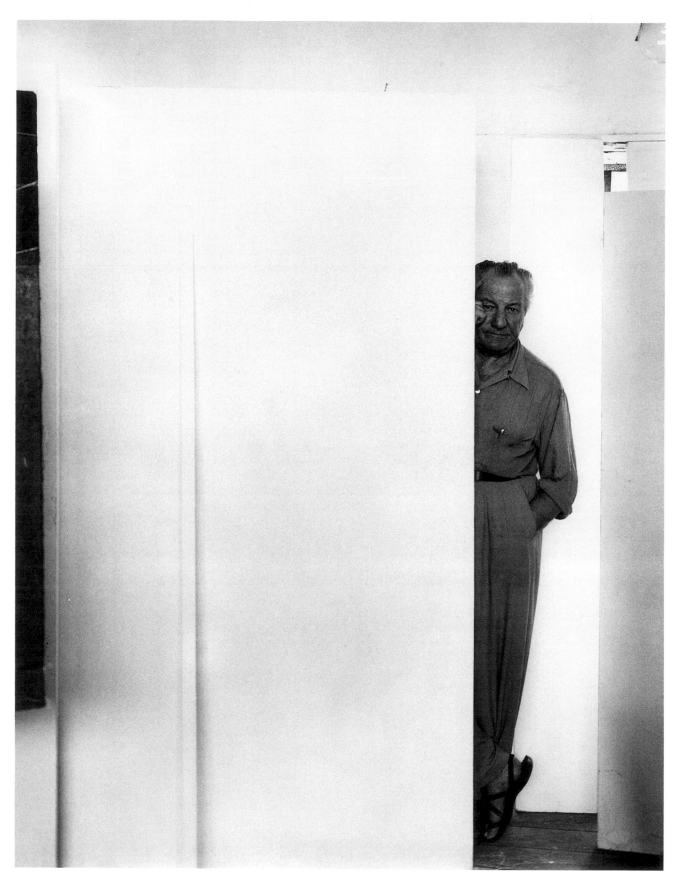

Hans Hofmann, 1960. Photograph by Arnold Newman.

Plates

74. *Idolatress I*, 1944. Oil on aqueous media on Upson board, 60⅛ × 40⅛ (152.7 × 101.9). University Art Museum, University of California, Berkeley; Gift of the artist

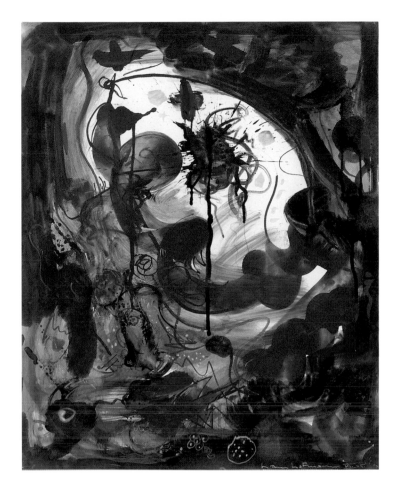

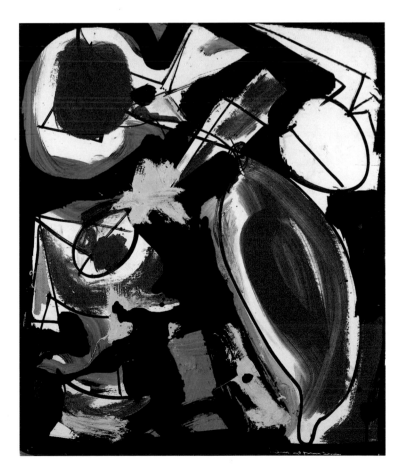

75. *Untitled*, 1945. Gouache and watercolor on paper, 28¾ × 23 (73 × 58.4). Collection of Beth and Steven Lever

76. *Red Shapes*, 1946. Oil on cardboard, 32½ × 28 (82.6 × 71.1). Collection of Sally Sirkin Lewis and Bernard Lewis

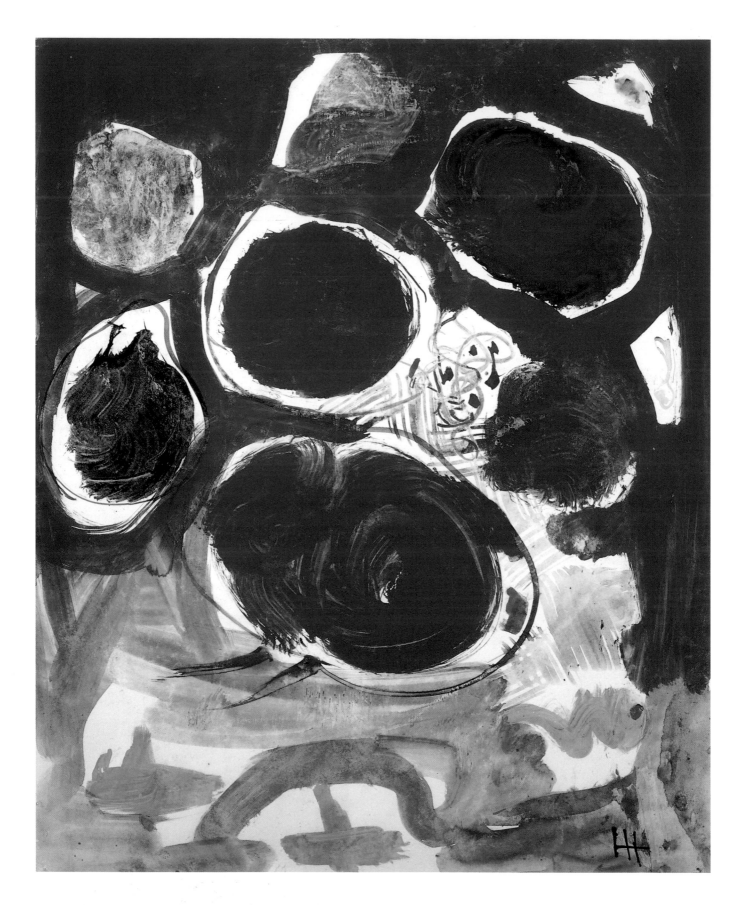

77. *Untitled*, c. 1946. Gouache on paper, 28¾ × 23⅛ (73 × 58.7). Private collection

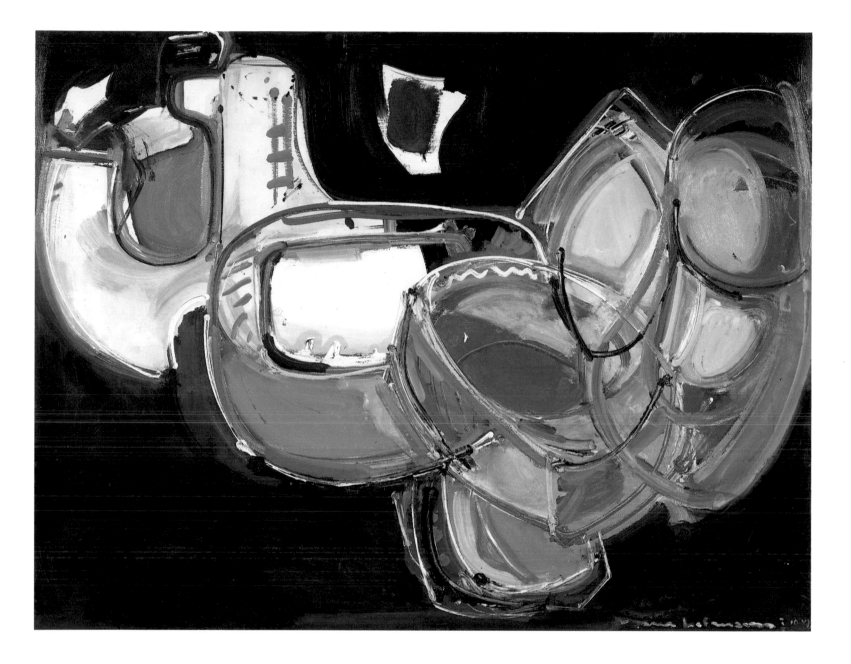

78. *Shifting Planes*, 1947. Oil on panel, 35 × 45 (88.9 × 114.3). Private collection

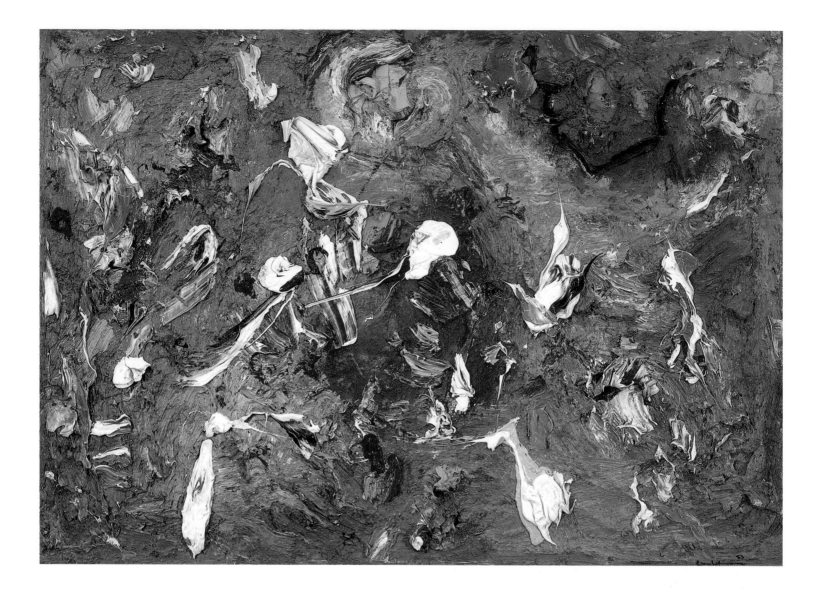

79. *Persian Phantasy*, 1953. Oil on plywood, 23 × 32 (58.4 × 81.3). Estate of the artist; courtesy André Emmerich Gallery, New York

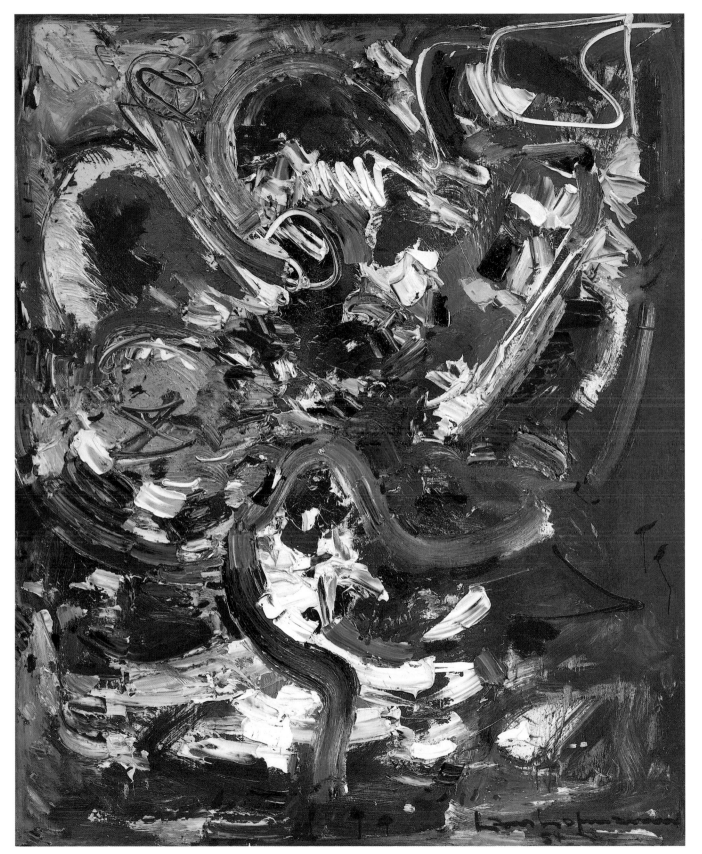

80. *Liebesbaum*, 1954. Oil on panel, 60 × 48 (152.4 × 121.9). Estate of the artist; courtesy André Emmerich Gallery, New York

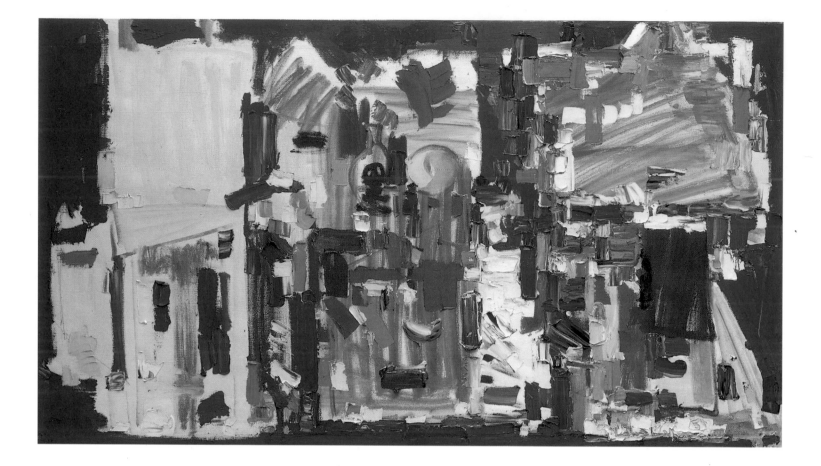

81. *Studio No. 2 in Blue*, 1954. Oil on canvas, 48 × 84 (121.9 × 213.4). Collection of Mr. and Mrs. Gerhard Andlinger

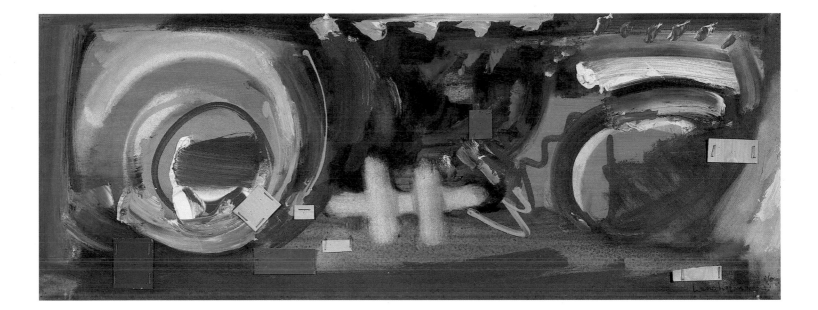

82. *Circles*, 1956. Oil on cardboard, 12 × 31 (30.5 × 78.7). Private collection; courtesy André Emmerich Gallery, New York

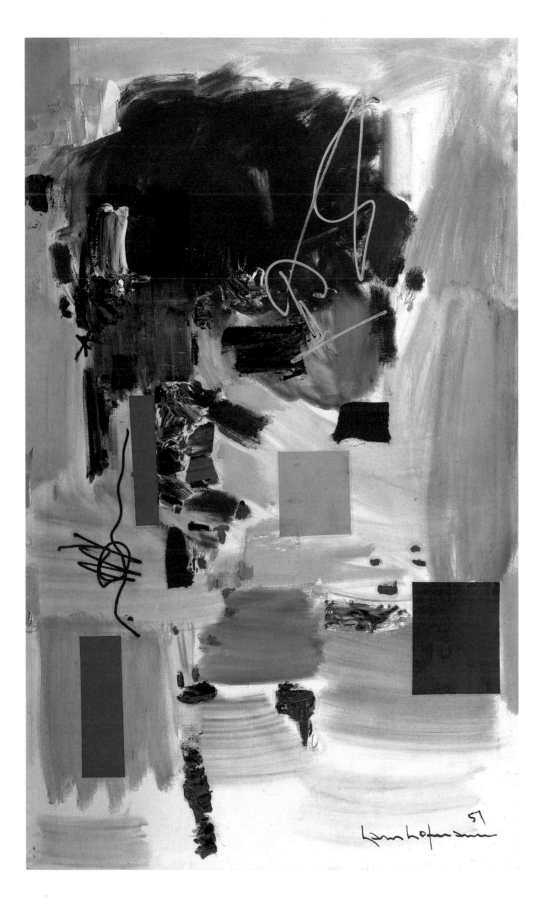

83. *Golden Splendor*, 1957. Oil on canvas, 84 × 50 (213.4 × 127). Private collection

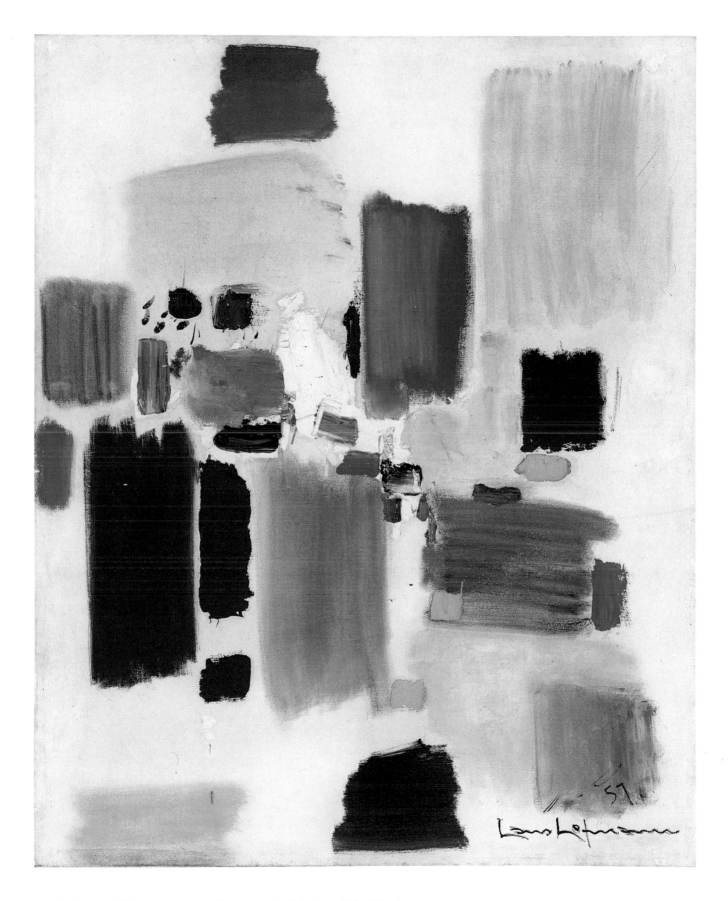

84. *Sparks*, 1957. Oil on canvas, 60 × 48 (121.9 × 152.4). Collection of Mrs. Theodore Law

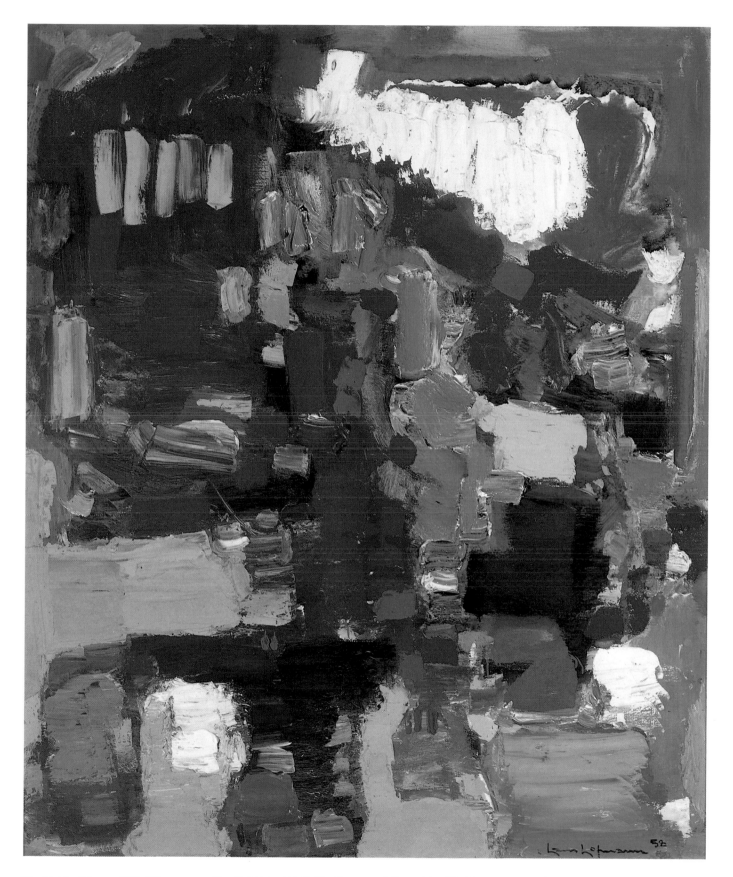

85. *Golden Blaze*, c. 1958. Oil on canvas, 72 × 60 (182.9 × 152.4). The Corcoran Gallery of Art, Washington D.C.; Gift of The Friends of the Corcoran and Mr. Maxwell Oxman, 1968

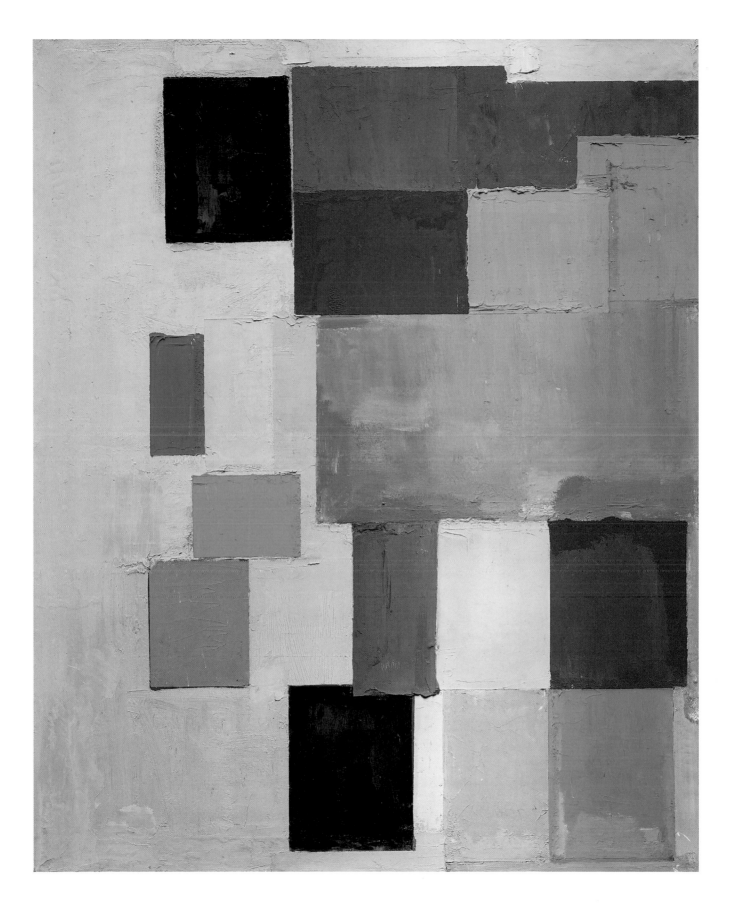

86. *Pastorale*, 1958. Oil on canvas, 60 × 48 (152.4 × 121.9). Private collection

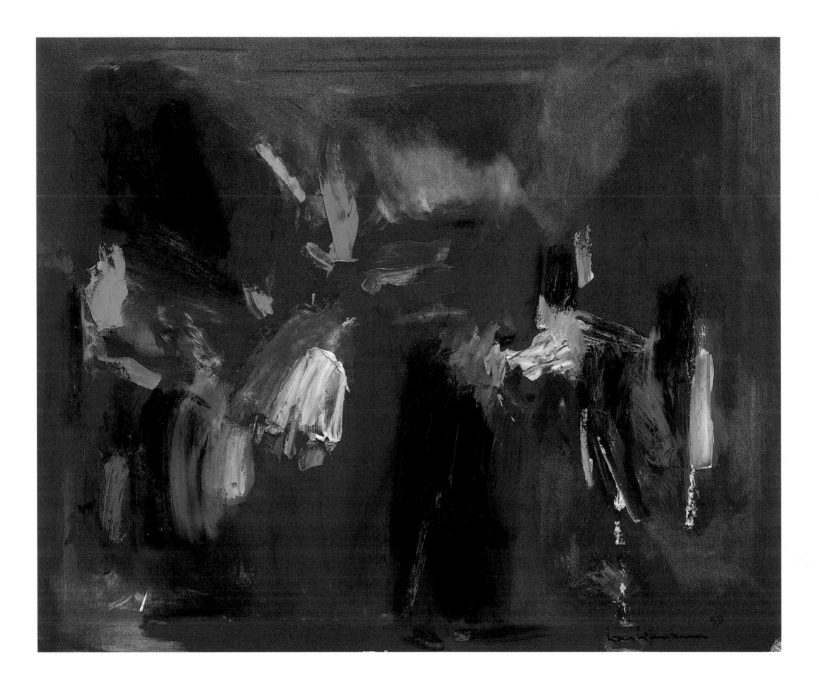

87. *Festive Pink*, 1959. Oil on canvas, 60 × 72 (152.4 × 182.9). Collection of Mr. and Mrs. Kenneth N. Dayton

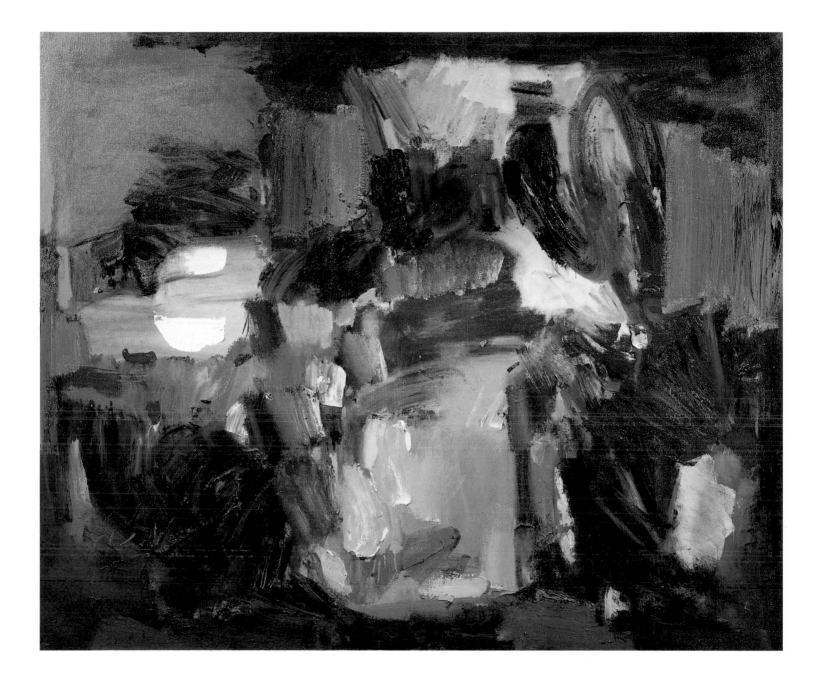

88. *Jardin d'Amour*, 1959. Oil on canvas, 60 × 72 (152.4 × 182.9). Private collection

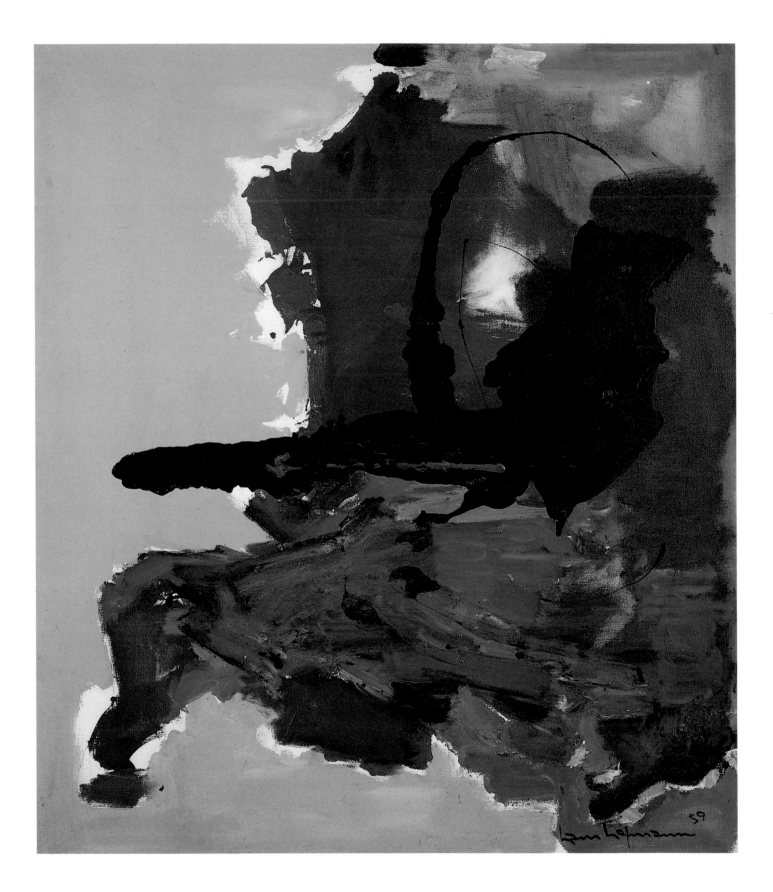

89. *Chimera*, 1959. Oil on canvas, 60 × 52 (152.4 × 132.1). Collection of Thomas Marc Futter

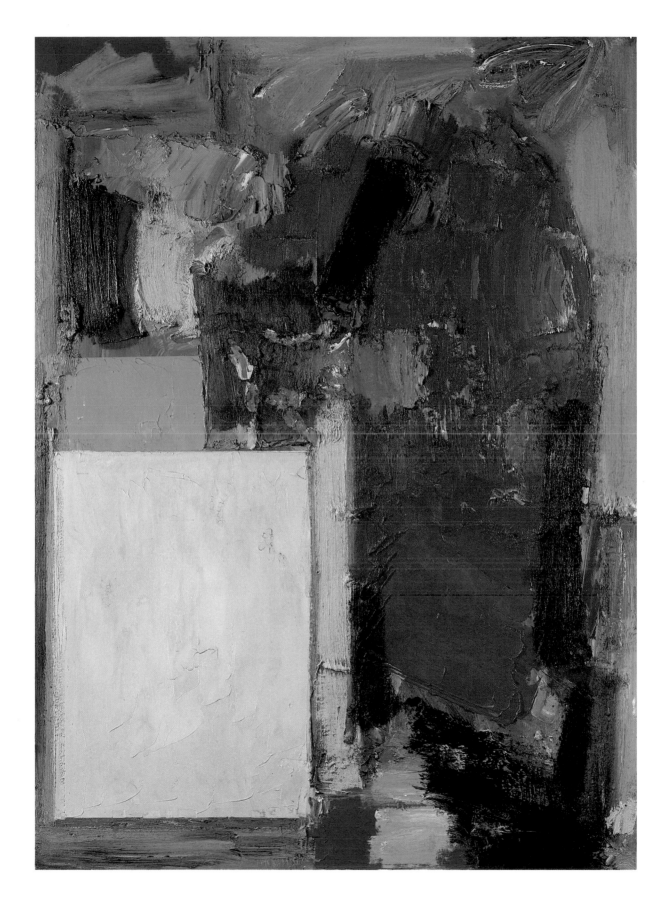

90. *Smaragd, Red, and Germinating Yellow*, 1959. Oil on canvas, 55 × 40 (139.7 × 101.6). The Cleveland Museum of Art; Contemporary Collection

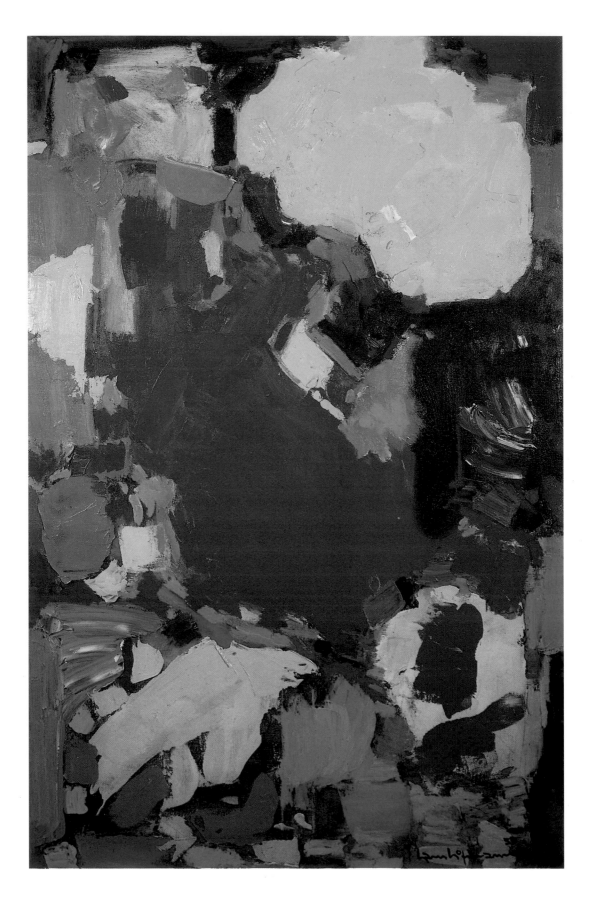

91. *Voices of Spring*, 1959. Oil on canvas, 74 × 48 (188 × 121.9). Collection of Mr. and Mrs. Gilbert H. Kinney

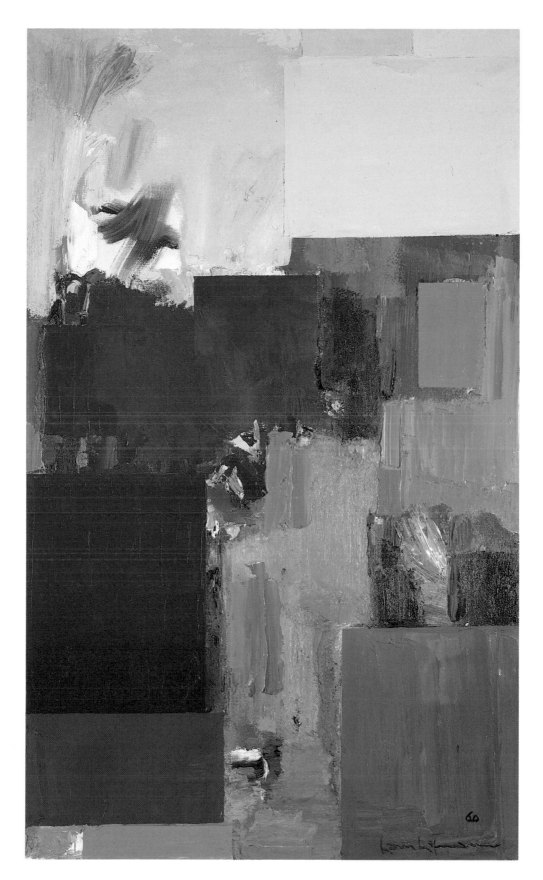

92. *Elyseum*, 1960. Oil on canvas, 84½ × 50¼ (214.6 × 127.6). Archer M. Huntington Art Gallery,
The University of Texas at Austin; Lent by Mari and James A. Michener

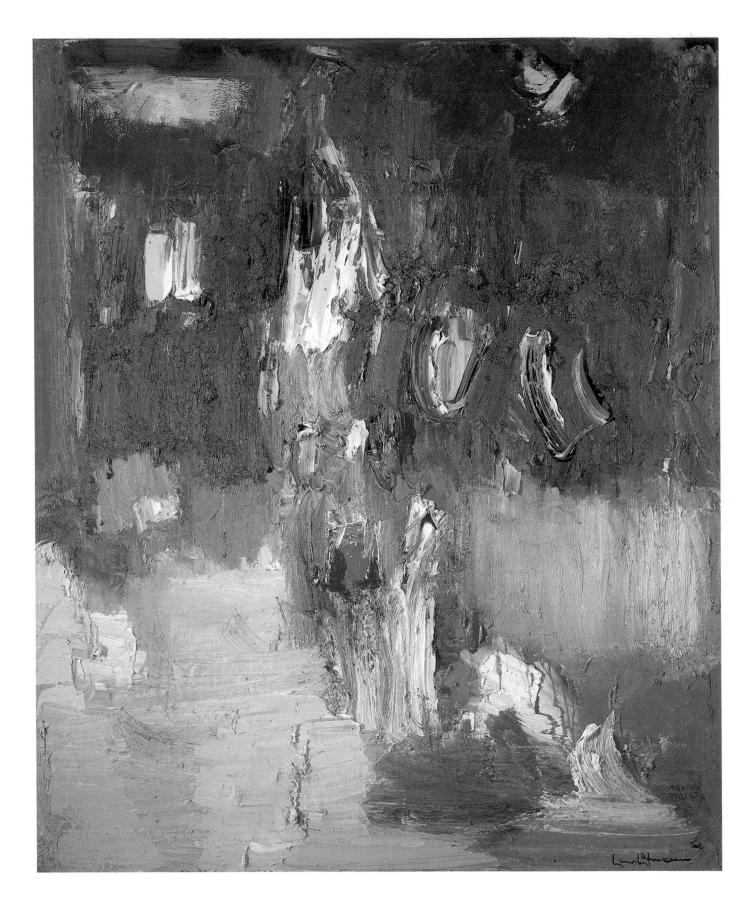

93. *Lava*, 1960. Oil on canvas, 72 × 60 (182.9 × 152.4). Private collection

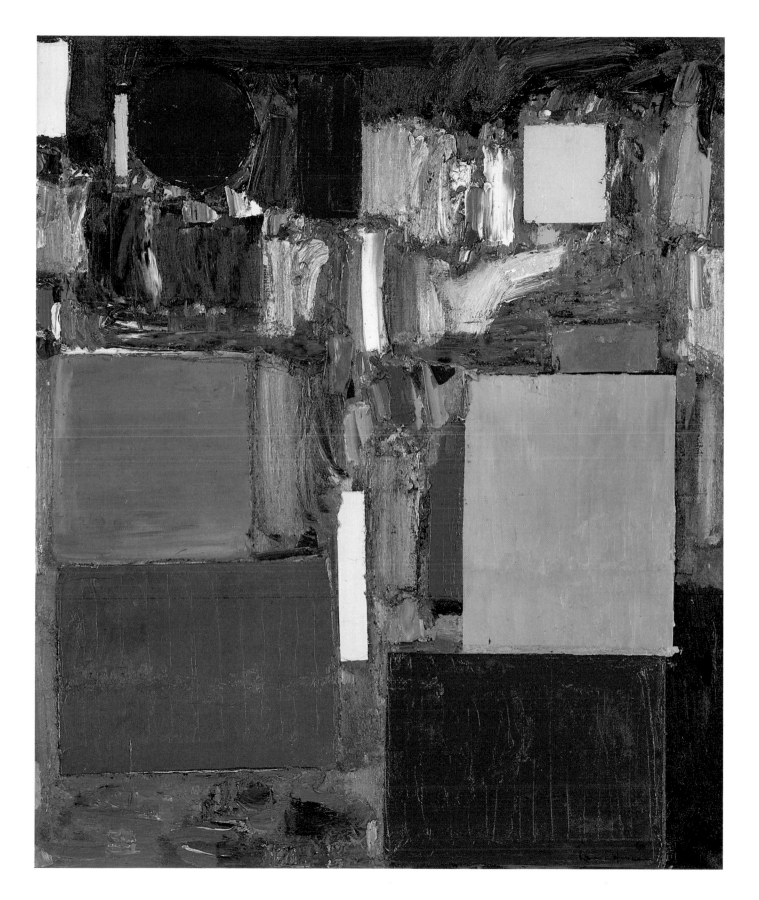

94. *Pre-dawn*, 1960. Oil on canvas, 72 × 60 (121.9 × 182.9). Australian National Gallery, Canberra

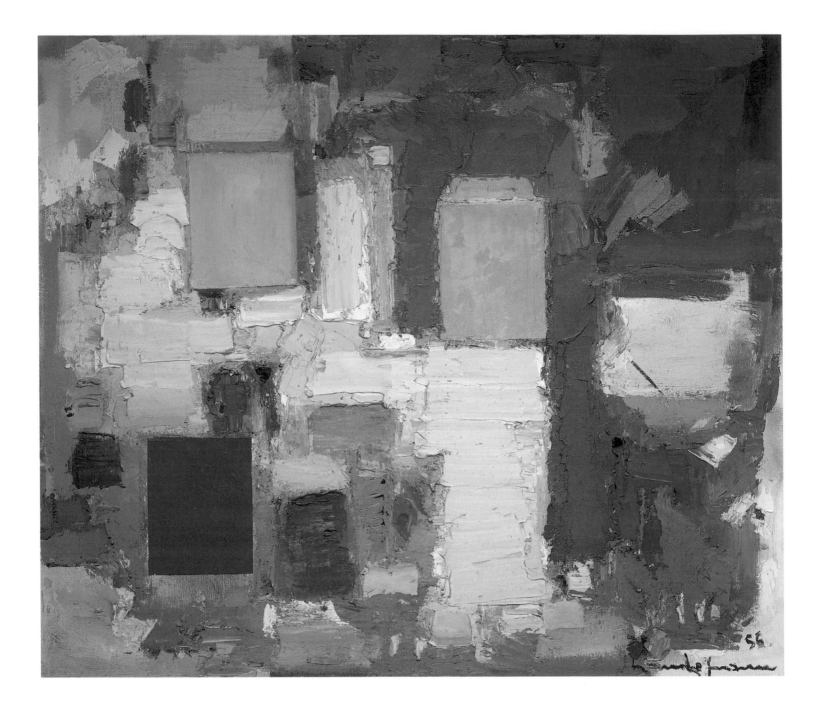

95. *Yellow Burst*, 1956. Oil on canvas, 48 × 60 (121.9 × 152.4). Collection of Berthe and Oscar Kolin

Hofmann

Clement Greenberg

Hans Hofmann's art is recognized increasingly as a major fountainhead of style and ideas for the "new" American painting, yet its value, independent of its influence and of Hofmann's role as a teacher, is still the object of qualifications. His omission from the "New American Painting" show that The Museum of Modern Art sent to Europe (1958−59) is a case in point (an omission which did more to distort the picture than did the number of highly questionable inclusions). A good share of the blame rests with the public of advanced art, which has its own kind of laziness and obtuseness, and usually asks that a "difficult" artist confine himself to a single readily identifiable manner before it will take trouble with him. (One would think that the exhilaration and satisfaction to be gotten from following advanced art were proportionate to the effort of discrimination required, but most of those who do the following do not seem to agree. Having accepted advanced art in principle, they want it to be made easy within its own context, apparently.) But Hofmann himself is also to blame in some part — and actually, the more excellence I find in his art the more I incline to shift the blame toward him. The variety of manners and even of styles in which he works would conspire to deprive even the most sympathetic public of a clear idea of his achievement. At the same time, such a

Reprinted, with permission, from Clement Greenberg, Hans Hofmann
(Paris: Éditions Georges Fall, 1961).

diversity of manners makes one suspect an undue absorption in problems and challenges for their own sake. Or else that this artist too implicitly follows wherever his inventive fertility leads him instead of bending that fertility to his vision. And Hofmann's inventiveness is truly enormous, to the point where he might be called a virtuoso of invention — such as only the Klee of the 1930s was before him. But, in art, one cannot scatter one's shots with impunity, and Hofmann has paid a certain price, in terms of quality as well as acceptance, for doing so. That price is certainly not as large as the price Klee paid in the 1930s, but it may be larger than the one Klee paid in his prime (when his "hand-written" approach and the small formats to which he restricted himself conferred a real unity of style upon all the different notational systems he used). And unlike Picasso since 1917, Hofmann has no ostensible main manner to which all his others are kept subordinate; he can work in as many as three or four different ones in the span of a year and give them all equal emphasis. The notion of experiment has been much abused in connection with modernist art, but Hofmann's painting would seem to justify its introduction if anything does.

Hofmann is perhaps the most difficult artist alive — difficult to grasp and to appreciate. But by the same token he is an immensely interesting, original, and rewarding one, whose troubles in clarifying his art stem in large part precisely from the fact that he has so much to say. And though he may belong to the same moment in the evolution of easel painting as Pollock, he is even less categorizable. He has been called a "German Expressionist," yet little in what is known as Expressionism, aside from Kandinsky's swirl, predicts him. His color and color textures may be "Nordic," but one clutches at this adjective in despair at a resolute originality in which the "Mediterranean" is assimilated. I would maintain that the only way to begin placing Hofmann's art is by taking cognizance of the uniqueness of his life's course, which has cut across as many art movements as national boundaries, and put him in several different centers of art at the precise time of their most fruitful activity. On top of that, his career as an artist has cut across at least three artists' generations.

Born and educated in Germany, Hofmann lived in Paris on close terms with the original Fauves and the original Cubists in the decade 1904 to 1914, during which both movements had their birth and efflorescence. (He was particularly close to Delaunay.) He made frequent trips to France and Italy in the twenties, after having founded his school in Munich. In 1931 he settled permanently in this country. For fifteen years he hardly picked up a brush but drew obsessively — as he says, to "sweat Cubism out." Only in 1935 or 1936, when he was in his mid-fifties, did he begin to paint again consistently — and only when he was

already sixty, at a time when many of his own students had long since done so, did he commit himself to abstraction. His first one-man show in New York was held at Peggy Guggenheim's early in 1944, and since then he has shown in New York annually, as an artist with his reputation to make or break along with artists thirty to forty years younger, and asking for no special indulgence.

Hofmann himself explains the lateness of his development by the relative complacency fostered in him during his Paris years by the regular support of a patron, and by the time and energy he needed, afterward, to perfect himself as a teacher. But I would suggest, further, that his Paris experience confronted him with too many *faits accomplis* by artists his own age or only a few years older; that he had to wait until the art movements of those and the inter-war years were spent before making his own move; that he had first to "get over" Fauvism and Cubism, and over Kandinsky, Mondrian, Arp, Masson, and Miró as well.

His own move started with Fauvish landscapes and large still-life interiors that he began painting shortly after 1935. The interiors amalgamate Matisse with Cubism in a fully personal way, but are if anything a little too brilliantly wrought. The landscapes, however, especially the darker ones, open up a vision that Nolde alone had had a previous glimpse of, and Hofmann opens it up from a different direction. Their billowing, broadly brushed surfaces declare depth and volume with a new, post-Matissean, and post-Monetian intensity of color, establishing unities in which both Fauvism and Impressionism acquire new relevance. Although there are already a few Hofmanns from 1939 in which no point of departure in nature can be recognized, the effective transition to abstract art takes place in the first years of the forties. Figures, landscapes, and still lifes become more and more schematically rendered, and finally vanish. What appear to be allusions to Kandinsky's near-abstract manner of 1910–11 constitute no real debt in my opinion; Hofmann would have arrived at the same place had Kandinsky never painted (though perhaps not if Miró, himself in debt to Kandinsky, had not). Rather than being influenced by Kandinsky, Hofmann seems to have converged with him at several points on the way to abstraction — a way that in his case was much broader, since it ran through the whole of Matisse and the whole of Cubism.

No one has digested Cubism more thoroughly than Hofmann, and perhaps no one has better conveyed its gist to others. Yet, though Cubism has been essential to the formation of his art, I doubt whether any important artist of this postwar era has suffered by it as much as Hofmann has. It is what I would call his "Cubist trauma" that is responsible, among other things, for the distractedness of his art in its abstract phase. Without the control of a subject in nature, he will too

often impose Cubist drawing upon pictorial conceptions that are already complete in themselves; it will be added to, rather than integrated with, his redoubtable manipulations of paint. It is as if Hofmann had to demonstrate to himself periodically that he could still command the language with which Braque and Picasso surprised him fifty years ago in Paris. Yet the moments of his best pictures are precisely those in which his painterly gift, which is both pre- and post-Cubist, has freest rein and in which Cubism acts, not to control, but only to inform and imply, as an awareness of style but not as style itself.

To the same painterly powers are owed most of the revelations of Hofmann's first abstract period, before 1948 — when, it is interesting to note, he painted almost exclusively on board. In a picture like *Effervescence* of 1944 he predicted an aspect of Pollock's "drip" method and at the same time Clyfford Still's anti-Cubist drawing and his bunching of dark tones. In *Fairy Tale* of the same year he expanded and deepened a hint taken unawares from Masson (whom Hofmann has never admired) in a way that anticipated Pollock's great *Totem No. 1* of a few months later. In the tempera-on-gesso *Cataclysm* of 1945 (subtitled *Homage to Howard Putzel,* Fig. 96) still another aspect of Pollock's later "drip" manner was anticipated ("drip" is inaccurate; more correct would be "pour and spatter"). These works are the first I know of to state that dissatisfaction with the facile, "handwritten" edges left by the brush, stick, or knife which animates the most radical painting of the present. The open calligraphy and "free" shapes that rule in "Abstract Expressionism" were foretold in many other pictures Hofmann did before 1948, and especially in numerous gouaches and water colors in which paint is wielded with a disregard of "construction" that represents the most inspired possession of it. Most of these pictures are more important as art than as prophecy, but it is only in the light of what they did prophesy that people like myself have learned to appreciate them; ten years ago and more, when they were first shown, they were too new.

In certain other pictures, however, Hofmann anticipated himself alone. *Summer Glory* of 1944 and *Conjurer* of 1946 declare the impastoed, non-linear manner which, in my view, was his most consistently successful one in the ten years after 1948. Here color determines form from the inside as it were; thick splotches, welts, smears, and ribbons of paint dispose themselves into intelligible shapes the instant they hit the surface; out of the fullness of color come drawing and design. The red and green *Flowering Desert* of 1954 is done in this manner, and so are many much smaller paintings in which warm greens (a color of which Hofmann is the unique master) predominate, as they do also in a masterpiece like *Le Gilotin* of 1953 (which, in drying, has unfortunately lost almost all of its original luster); and there is also the *Bouquet* of 1951.

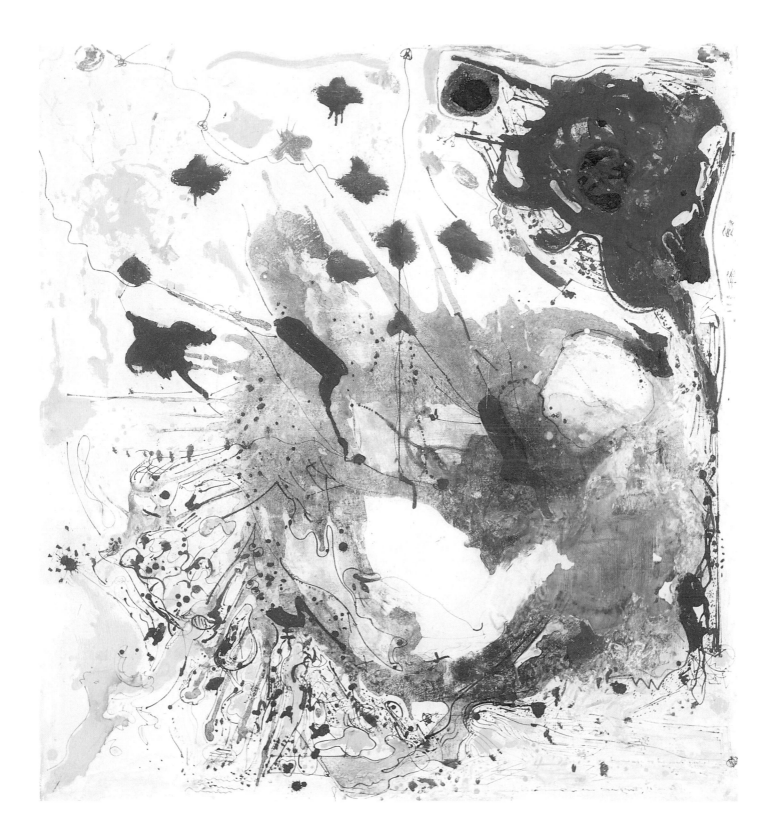

96. *Cataclysm (Homage to Howard Putzel)*, 1945. Casein on gesso on board, 51¾ × 48 (131.4 × 121.9). Collection of Lee and Gilbert Bachman

When Hofmann tries to reinforce contrasts of color and shape with taut contour lines, and when he trues shapes into a Cubistic but irrelevant regularity, it is then that his art tends to go off in eccentric directions. Given that the originality of his color consists often in oppositions of intense hues of the same degree of warmth and even of the same value; that a cool color like blue or an ambiguous one like green will be infused with unaccustomed heat; and that such things can tax the eye the way an unresolved chord taxes the ear — given all this, design becomes a very precarious matter in which it is safer to stop too soon than too late. To insist on line or edge can be excessive or disruptive. And sometimes the energy of Hofmann's line can be more nervous, more machined, than pictorial, and it can force an illegitimately sculptural effect. Or, as more recently, an overloaded effect is created by the compulsion to articulate every square inch of the surface with chromatic and graphic detail. For Hofmann's overriding weakness has nothing to do essentially with drawing, but lies in a tendency to push a picture too far in every direction. There is the endeavor to achieve, as it would seem, an old-fashioned synthesis of "drawing" and "color" — a grand-manner synthesis. This is an ambition that identifies Hofmann with his own chronological generation of artists and separates him from the generation he actually paints with. But it separates him only insofar as it distracts him, and in his bad paintings, not his good ones.

But if not all of his bad pictures are due to displaced draftsmanship, neither are all of his good ones a function of color first and foremost. There are many oils on paper, gouaches, and water colors in which Hofmann's Cubism develops a Matissean rather than Con-structivist grace of line. There are paintings, like *Burst into Life* of 1952 and *The Prey* of 1956, in which thick pigment is handled calligraphically over clear white areas. And there is the large and superbly original *Undulating Expanse* of 1955, which, along with four or five other, and smaller, paintings in the same series of studies — all inspired by the pos-sibility of an architectural commission — is rapidly and almost transpar-ently brush-drawn on the bare priming. These pictures strike one of the freshest notes to be detected anywhere in the painting of the last ten years, but it is characteristic of Hofmann not to have pursued further an idea that another artist would have built a whole career on. Pictures like these confirm, at any rate, one's impression that his first impulses are usually his best ones; when he fails it is most often because he forgets what he himself has drummed into his students: that science and discipline which have not become instinct are cramping rather than enabling factors.

A good deal of what is so rashly called "Abstract Expressionism" amounts essentially to a kind of Late Cubism (which takes nothing away from it in principle). In some of his best work

Hofmann is almost as much a Late Cubist as Gorky or de Kooning. In another and even better part of it, however, he points to and enters a way that is fully post-Cubist, and when he does so he follows his deepest bent, whether he himself recognizes it or not, and fulfills his most personal vision. Klee and Soutine were perhaps the first to address the picture surface consciously as a responsive rather than an inert object, and painting itself as an affair of prodding and pushing, scoring and marking, rather than of simply inscribing or covering. Hofmann has taken this approach further, and made it do more. His paint surfaces *breathe* as no others do, opening up to animate the air around them, and it is by their open, pulsating surfaces that Hofmann's very best pictures surpass most of Kandinsky's, as I feel they do. And it is thanks in part to Hofmann that the "new" American painting in general is distinguished by a new liveness of surface, which is responsible in turn for the new kind of "light" that Europeans say they find in it.

But that part of the "new" American painting which is not Late Cubist has distinguished itself further by its freedom from the quasi-geometric truing and fairing of lines and edges which the Cubist frame imposed. This freedom belongs with Hofmann's open surfaces as it does not with de Kooning's or Kline's, and his hesitancy in fully availing himself of it — despite the large part he had in the winning of it — must be blamed on his reluctance to cut himself off from Cubism as a base of operations. And as I have already suggested, this reluctance seems the most immediate, if not the only, reason for the lack of self-evident coherence in the development of his art.

Yet having said all this, we are still far from done with Hofmann and his art. His name continues to be the one that springs to mind when we ask who, among all recent painters in this country, deserves most to be called a master in the full sense of the word. This may have something to do with his age, but it has more to do with his range and variety. It has also to do with his accomplishedness, his literal mastery. But it has even more to do with the fact that only a master could remain problematical over so long a period and continue to challenge taste in so sustained a way.

Hofmann's inconsistency itself is part of the challenge. His fully successful works may seem relatively few and far between, but each of them sums up so much that their fewness has to be explained as the result of something other than mere unevenness. It is as though he worked his way toward each success as toward so many different climaxes of so many different processes of distilling and decanting. The less successful pictures point toward the more successful ones, and in the retrospective light of these they acquire a necessity that can endow them with conclusive qualities of their own. Thus the fewness itself of Hofmann's

successful works becomes open to doubt — and all the more so when we remember how long it took us to recognize his masterpieces of 1943–48 for what they were. There is also the fact — not as minor as it looks — that, just as some of his thickly impastoed pictures (like the already mentioned *Gilotin*) lose quality when they dry out, so others gain quality in doing so. For these and other reasons — not least among which is the fact that, though in his early eighties, he is still in his full artistic prime — Hofmann's art contains promises whose fulfillment is not as yet made any the more foreseeable by the large part of it already present in paintings which go back twenty years and more.

Single-minded innovators usually make themselves understood quicker. The more puzzling ones — who often precede the single-minded ones — are those who innovate reluctantly, and in spite of themselves, because they find in innovation the only means to conservation. Among the puzzling, reluctant innovators, Hofmann, the first "drip painter," belongs. As I have said, he continues to dream of old-fashioned "syntheses." And as I have also said, this dream can do violence to his inspiration — but it can also furnish inspiration in itself. As far as the "history of forms" is concerned, the main event in postwar painting seems to me to be the transition to a newer and looser notion of the easel picture. Hofmann's dream of syntheses expresses a certain opposition to this. But his painting itself, as distinct from what he wants of it, renders this opposition fruitful by assimilating the very tendencies it resists. It is the habit of his art to admit contradictory impulses without weakening their force, and to refuse to overcome their contradictoriness except in the most difficult way possible, which is by transcending it. Not only will Hofmann maintain emphatic, Fauvist color against emphatic, Cubist drawing: he will oppose compression to diffusion, centripetality to centrifugality, in one and the same picture. (The "explosiveness" of Hofmann's paintings has been remarked on, but I do not see why their "implosiveness" is not equally remarked on.) Here unity is attained, if it is attained, by fusion rather than by reconciliation, and fusion itself is attained by dint of a heightening of intensity that is without like in contemporary art. At more than one group show I have had the experience of seeing even a rather indifferent Hofmann make all the other works present, including those by more cried-up artists, seem a little less than present by contrast with its own intense weight of presence. This weight equates itself not so much with violence of color or shape — it can be there in a quiet Hofmann too — but with something more pervasive that might be called the picture's concentrated radiance, its effulgence and plenitude as an identity: an identity gained as the result of a complete insistence on the paint-covered rectangle as a dramatically self-contained and involuted

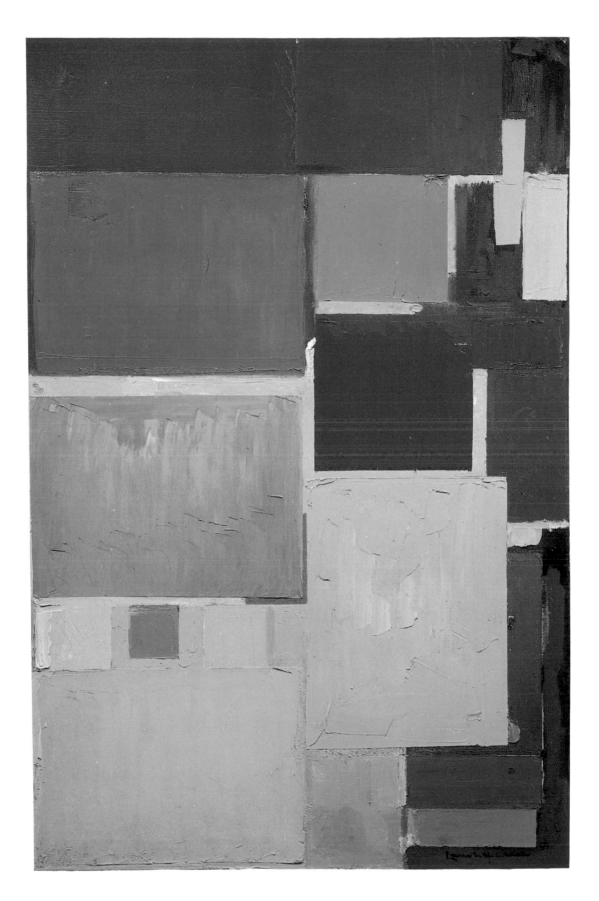

97. *Cathedral*, 1959. Oil on canvas, 74¼ × 48¼ (188.6 × 122.6). Private collection

statement. And what makes the paint-covered rectangle all the more such a statement is its admitting of so many accents in the way of color, shape, and the line that seem to negate involution. The risk incurred used to strike me as foolhardy or perverse; then it stopped striking me that way: it began to explain why Hofmann's pictures manage in the long run to keep on succeeding a little even when they seem most to fail.

There is, however, one risk — if it is a risk — that Hofmann refuses to take. He has not joined that trend to oversize canvases which has become prevalent lately in American abstract painting. Not that he cannot handle the oversize format — perhaps he can handle it more easily, and with more frequent or obvious success, than the one of twenty square feet or so that he generally favors — but it is typical of him not to take the path of least resistance. At the same time, however, I interpret him as feeling that "balance and luminous charge of mass and saturated volume" (to use his own words out of context) cannot be obtained from a surface so large that every part of it is not within easy arm's reach of the artist planted before it. The big canvas can, of course, achieve a charge and saturation of its own (as Hofmann's own *Undulating Expanse* of 1955 shows), but it is not the immediate, almost corporeal kind that Hofmann asks. The big canvas dictates too ineluctable an openness. Actually, Hofmann often appears to be demanding of abstract, shallow-depth painting the kind of closely wrought, intensive effects that seem possible only to illusionist painting with its *trompe-l'œil* depth within depth.

Matisse was the first to understand how the increasingly stringent modernist interdiction of *trompe-l'œil* made it necessary for the painter to seek in the extension of the sheer surface an equivalent of the space he used to find in the in-tension of illusioned depth. Matisse's reliance on mat and uniformly thin paint was a further inducement to the use of large surfaces, for no matter how saturated, thin pigment that swallows light instead of reflecting it needs to be spread over a relatively large area if it is to acquire intensity. Matisse was the artist of this century from whom Hofmann learned most, and about color above all, but Hofmann's reluctance to follow Matisse in the matter of the big format is connected, I feel, with his final independence from him as a colorist — an independence won in his very first abstract paintings.

Unlike Matisse, Hofmann has come to require his color to be saturated corporeally as well as optically. The weight and density of his paint — attributes it has even when it is not thickly impastoed — contribute to the presence his pictures have as *objects* as well as pictures. This is not the same as the superb physical identity (too little noticed) with which the Old Masters, even as they tried to conceal art with art, endowed their pictures by covering them with multiple films and scumbles of paint.

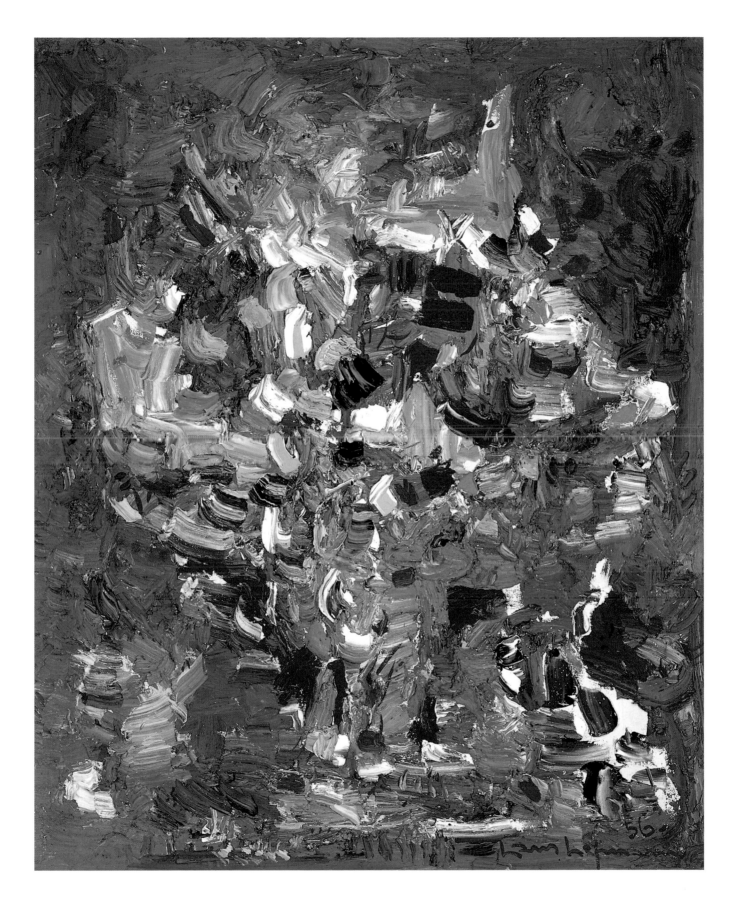

98. *Fragrance*, 1956. Oil on canvas, 60 × 48 (152.4 × 121.9). Honolulu Academy of Arts; Purchase, 1968

The Old Masters were apt to conceive of the picture, with its enclosing shape and flat surface, as a receptacle into which things were put, whereas modernist painting tends increasingly to erase this distinction and make the picture as such coincide with its physical, literal self. Where the corporeality of an Old Master painting was supposed to contain the picture as something separate lying *behind* the paint surface and *inside* the frame, the paint surface and frame of a modernist painting are assumed to be just as obviously and essentially pictorial as the con-figurations they support and enclose. In his very first abstract works, Hofmann took this approach further perhaps than anybody else (not excluding Rouault) had up to that time. It was he — not Pollock or Dubuffet — who launched the "heavy" surface in abstract art, that fat, heavy, and eloquent surface which so many younger painters, both in America and in Europe, are now mechanically driving into the ground. Here again, Hofmann preserved the easel picture by going to certain extremes in the way of its subversion, and here still again, great but difficult pictorial qualities were born out of contradiction because they could not be born out of anything else.

Though color is the element in which Hofmann is most independent and original, it is simultaneously his chief means of conservation. He could be said to take the easel tradition into regions of chromatic experience it never before penetrated. In these regions he preserves the easel picture's identity by showing how oppositions of pure color can by themselves, and without help of references to nature, establish a pictorial order as firm as any that depends on conspicuousness of contour and value contrast. Since the decline of stained-glass painting the trend of Western tradition has been more or less to exclude color from a decisive role in pictorial art. The Impres-sionist and Fauve episodes may have checked this trend, but they did not really reverse it. Color still gets taken for granted as a secondary element. Not one of all those self-proclaimed nihilists of art, from Duchamp and Picabia to the "Neo-Dadaists," who profess to reject aesthetic norms *in toto,* seems to consider color important enough to treat unconventionally. On the other hand, the opinion is still common, in the avant-garde as well as the academy, that a primary emphasis on color means surrender to the purely decorative. Even Matisse's enor-mous example seems not to have dissipated this idea. Yet despite his reliance on the autonomous powers of color, the decorative has never been even an issue for Hofmann, either as an asset or liability; and like Matisse, he has actually had only indifferent success with outright decoration on the few occasions when he has put his hand to it. One might say even that this is because the decorative presents itself to him too much as a question of drawing and not enough as one of color.

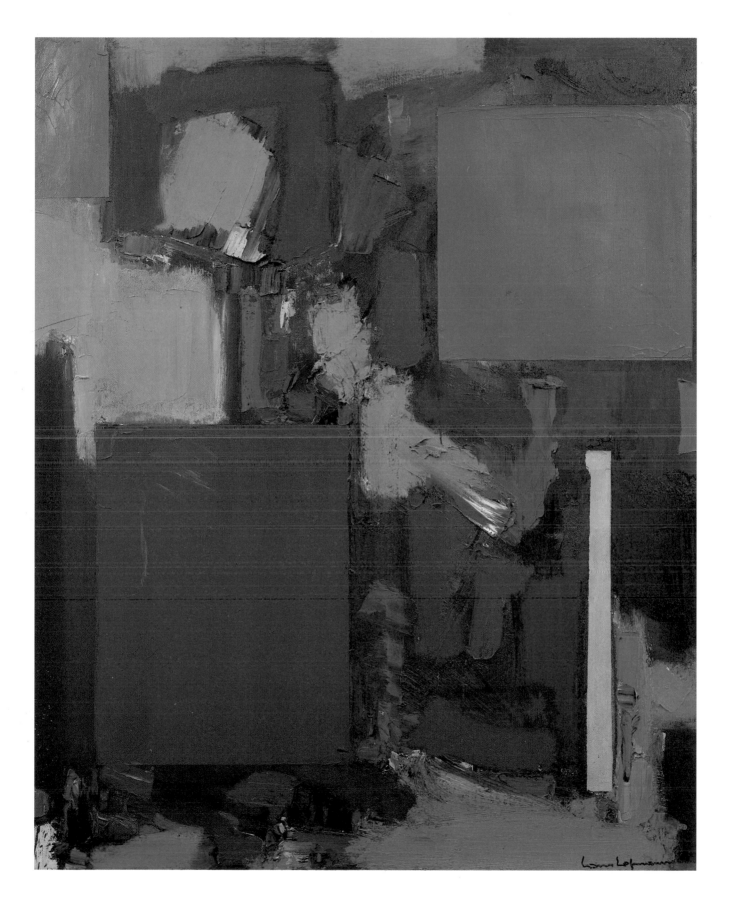

99. *Cap Cod–Its Eboulliency of Sumer*, 1961. Oil on canvas, 60 × 48 (152.4 × 121.9). Private collection

What Hofmann has discovered, or rather rediscovered, is that color, when its resources are sufficiently called on, can galvanize the most inertly decorative pattern into a pictorial entity. This could not be made explicit — at least not in our time — until the arrival of fully abstract art, and Hofmann, as it seems to me, has made this even more explicit than Delaunay did (however much he himself may owe to Delaunay). Cézanne said, and perhaps he demonstrated (though I am not sure), that fullness of color insured the fullness of form or shape; Hofmann, freed from all obligations to three-dimensional form, has shown how color can subsume form; and in doing so he has linked up, over Delaunay's and over Matisse's head, with Monet's last phase. Monet is not a painter whom Hofmann seems ever to have particularly admired, but only in him do we find any possible precedent for the elisions of light-and-dark contrast that Hofmann dares to make for the sake of pure, singing color. But Hofmann goes beyond Monet and beyond all other precedent, Western or Oriental, when he contrives to make the variables of saturation and texture, as well as those of pure hue, determine drawing and pattern as consequences rather than as preconditions of themselves. Perhaps Soutine had a similar vision of a fully chromatic art, but it was with hardly anything like a similar awareness or command of such variables. Hofmann has not solved all the problems these present, but his being the first to broach them is enough of itself to give him a secure place in the history of painting.

I have dwelt on the difficulty of following Hofmann's evolution, and I attributed it, along with what seemed some of the failures of his art in itself, to his excessive attachment to Cubism. But even as I was putting the present text together, the coherence of one important theme of his recent development emerged with sudden and unforeseen clarity. In this theme, Hofmann's Cubism, while becoming more outspoken than ever before in oil, began at the same time both to vindicate and transcend itself — as if purposely to refute what I had already said about it. It was one more example of the way in which his art kept one off balance.

The beginnings of this particular theme go back to 1954. A number of paintings of that year show, against larger, brushed-in forms, little knifed-on oblongs of thicker pigment that resemble mosaic pieces. (*Orchestral Dominance in Green* is a particularly successful but characteristically knotty example.) In every year since then, pictures increasingly dominated by these "mosaic pieces" have appeared along with pictures in a variety of other directions. The little oblongs, though multiplying over the surface, do not grow particularly in size until 1959, when they suddenly swell out into large square, or nearly square, slabs of equally uniform color that settle themselves — though without

being evenly aligned — on firmly horizontal axes. These slabs do not monopolize the surface entirely; even in a picture like *Cathedral* (Fig. 97), where they threaten most to do so, enough of a freely brushed and variegated ground shows through to compromise the suggestion of a purely geometrical art. Perhaps the kind of color involved would suffice to do this all by itself; but even without the color and without the ground, the tactile connotations of the slightly raised edges and the thickened paint surfaces of the squares would be enough to suppress any real feeling of geometrical "purity." Yet the very fact that *Cathedral* teeters on the edge of a kind of art like Mondrian's is one of the things that give it its climactic quality as a work that sums up the realizations of a whole epoch of modernist art, and at the same time points toward the next one — in which geometrical and painterly drawing will become indistinguishable because they will have cancelled each other out under the pressures of color. Barnett Newman and Mark Rothko have already entered that epoch, and so have two or three younger American painters, but it has been left to Hofmann to establish firmly, and interestingly, the explicit no less than implicit continuity with the past of the new vision of color that is at stake.

Hofmann's *Cathedral* vein takes up Analytical Cubism, in order to continue it, at the very same point at which both Mondrian and Pollock took it up in order to continue it, which was where Braque and Picasso left it in 1912 when they saw it threatening to carry them all the way over into abstract art. The facet-planes of Analytical Cubism were left hanging as it were, until Mondrian flattened them out into exact rectangles that were subsequently enlarged into area-shapes. Thirty years later Pollock pinned the facet-plane down once again, smaller in scale than originally, in the interstices and flecks of the skeins of paint that fill his 1947–50 pictures. In its first stages, Hofmann's "mosaic" series seems closer to Pollock, and then it seems to recapitulate Mondrian's expanding and squaring-up of the facet-plane. But Hofmann's actual course diverges from Mondrian's as much Mondrian's does from Pollock's, and in the end he is further away from both than either is from the other. Mondrian and Pollock think and feel throughout in terms of light and dark. Mondrian drives Analytical Cubism to an ostensibly simplifying conclusion in order to enhance the silhouetting, the drafts-man's function of value contrast. Pollock pulverizes value contrast in order to loosen the Cubist surface (by prying it away from itself so to speak), but color stays in a subordinate role. Hofmann reaches *his* ostensibly simplifying conclusion in order precisely to aggrandize the role of color. Mondrian's edges assert themselves by their stark straight-ness; Hofmann's edges more or less efface themselves by the same means, their straightness serving to render the contrasts of the color areas they

divide more evidently, more sheerly defined in terms of color. Because the drawing is geometrical, it is simple, and because it is simple, it is expectable, and being expectable, it leaves all the more room for a rich and unexpected complexity of color relations.

Such color relations are, of all things in the art of painting, the hardest to point to with words. Suffice it to say that in *Cathedral* the picture plane is dissolved both by warm hues that advance and cool ones that retreat, yet restored at the same time by the interaction of warm and cool, light and dark, thin and thick, saturated and diluted. The deep blues, oranges, mauves, and browns in the upper third of the canvas loom over and weigh down the ochers, pistachio greens, and various whitened yellows in the lower two thirds, but these throw off the weight of the heavier colors above by virtue of their own greater brilliance, and also by virtue of the greater size, individually and collectively, of the squares they occupy. The outcome, like the outcome in every profoundly successful picture, is a stability that is sovereign because it is hard-won and precarious.

Hofmann offers a lesson in patience. That lesson, from him and from others, I shall never finish learning. It includes one's own mistakes. One is also reminded of how in art the tortoise so often overtakes the hare. Not all, but too many of the best writers, composers, and artists of our time begin to be acclaimed only when they no longer have anything to say and take to performing instead of stating. This is how they first become accessible to broad taste, which is lazy taste, and by the same token to the processes of publicity and consecration. As long as they were trammeled up in the urgency of getting things said they were too difficult, too "controversial." With the best will in the world Hofmann could not turn himself into a performer; far from ever being without enough to say, he will always have to cope with the opposite problem of having too much to say.

The consecration of one's reputation may be a cause as well as an effect of decline. Hofmann has one of the profoundest instincts for self-preservation I have ever become aware of, and I am inclined to think that, subliminally, he prefers, and needs, to delay his canonization. It is mostly, as I said at the beginning, his own doing. Though his name does not exactly go uncelebrated, though museums and collectors acquire his work, and though he does not refuse the honors that come his way or adopt attitudes of intransigence, he manages to keep at a distance the corrupting odor of incense.

Plates

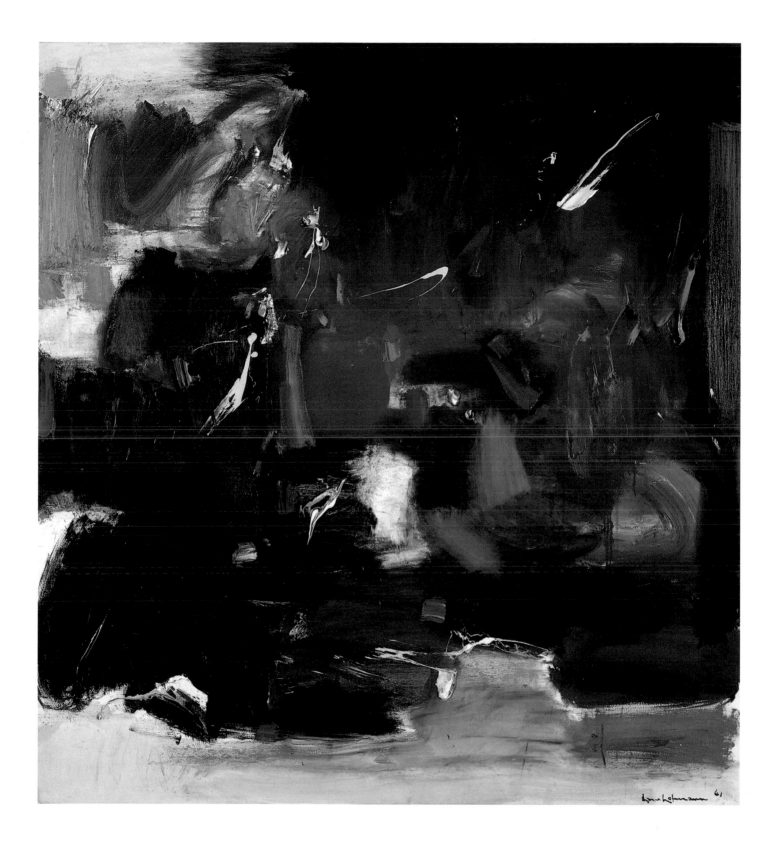

100. *Summer Night's Bliss*, 1961. Oil on canvas, 84 × 78 (213.4 × 198.1). The Baltimore Museum of Art; Gift of the artist

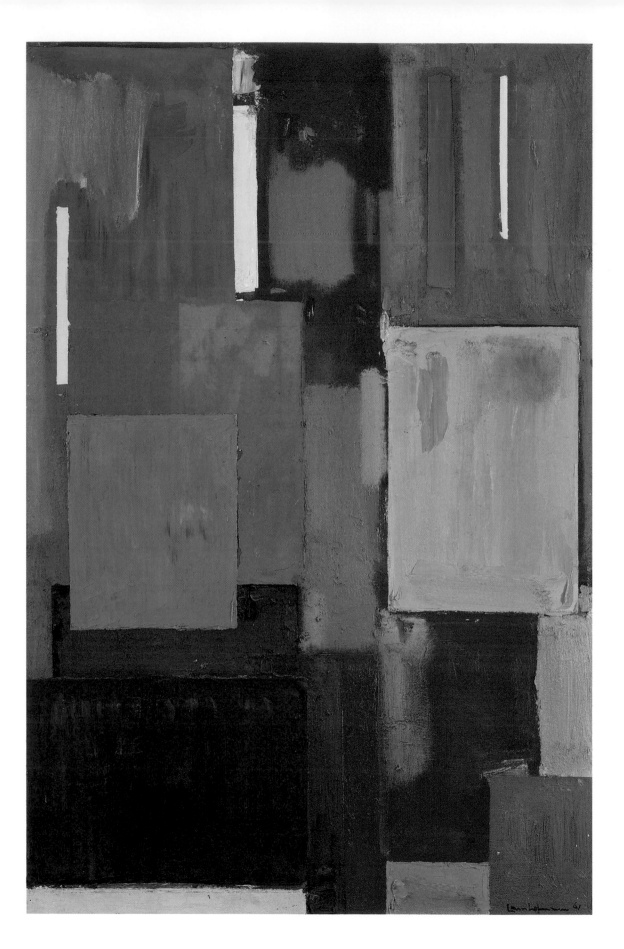

101. *Leise zieht durch mein Gemüht liebliches Geläute*, 1961. Oil on canvas, 74 × 48 (188 × 121.9). Collection of Mrs. Jan Cowles

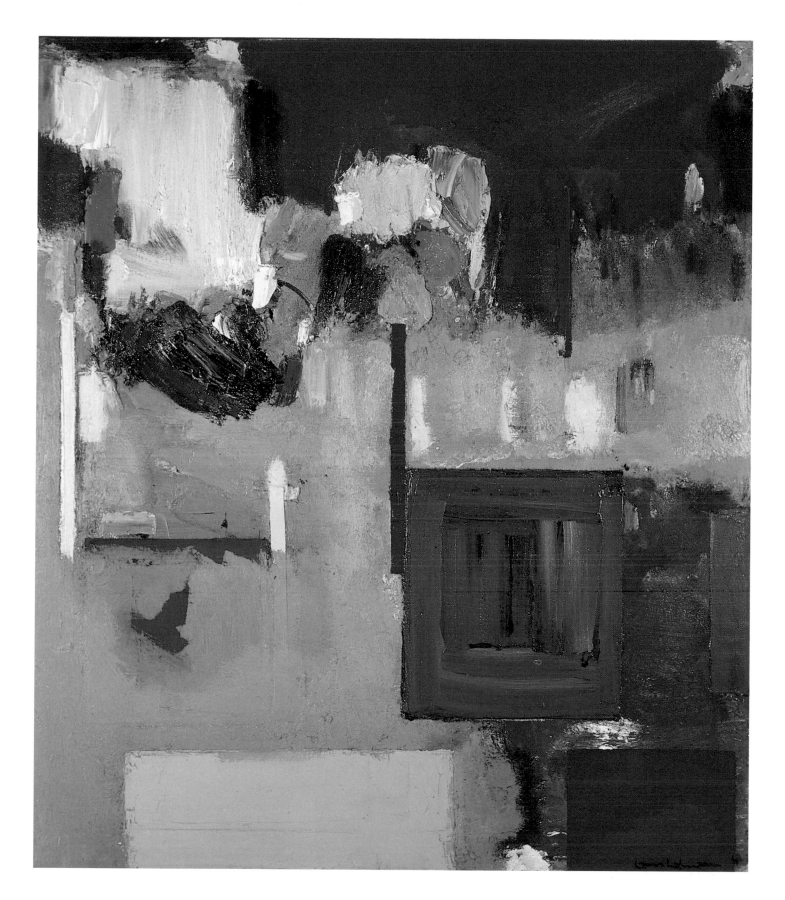

102. *Image of Cape Cod: The Pond Country, Wellfleet,* 1961. Oil on canvas, 70 × 61 (177.8 × 154.9). Collection of Dr. William C. Janss, Jr.

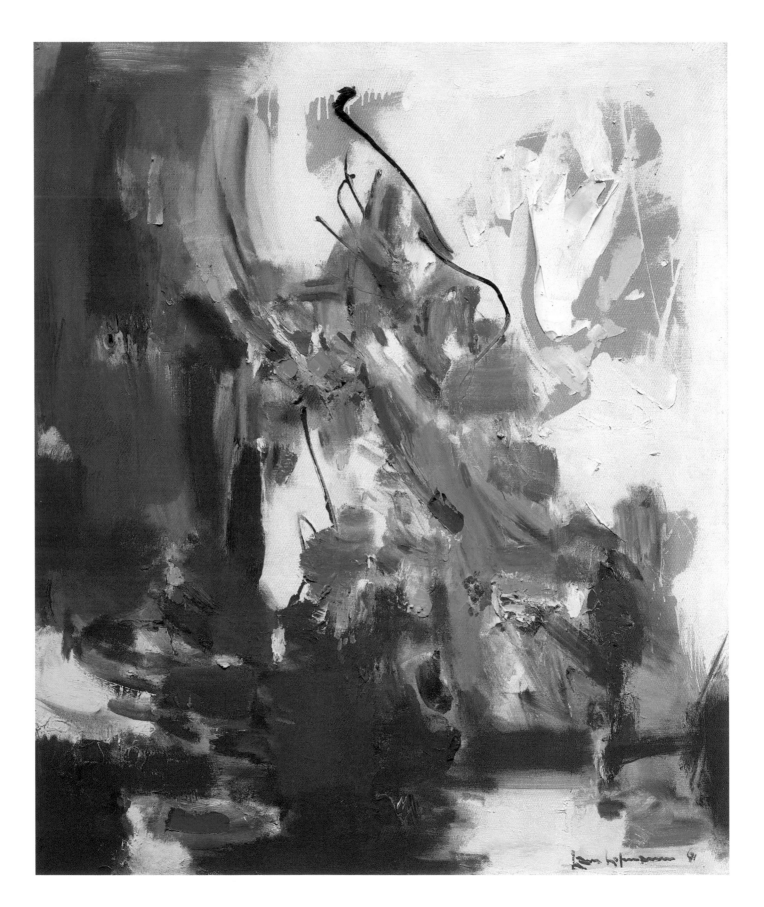

103. *Wild Vine*, 1961. Oil on canvas, 72 × 60 (182.9 × 152.4). Collection of Mr. and Mrs. Harold Price

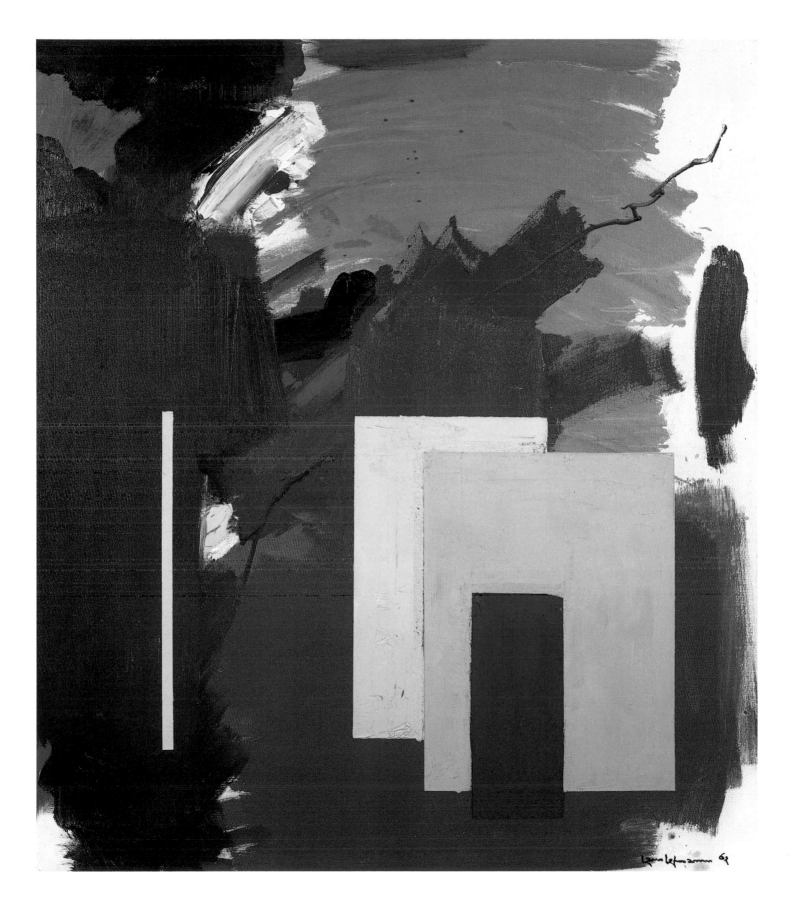

104. *Autumn Chill and Sun*, 1962. Oil on canvas, 60⅛ × 52 (152.7 × 132.1). Collection of Donna Stone

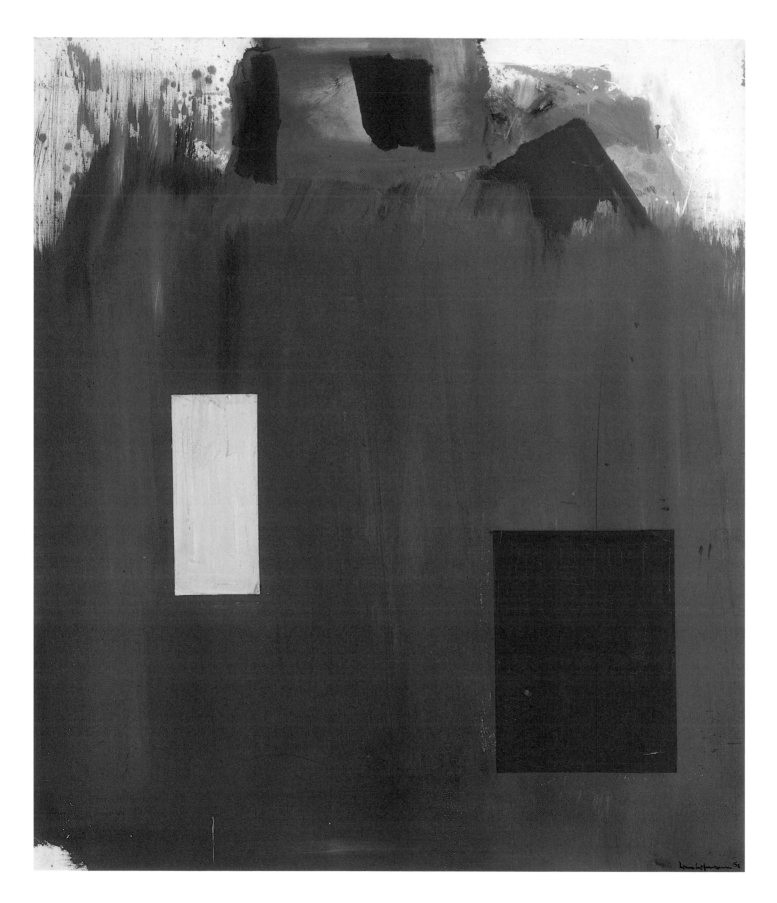

105. *Memoria in Aeternum*, 1962. Oil on canvas, 84 × 72⅛ (213.4 × 183.2). The Museum of Modern Art, New York; Gift of the artist

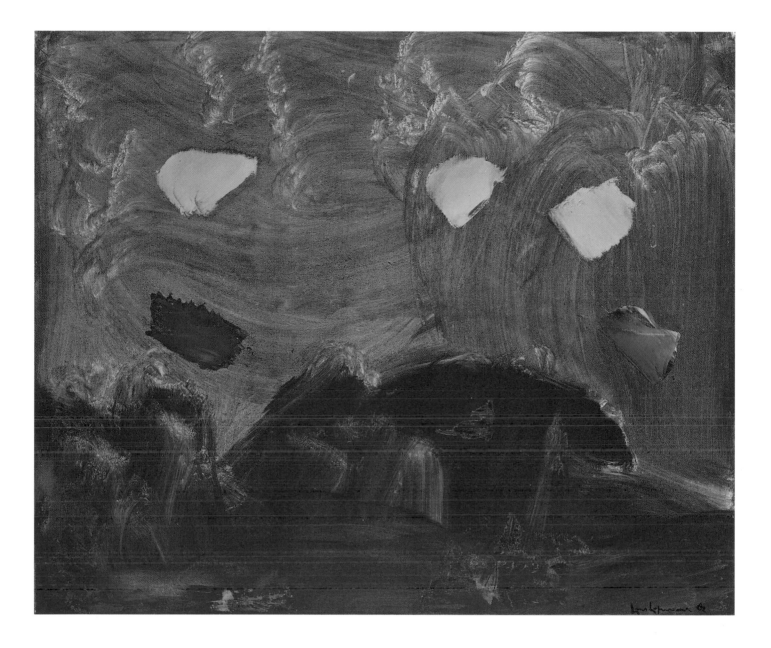

106. *Summer Over the Land*, 1962. Oil on canvas, 60 × 72 (152.4 × 182.9). Collection of Mrs. Theodore M. Law

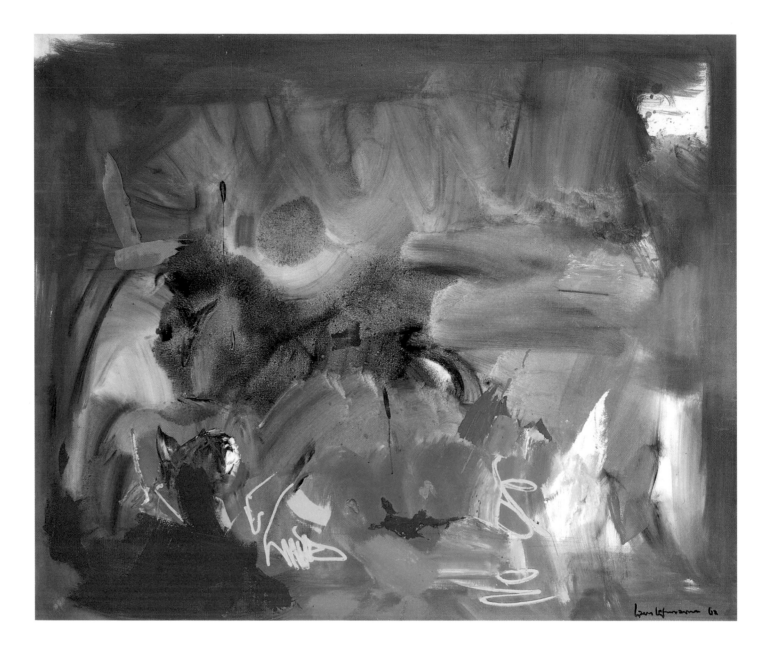

107. *Sic Itur Ad Astra*, 1962. Oil on canvas, 60 × 72 (152.4 × 182.9). Private collection

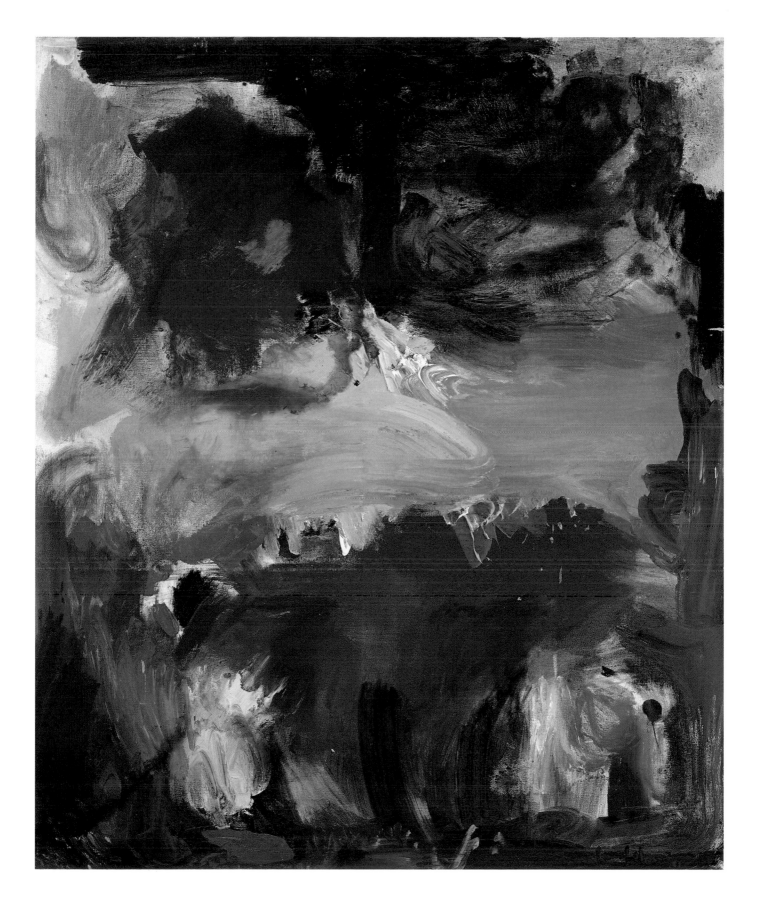

108. *Fiat Lux*, 1963. Oil on canvas, 72 × 60 (182.9 × 152.4). The Museum of Fine Arts, Houston; Gift of Mrs. William Stamps Farish, by exchange

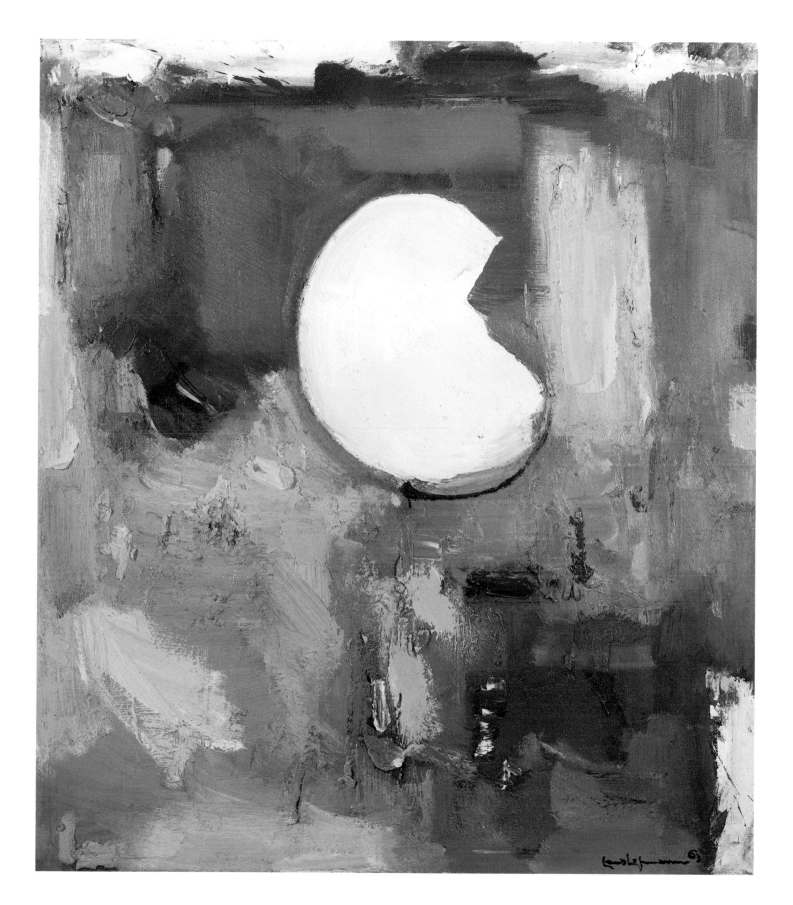

109. *Gloriamundi*, 1963. Oil on canvas, 60⅛ × 52 (152.7 × 132.1). University Art Museum, University of California, Berkeley; Gift of the artist

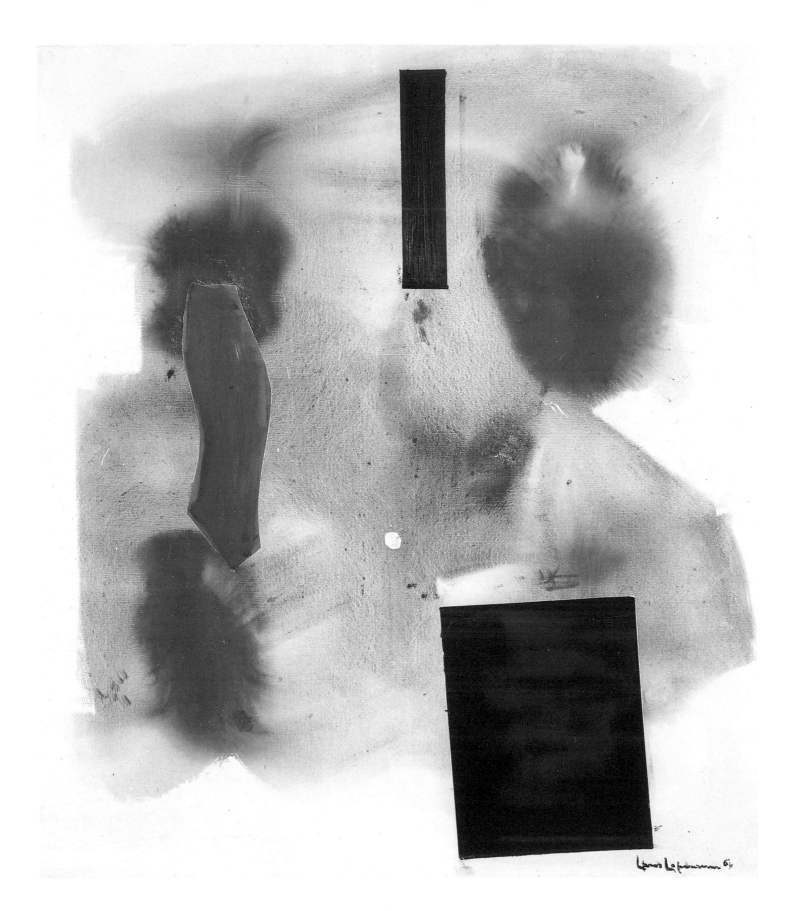

110. *Pendulare Swing*, 1965. Oil on canvas, 60 × 52 (152.4 × 132.1). Private collection

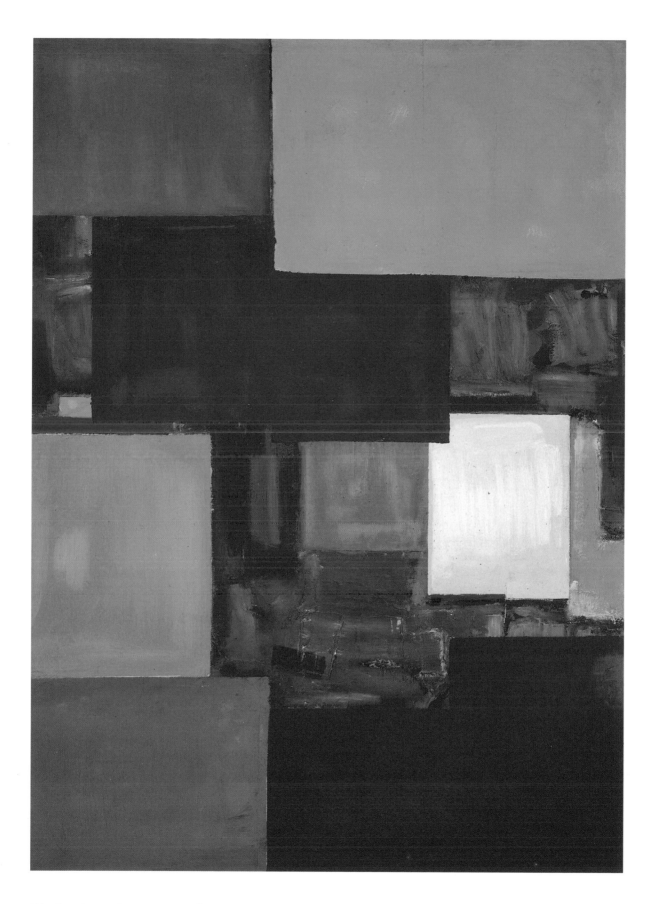

111. *Ignotium per Ignotius*, 1963. Oil on canvas, 84½ × 60 (214.6 × 152.4). Private collection

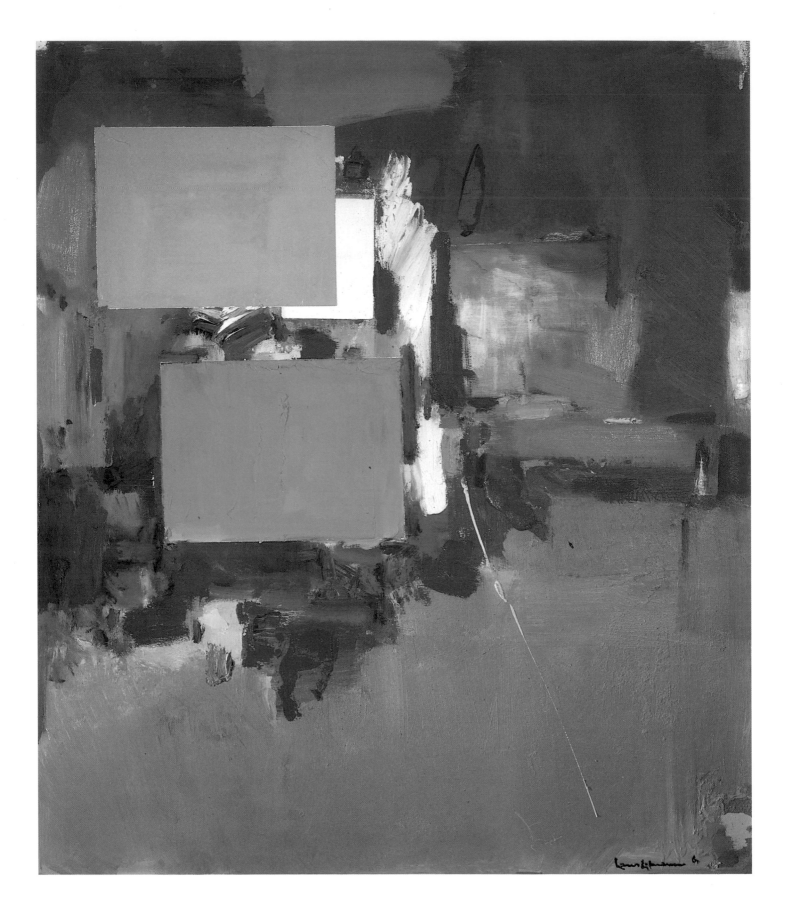

112. *Song of the Nightingale*, 1964. Oil on canvas, 70 × 61 (177.8 × 154.9). Collection of Barbara and Eugene M. Schwartz

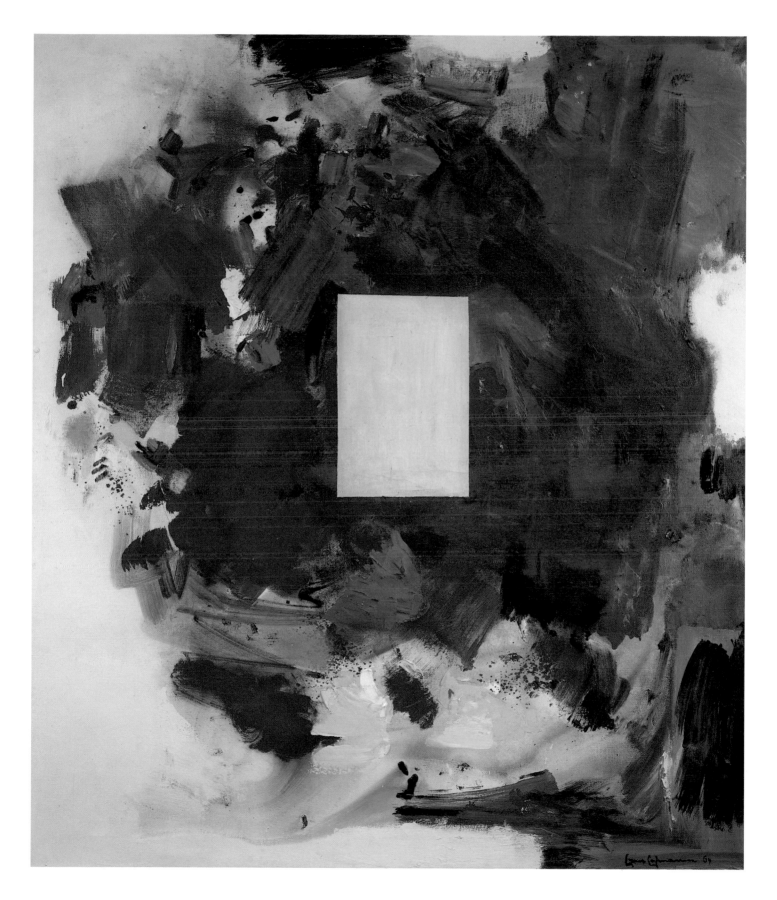

113. *Sun in the Foliage*, 1964. Oil on canvas, 84 × 72 (213.4 × 182.9). Collection of Mr. and Mrs. Graham Gund

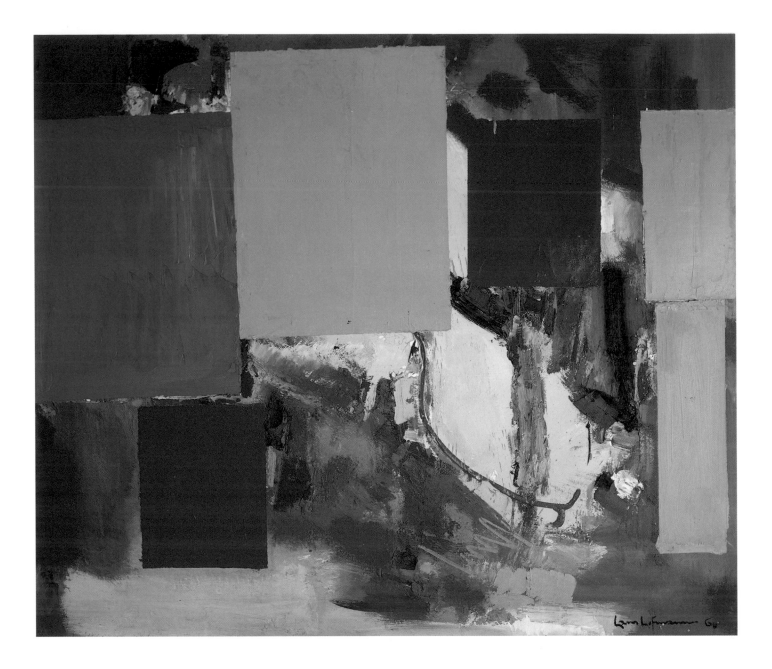

114. *Te Deum*, 1964. Oil on canvas, 52 × 60 (132.1 × 152.4). Private collection

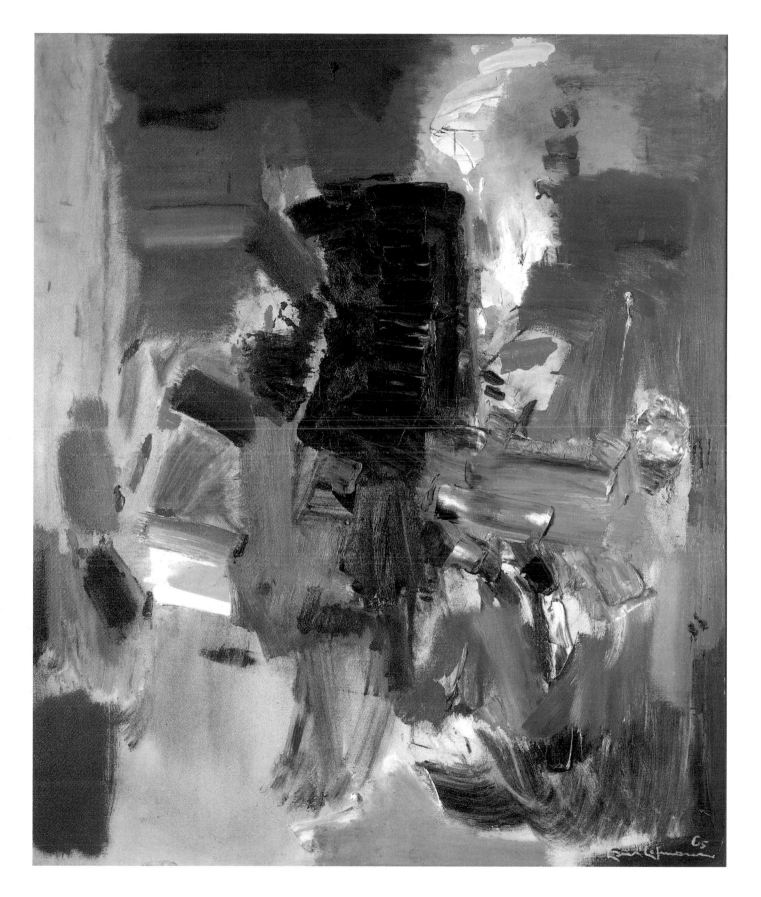

115. *Flaming Lava*, 1965. Oil on canvas, 72 × 60 (182.9 × 152.4). Private collection

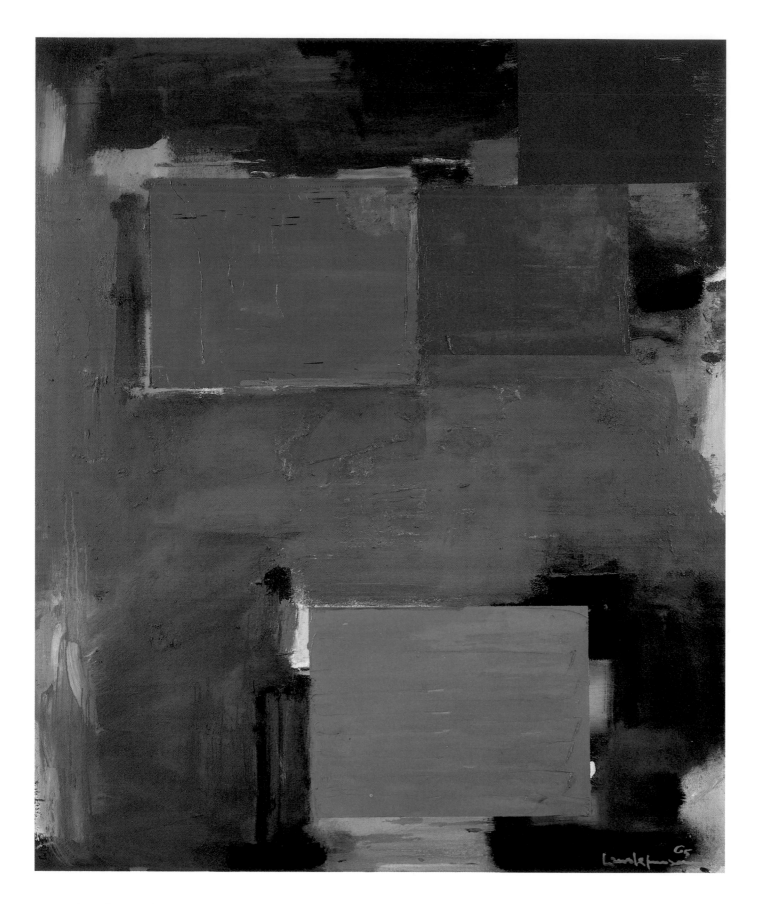

116. *Night Spell*, 1965. Oil on canvas, 72 × 60 (182.9 × 152.4). The Toledo Museum of Art; Gift of Edmund Drummond

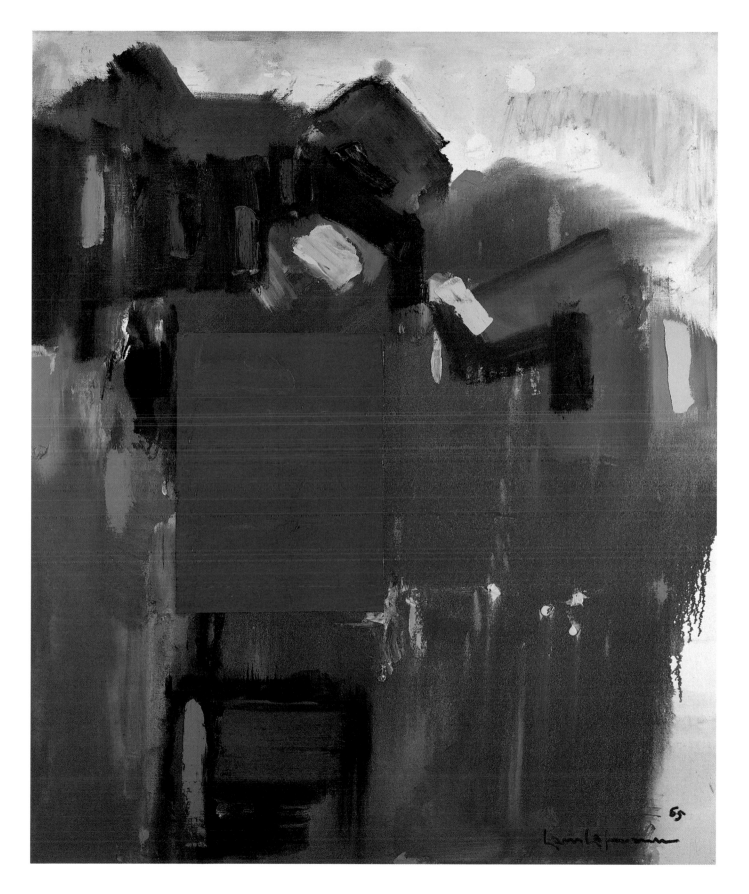

117. *Paling Moon*, 1965. Oil on canvas, 72 × 60 (182.9 × 152.4). Private collection

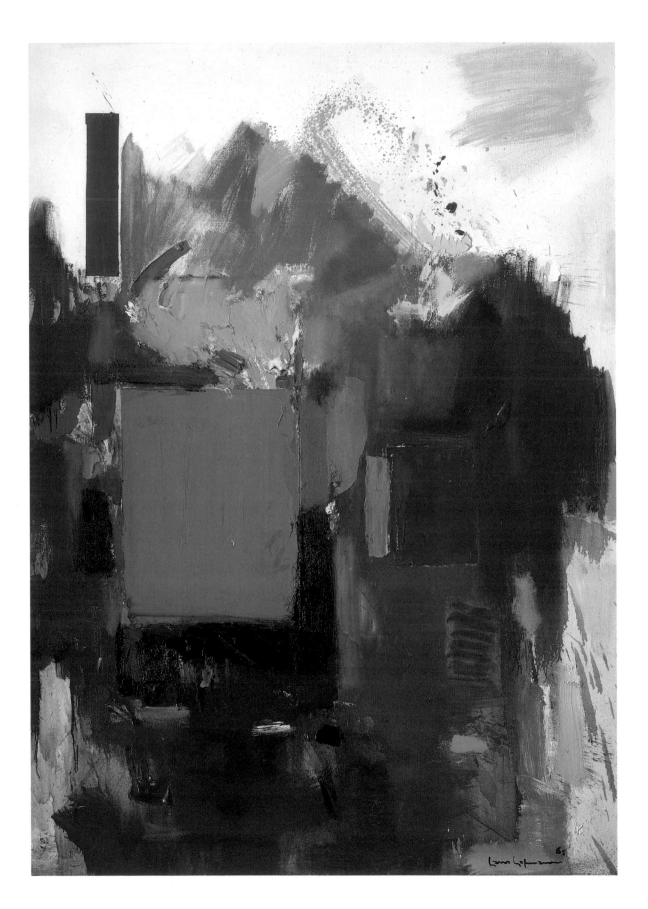

118. *Rapturious Smile*, 1965. Oil on canvas, 84 × 60 (213.4 × 152.4). Private collection

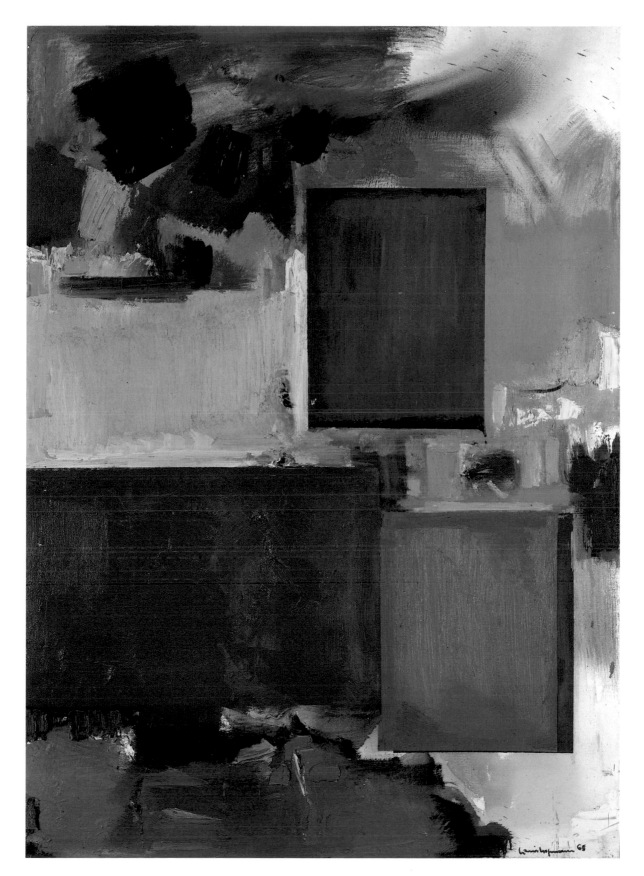

119. *Rhapsody*, 1965. Oil on canvas, 84½ × 60½ (214.6 × 153.7). The Metropolitan Museum of Art, New York;
Gift of Renate Hofmann, 1975

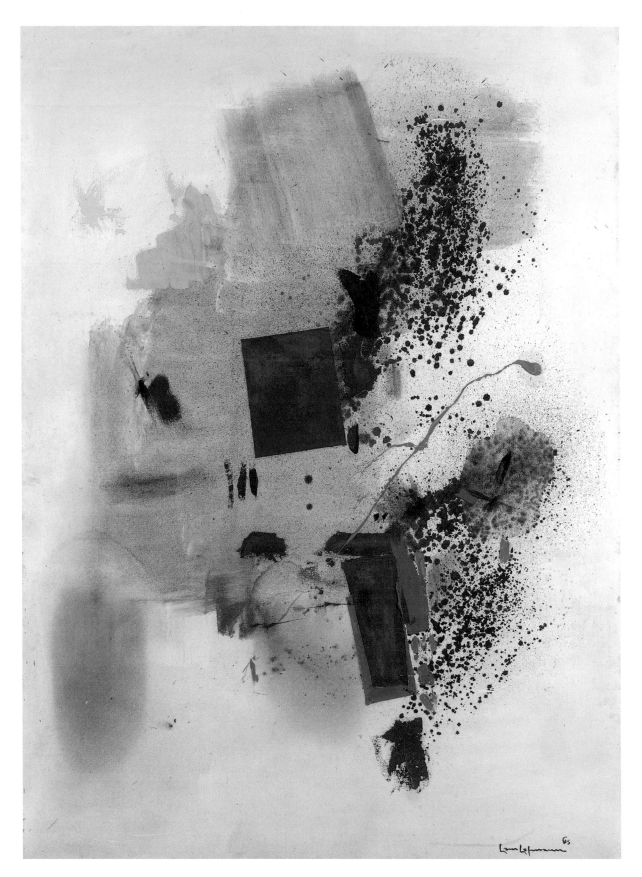

120. *Lust and Delight*, 1965. Oil on canvas, 84½ × 60¼ (214 × 153). The Metropolitan Museum of Art, New York; Promised gift of Renate Hofmann, 1975

Texts and Lectures by Hans Hofmann

This section presents eleven Hofmann texts and lectures, written over a period of thirty years. The majority are unpublished and retain Hofmann's characteristic spelling and style.

Statement, 1931

The formal elements of painting are: the line, the plane, volume and the resulting formal complexes. These are the elements of construction. The aim of art is to vitalize form.

The medium of expression is the picture plane, the means for its vitalization are color and light integrated into planes. Form develops its power through the creation of space unity. Color develops its power through the creation of light unity. The creation of space and light unity is in a certain sense synonymous. Light and space unity are identical with the essence of the picture plane. The essence of the picture plane is its two-dimensionality. It is possible, through the development of space and light unity to create three-dimensionality on this plane without destroying its essential two-dimensionality. The two-dimensionality of the picture plane is synonymous with the created space and light unity. We perceive this in the movement and tension relation of the form and in the movement and tension relation of the color which is expressed in intervals, complementary relations, contrasts and color complexes. From this the life of the composition becomes a spiritual unity.

My ideal is to form and to paint as Schubert sings his songs and as Beethoven creates a world in sounds. That is to say — the creation of one's own inner world through the same human and artistic

discipline. An inner sensation can find external expression only through a spiritual realization. When the impulses which emotionalize us are integrated with the medium of expression, every motivation of the soul can be translated into a spiritual motivation. This makes it necessary that the medium of expression be understood and mastered. A pictorial decorative arrangement is dictated only by taste. Pictorial homogeneity of the composition — plastic unity — is developed by lawfully governed inner necessities. From this derives the rhythm, the personal expression in the work.

Written in Berkeley, July 1931. Published in *Hans Hofmann*, exhibition catalogue (San Francisco: California Palace of the Legion of Honor, 1931).

creative teaching in the field of the plastic arts

Brochure, 1937–38

to avoid being academic a school of art must be a vital participant in contemporary aesthetics.

teaching which represents the renaissance tradition has deteriorated to a method of mere visual reproduction, where perspective, anatomy, dynamic symmetry and other scientific formulas have been placed as obstacles to the natural creative process of painting.

in america the general reaction against the academy has been toward an exclusive interest in subject matter and neglect of aesthetic considerations.

the aesthetic direction appeals to our sensibilities directly through the media of painting.

the organic elements of painting are the flatness of the surface used and its plastic medium, color. the pictorial development which retains the character of these elements in an equilibrium of volume and forces produces the plastic effect of "pictorial space."

"realistic space," that of the optical illusion, is contrary in its character to an instinctive use of the medium.

the emphasis today upon a concept of "pictorial space" in painting and of the instinctive approach to plastic creation, demands a correspondingly altered method of teaching.

a student's talent should be estimated by his instinctive faculty of plastic sensitivity: the power, when applied to the experience of nature, to penetrate the relationships of its colors, forms, weights, textures, etc.; in painting, a similar penetration of the pictorial elements in their plastic possibilities. as discerned from the more obvious ability to draw in

a facile way, this faculty should be encouraged and brought to consciousness.

it is therefore essential that the teacher have the capacity as an artist to demonstrate in a vital way the process of pictorial development, and the critical knowledge to clarify the student intellectually in his aesthetic concept.

in a sense, great art surpasses analysis. it affects us most profoundly through the spirit out of which it has evolved and through the expressive statement of the artist. however, it is equally necessary to discern its aesthetic quality: the form which gives to it its character of solidity as an object to be concrete and durable in the changing circumstances of time. from this aspect do we learn, and upon the understanding of this is built the progress of tradition.

Brochure, Hans Hofmann School of Fine Arts, New York, 1937–38.

Address, 1941

In every great epoch in painting there is always an indivisible relation between color and form. *This correlation between color and form is the plastic basis of painting.* Never was an epoch great through the presentation of a particular subject but rather in this: how such a subject matter was aesthetically presented.

The mutual dependency of form and color has a Life *of its own* — it is

pictorial Life.

A painting that does not fulfill this aesthetic necessity is rather everything else but painting. Modern art differs from the art of the past in its conception as well as in its means of execution. The artist of the past *copied* physical Life and used arms and legs and heads as means to give his work the appearance of Life. The modern artist uses the elements of construction to create pictorial reality: he creates pictorial Life.

Abstract art is, in my opinion, the return to a professional consciousness — a consciousness which controls the emotional accumulations in the process of creation. Such a control is only possible within the limitation of the medium of expression. I think there cannot be doubt that every artist attempts to say what he has to say, and he will say it within the limitation of his personality. Every art expression is rooted fundamentally in the personality and in the temperament of the artist.

It is in conformity with this temperament and in conformity with the accumulation of experience which he has gained through his work, that he uses his means of expression — when he is of a more lyrical

nature his work will have a more lyrical and poetical quality; when he is of a more violent nature his work will express this in a more dramatic sense.

Think of Renoir or of Seurat or Klee — they are lyrical; whereas Picasso or Greco or Rembrandt are dramatic. No artist can go away from his nature.

Every work of art is aesthetically a failure when it is not executed on a plastic basis. But besides the plastic qualities there exists another quality of equal importance — it forms finally the psychological content of the work. In the world of forms and shapes as well as in the world of colors, and in the correlation of these elements exists the faculty of attraction and repulsion — of sympathy and antipathy. It is a psychological effect which we cannot resist. And the artist's sensibility uses this effect on us to give his work a supernatural Life that surpasses the limit of construction and calculation. A work of art stays high over every construction and calculation. I consider, for this very reason, every theory in art not of much value.

There are as many possibilities in every medium of expression as there are creative artists. Abstract art does not however exclude representation — as long as the representation is the result of the functions and of the activities of the means of expression. We witness this and we admire this in the old masters.

A plastic work has always, however, a decorative quality, but not every decorative work has a plastic quality. There are therefore two kinds of decorative qualities. The one, which I call negative, is without a pictorial substance. The other which I call positive, *is* pictorial substance. The one — which is negative — furnishes only a flat pattern in design as well as in color.

The other — which is positive — is not only the effect of the resulting tensions in the correlation between form and color but the result of the *relationship under* the created tensions. It provides the work with the technical quality of volume and of translucence and further- more with the technical quality of expansion and contraction.

This is painting in the highest sense of the word and only a few artists ever have reached this high. Cézanne, Renoir, Matisse, Miró — the later Picassos a.s.o. I call this kind of painting

symphonic painting.

In it the plastic quality is finally absorbed in the psychological effect of the work. The final psychological effect may be:

voluptuousness (Renoir)

sensuality (Miró)

transfiguration (Picasso's la Guernica)

A decorative painting — and I mean this in a positive sense — has always the technical effect of flatness with a final psychological effect of restfulness and majesty.

This does not mean that such paintings do not have pictorial life — *but rather the opposite* — it is the type of painting that belongs on the walls of our buildings. I consider Léger and Mondrian the greatest mural painters of our time.

May I resume my statement in this:

Every creative arist works continually to penetrate the mysteries of creation.

There are not established standards or rules which could help him.

He must avoid borrowing from other artists.

He must always further develop his sensibilities.

He must doubt his best results that he may not be handicapped from such results or from outside admiration.

He must work and always work — on himself and on his craft — that he may develop to the point where he can say what he has to say, and that he says this in his own language.

This language is of course not always at once understood. It makes people furious when you speak your own language.

Ladies and Gentlemen, I thank you.

Address delivered on February 16, 1941, at the Riverside Museum, New York, at a symposium on abstract art held during the 1941 American Abstract Artists exhibition.

Letter, 1944

Space and the Picture

One cannot see space
one can only sense space —
Since one cannot see space
one can also not copy space
and since one senses space
 only
one must invent "the" pictorial
 space
as the finale of a pictorial
 creation.
Therefore one must be inventive
 in using the pictorial means.
the lines, the planes, the points
these are the architectural means
with which to build space as
 experienced
experienced by the senses
and not only perceived by
 physical vision
because vision and space experience
 together
create an "inner vision"
in the junction
 of a multiple physical
 experience
with a physical reaction

Letter to Alice Hodges and Lillian Kiesler, August 19, 1944, private collection.

I consider it part of my artistic responsibility to help, support and encourage always all that is young, vital, progressive and honest. This is the reason why I am part of this Forum.

I feel that Provincetown as an art center must revive its tradition created by some powerful artists in the past. Traditions must be kept alive — traditions must not end in self-contentment. This is another reason why this Forum came into existence.

All great things came into existence through struggle and fight. All that is alive is alive through continued struggle and fight. We — the elder — are the Fathers of the youth — but it is the youth in demanding a rightful place among us that keeps us young and alive. This Forum came into existence to give the youth this place.

Let us not forget the tragic past of the cultural pioneers of modern art in America. They have been badly neglected, misunderstood, ridiculed and maliciously persecuted either as charlatans or as fools or as communists to the extent of a final personal catastrophe to the artist for many of them, and to a near cultural catastrophe for this country.

In the future this shall never happen again. It shall not happen to the younger generation of this country, whom I know to be so well equipped with great promise for the future.

What is an artist? is the theme of the evening.

Well, I don't know what an artist is — but I know what makes an artist: I do know that only the man equipped with creative instincts and a searching mind is destined to become an artist. As an artist I do know that only the highest exaltation of the soul will enable the artist to transform the deepest and the weightiest of his experiences into a new dimension of the spirit that is art.

Creation is a mystery, and so is the artist in the act of creation.

Every great work is a new reality — but it is the life's work of an artist that creates a new dimension of the spirit. The life's work of an artist is "the work of art...." It includes the whole behavior of the man, his ethical standards, and his awareness of his creative responsibilities.

Talent is everywhere — it does not make the artist. It is often a handicap because it invites cleverness, which always chooses the easier side of life.

André Malraux says: "Only sensitivity achieves creativeness." I feel inclined to expand this by saying: "Only *conscious* sensitivity achieves great art."

Quality must be conquered. And I mean by quality that which carries a message; in painting this must be a plastic message.

I said: quality must be conquered. It asks for struggle — it often means despair — it asks for character.

I do not believe that any political or religious standing has anything to do with art, either directly or indirectly. Any ideology that has dominated the human mind in the past has always produced good and bad art. Only Quality, in the sense I have here defined it, conveys and convinces. In any other way it is just not Quality.

A society's vital beliefs will certainly leave its mark on the artist. This mark will be deeply imbedded in his art — not in the sense of propaganda, but in the sense of his awareness of his *cultural mission.*

Modern art is exactly the opposite of what it lately has been officially accused of being. Modern art is the symbol of our democracy. It is the privilege of a democracy like ours to expect the artist, through his art, to be the personification of its fundamental principle by giving the highest example of spiritual freedom in the perfomance of *"unconditioned, unrestricted creativeness."*

Ideas must be steadily reborn. Unconditioned creativeness is its prerequisite.

Our Constitution is a great work of art; it must not be destroyed by mediocrity. Let the youth of America speak. Let a free press and a creative critic speak. Long live the arts and the artist in a free future.

"What Is An Artist?," address given at "Forum '49," July 3, 1949, Provincetown.

Statement, 1951

The object in the visual arts — its function in three-dimensional reality and its two-dimensional pictorial realization.

Cézanne has said once: it has taken him forty years to discover that painting is not sculpture. One may still say today that modern art has not yet digested the fundamental problems of pictorial creation in its entirety. All attempts so far to go unrestrictedly to the roots of the problem have yielded only sophisticated fragmentations, each one of them on a very high esthetical level. This fragmentation characterizes our entire time. We put tens of thousands of mechanical parts together to create living mechanical wonders. The multi-expression of modern art confirms only the immensity of all the problems involved in pictorial creation. It is understandable that in earlier times the great discovery of the old masters has been buried in the convents in great secret. The Twentieth Century Artist *does the opposite* — he has used the broom of good reasoning to liberate the arts of all the coagulated wisdom of the Academy. It started with the dethroning of the object by the Impressionists. The tyranny of its synthesis has obscured and tortured the minds of centuries. Considered only as what it really is — it lost its

significance of being itself a creator of highest order solely in its reflection of its environment. It must be categorically emphasized: the object is a creator itself. Beside its characteristic and its psychological function, it enlivens space — it creates all *its rhythmic wonder and (in total) the unbelievable beauty of space*. Space lives from the object which is space … just as every form of life lives from life. In recognizing its creative function the modern artist by no means destroys the object, but on the contrary sublimates it through subordination and integration into the higher form — of a compositoric entity given by *the esthetic form in which every genuine work exists*. The object can never create a work of art without the demand of such a higher sublimation, whereas an esthetic form can exist without any object solely through the animation of the pictorial means. This is the reason for non-objective art. It is primarily the animation of the pictorial means — not the animation of the object — *that leads into pictorial over-all animation*. The pictorial realization and animation of an object will result from a step by step development of such an over-all animation, wherein the final plastic and psychological realization of the object represents the logical *finale* of the creation.

We differentiate today between form in a biological sense, which concerns the object, and between form in an esthetic sense, in which the work exists spiritually as a work of art. The first concerns the physical logic of the object — the other is a form which is exclusively created by the mind. The merging of both is documented in all the great works of the old masters. Only Matisse, Picasso and Braque, each of them in his own way, and a few others have mastered this mammoth problem.

It is still not yet generally recognized that the picture surface answers the animation of a plastic impulse automatically with a plastic counter-impulse. That means the automatic reaction of the picture surface of pictorial animation is dominated by inherent laws which *respond* plastically with highest precision to such animation. It is for this reason possible to generate forces on such a surface which respond to each other not only with greatest exactitude in the sense of push and pull, but furthermore and with the same exactitude in the sense of intensity and speed with which to vary depth penetration as well as its answering counter-echo. *Only from the varied counterplay of push and pull and from its variation in intensities will plastic creation result.* Let us repeat that the object is a space-creator. Considered as such, it is a source of highest inspiration for plastic creation. But to be of use for pictorial animation the object, or, in short, the model must be broken down into spatial fragments. These fragments must be further considered in their function not only in relation to the object, but predominantly in

relation to the spatial totality in the frame of which the object is only a subordinated part. It is therefore not a consciousness of the synthesis of the object that should primarily dominate the creation, *but a consciousness of the synthesis of the spatial totality* should consider the object as an integrated part of it. It is out of the pictorial realization of spatial totality that the image of the object should finally "emerge." It should be the confirmation as the "finale" of the creation.

In breaking down the spatial totality into spatial fragments this fragmentation assimilates itself with the pictorial means: points and lines and planes a.s.o., to serve pictorial necessities in the creation of pure plastic form which is given only *through identity of form and content*. Spatial synthesis is *a priori* given in the picture surface — its synthesis should never be broken throughout the whole pictorial development, but its synthesis can be transformed by subdivision into the infinite. The beauty of space is finally presented *in the rhythmic relation* of all parts involved within the meaning of its pictorial functions. It is only through step by step development that the transfiguration of plastic experience into the plastic realisation on the picture surface takes hold. Simplification of spatial totality under consideration of the Essentual and Elimination of the unessential — an art in itself — leads to abstraction. Objective consideration must be subordinated.

Plastic creation asks for feeling into the essentuality of nature as well as for feeling into the essentuality of the nature of the medium of expression. The plastic experience gained by the former must be transformed into the plastic language of the other. Nature cannot be copied. A continued counter-balancing from one feeling-aspect into another determines the quality of the work. *It involves the whole sensitivity and the temperament of the artist.*

The foregoing findings deal only with the formal problems of composition. Painting involves color — but the color problem is also to a great extent a formal problem, in the way in which color is placed on the picture plane. Color has the faculty to create volume and luminosity. Volume is a dimension — a dimension in and out of depth. Every difference in color shade produces a difference of speed in depth penetration. In hand with it goes its luminosity, which is not so much presented in the color shades as in the relation of corresponding color shades: corresponding either by contrast or harmony and through differences of intensity or by dissonance as simultaneous rendering. Colors correspond in the form of intervals: in seconds, thirds, fourths, fifths a.s.o., as music does. This faculty makes color a plastic means of first order. The way that colors are related can create drama, poetry, lust, pain, pleasure, ache a.s.o. Color development follows its own laws. The color development is not necessarily the same as the formal development. Independent

as it is, it overlaps however perfectly with the formal development of the composition. Objective presentation arrives finally exclusively only from the color development. And it is not form, in the sense of the physical logic of the object, that determines the development of color, but it is on the contrary the color development under consideration of pictorial laws that determines integrated objective form. This is painting! Objective form and also esthetic form *not* arrived at through the fire and blood of the color — or not arrived at through the demand of integration, is only design. It is decor and ornamentation and belongs, as such, in the realm of applied art — not painting.

New York, May 1, 1951, typescript, estate of the artist.

Space pictorially realized through the intrinsic faculty of the colors to express volume

Statement, 1951

Only a plastic statement on the picture surface that has resulted from a strictly spatial experience from nature, and from the automatic response of the picture surface in answer to its plastic animation, can be considered "absolute" in the sense that it will permit the use of unbroken pure colors. This binds the colors from the beginning to a formal problem, in the way in which color is compositionally placed and formally measured on the canvas by shading and size.

A pure color can be any mixture of color as long as such a mixture is handled flat and unbroken, so that the totality of its formal extension offers only one color shade and with it only one light-meaning. By this I mean, as long as the area that is given to the color or the shape in which the color exists is not shaded down in a multitude of different light values as the Impressionists did. (This dissolves the areas or the shapes.) By relation with other colors, the aspect of such a pure color mixture becomes translucent by suggesting depth penetration and with it volume of varied degree. The suggested volume will be the exact plastic equivalent that the color is intended to present, to counteract its formal placement in the necessary compositoric attempt to re-establish two-dimensionality. *In other words any color shade must be in the volume that it suggested, the exact plastic equivalent of its formal placement within the composition.* The depth meaning (volume suggestion) inherent in any color shade is therefore in direct dependency from its compositoric placement. The impressionistic method leads into a complete splitting and dissolution of all areas involved in the composition, and color is used to create an overall effect of light. The color

is, through such a shading down from the highest light in the deepest shadows, sacrificed and degraded to a black — and with function. This leads to the destruction of the color as color. To understand this, one must be clear that any light value can be brought to expression through thousands of different color shades. Such a handling of colors leads to an overall effect, but to an overall effect that destroys the *intervalle* and contrast-faculty of the colors. The *intervalle* faculty makes the color a plastic means of first order. The consequence in the lack of such a conception is that all pictures handled in this way present themselves in a similar overall tonality. It was Cézanne who said at the end of his long search for pictorial truth: "All lies in the contrast." He obviously meant to say, as far as color is concerned: "The finest color shades offer powerful contrasts." We find his statement documented: in the Icons, in Cimabue, in Giotto and in Fra Angelico — in Matisse and in Miró and in all work where color is understood in the psychological rapport and *intervalle* capacity which they offer.

The effect of this capacity is mystic. *Mystic expression in the plastic arts stems mainly from the psychological rapport capacity of the colors.* The mystic quality of the colors will come, however, to appearance only in relation to a strict mastery of the colors within the composition through the placement of the colors. — It concerns predominantly the formal handling of the color. Color must not be enslaved into a function foreign to its intrinsic faculties. — When mutually related, everything makes its mark on another thing. So do colors. They influence each other considerably in a psychological sense, as shapes do. — A different color shade gives the same shape another psychological meaning. Difference in plastic or spatial placement (composition) causes any color or shape or color-shape to change completely in psychological expression. This explains the magic of painting.

Statement in *Hans Hofmann: New Paintings,* exhibition catalogue (New York: Kootz Gallery, 1951).

Statement, 1952

I develop two styles in painting. Neither, however, differs conceptionally from the other; they differ in approach and technicalities.

An artist's concept is basically given in his whole outlook to the world and in the consciousness of his professional responsibilities. The subject has only an initiating function to be restless, absorbed by the personality of the artist — as such it will determine the whole creative process.

I have devoted my whole life to the search of the Real in painting. I never believed in an academic training — I had none. My instinct told me that I must find everything within myself when it is intended to become significant for the whole spread of my own development. I was privileged to be brought up in a highly artistic environment. I love beautiful things not for want's sake — but they inspire me to create them myself. To me they have the capacity of emanating a mystery power that is able to hold the mind under the spell of ecstasy.

Art is to me the glorification of the human spirit and as such it is the cultural documentation of the time in which it is produced. The deeper sense of all art is obviously to hold the human spirit in a state of eternal rejuvenescence in answer to an ever-changing world. Art is an agent destined to counter-balance the burdensomeness of everyday life — it should provide constant esthetic enjoyment.

I still make the difference between Fine and Applied Art and between art in general. The difference is revealed in the creation of quality through which the created image becomes self-evident. Quality results in every instance from a creative act. I make further the distinction between easel and mural painting. Easel painting is to me a symphonic art; the mural is predominantly a decorative art and asks for simplification (but it must not deteriorate into a poster-art).

There is a difference between "decorative" and "decoration." Decoration is based on design. Design in the usual sense results from taste only. *Taste is not a creative faculty.* The function of design is ornamentation. As such it is either art or it is not. When it is art it offers quality; when it is not art — it does not. To be truly decorative presumes the *faculty of plastic and esthetic creativeness*. A decorative work is basically always a plastic work of art. It is *de facto* two-dimensional but in "suggestion" three-dimensional; in other words it is *eo-ipso* — three-dimensional in concept and *de facto* two-dimensional in execution. Design that does not result from plastic and esthetic experience will only produce empty flatness — especially when it is further devoid of some other spirited revelation. This is then bad design. There is good and there is bad design. Good design has a life of its own. Bad design is lifeless and monotonous. By strictly limiting the meaning of the word design to its *de facto* meaning we are further induced to make a strict and sharp differentiation between design and plastic creation.

Mural and easel painting must be, further, differently approached as far as color is concerned. In a mural, color is to be simplified to its decorative purpose. A too rich overcast in tonal transition would destroy the attempted decorative effect. It would destroy the contrast faculties of the color. In a mural, color should be handled flat over huge expanded areas in a simultaneous way by which the picture sur-

face will be kept in a constant pictorial balance. This will occur when colors answer each other in the combine of their plastic and psychological rapport capacity which they offer. This emanating capacity of the color depends a great deal on the formal placement of the colors within the composition, and from the creation of varied intervals that makes the color a plastic means of first order. The easel painting asks for greater intimacy. It is in character more lyrical and it asks therefore for a richer orchestration. Basically it must be flat like the mural. But the flatness must become the expression of volume — it must be the end-product of an immense accumulation of intrinsic values which have conditioned each other esthetically in a step-by-step development to summarize finally in the creation of this all-dominating singular luminous and translucent volume that is to make the spatial totality and monumentality of the picture. Only this I consider "cultivated" painting.

I have said that I develop two styles — a decorative one and a highly symphonic one. Besides these, I work as I please, by heart or from Nature. My sense of independence does not permit me to commit myself to any retarded or advanced method. There is in reality no such thing as modern art. Art is carried on up and down in immense cycles through centuries and civilizations. No choice is given us. Goethe says *"the wave that lifts us will finally swallow us."* It is our destination and the destination of every culture.

Statement in *Hans Hofmann*, exhibition catalogue (New York: Kootz Gallery, 1952).

Statement, 1956

The creative process: its physical and metaphysical performing
In my own way of search as artist, the universe seems to be a will-directed magnetic entity with all life embedded in it. It is figuratively speaking, a vast ocean that holds the sum total of all energy and the potentiality of all forces. The sum total being gravity. Forces come into being through compensation arrived at by level — intensity — and tensional differentiation either toward a static magnetic overall level or through compensation by existing level — or other differentiation within the inherent nature in a given medium. The compensation becomes in this way the *"dynamic* source of all" free energy. Free energy may condensate either into substance by expansion or contraction or in time — and space demanding movement and rhythm. Viewed in this way "time and space" are both either *"consumed" energy (in the past) or "consume-demanding" energy (in the future)*. Past and *future* keeps the cosmos in a constant but balanced state of expansion and contraction.

Still we do not yet know the origin that initiated the impulse and its self-sustaining and reproductive capacity that is life … how the phenomena of flesh and blood came to be, or a thinking and sensing mind. We know only the creative physical facts whereby a positive produces a negative — a high a low, a right a left — a push a pull and vice versa. All optical phenomena are the result of complimentary compensation. Here we seem to be given an analogy between the universal laws and our creative mind. Our creative capacity sees itself mirrored in these laws. We are actively interwoven in it and so are our creative means. A picture is in the same way a universe — it holds its own life and mirrors a mind and a soul. Within all these laws seem to be a *directing will* and we are also directed by this will — this will is *the urge* to create — it is a cosmic will that determines all creation.

January 12, 1956, typescript, estate of the artist.

Statement, 1956

A reply to the demand to name some of my students who have come into prominence

I never have considered myself the founder of a particular school. I am not a teacher in the usual sense. I am a painter who had to teach for his livelihood to assure artistic independence. In this function I became the initiator and disseminator of certain creative ideas that have contributed to the cultural evolution of our time. My very inmost thoughts hold in my opinion the key to many schools — past, present and of the future. I enjoy the wrong reputation that I love to teach. What I love really in the function as a teacher is the steady contact with new possibilities in the future — with new generations. Because teaching is not really a vocation on my part, I made teaching the greatest pleasure for myself by giving myself completely as artist and human being determined to investigate and to clarify the mysteries of the creative process. It never makes any difference to me if a work brought before me is of greater or minor quality; it offers always the substance on which to demonstrate the creative process and this under consideration of individuality and temperament. This seemingly heterogeneous professional attitude has built up my reputation as artist and teacher. I have students all over the world — many thousands of them who have become ambassadors for the spread of my basic ideas, and every one of them is doing it in his own individual way. This makes it impossible for me to name any one person — it would not be ethical. No one can make an artist and I do not claim the "qualité d'auteur" for any one of them.…

January 25, 1956, typescript, estate of the artist.

Statement, 1963

The way we see: analysis of eyesight in relation to physical experience of nature

Analysis of eyesight goes hand in hand with our visual relation to nature. We must therefore understand nature's function in regard to visual experience.

Nature surrounds us unlimited in every direction. We may proudly consider ourselves as her middle point — the middle point of unlimited space.

Unlimited space is three-dimensional. Appearance is two-dimensional.

We have, however, learned through experiences of all our other senses to interpret appearance as a three-dimensional Reality. Nature has equipped us with eyes which have a horizontal common axis and everything we see has a related and very distinct movement to it.

This axis is constantly on our mind and acts magnet-like in respect to plastic analysis of vision. Our eye axis is also identical with the horizontal axis of appearance and with the horizontal axis of the picture plane.

Everything in the outer world is related to it in position, movement, rhythm, depth projection, colour, light, etc.

The relation of unlimited Reality and all that she visually offers in relation to our eye axis is the reason for coming into being of a visual phenomenon which I call Push and Pull.

Push and Pull is a colloquial expression applied for movement experienced in nature or created on the picture surface to detect the counterplay of movement in and out of the depth. Depth perception in nature and depth creation on the picture-surface is the crucial problem in pictorial creation. Nature as well as the picture plane have each its own intrinsic laws which are dissimilar but do in fact *not* refuse to compensate each other when handled by a creative mind.

"The Painter and His Problems: A Manual Dedicated to Painting," 1963, typescript, estate of the artist.

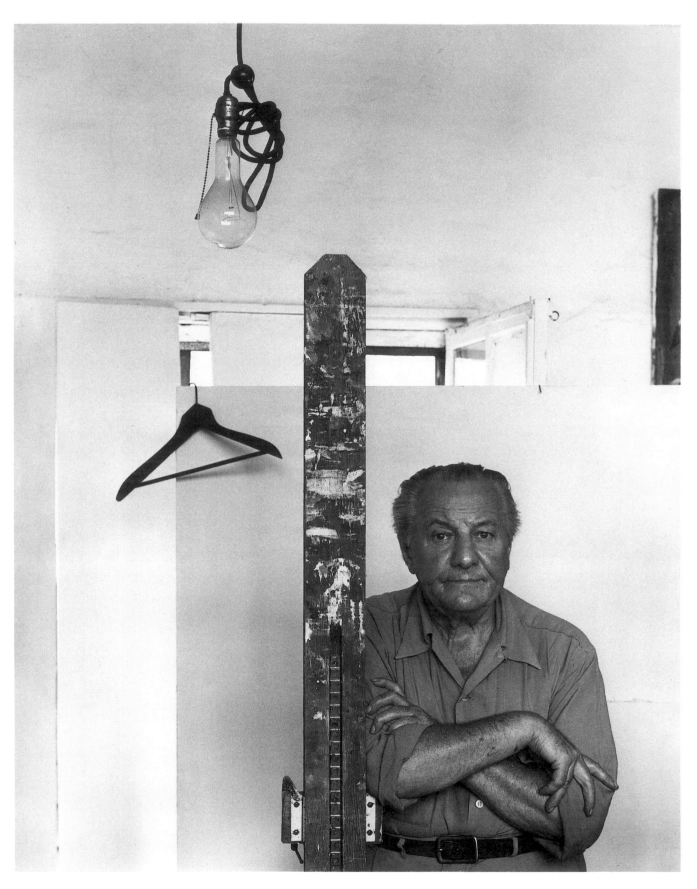

Hans Hofmann, 1952. Photograph by Arnold Newman.

Selected One-Artist
Exhibitions

1910

Paul Cassirer Gallery, Berlin.

1931

University of California, Berkeley, July.

California Palace of the Legion of Honor, San Francisco, August.

1941

"Hans Hofmann," Isaac Delgado Museum of Art, New Orleans, March.

1944

"First Exhibition: Hans Hofmann," Art of This Century, New York, March 7–31.

"Hans Hofmann: Paintings, 1941–1944," Arts Club of Chicago, November 3–25.

1945

"Hans Hofmann," Milwaukee Art Institute, January 1–14.

"Hans Hofmann," 67 Gallery, New York, April.

1946

"Hans Hofmann," Mortimer Brandt Gallery, New York, March 18–30.

"Hans Hofmann," American Contemporary Gallery, Hollywood, May.

1947

"Hans Hofmann: Space Paintings," Art Department of the Texas State College for Women, Denton, March 6–April 3.

"Hans Hofmann," Betty Parsons Gallery, New York, March 24–April 12.

"Hans Hofmann," Kootz Gallery, New York, November 23–December 13.

"Hans Hofmann," Pittsburgh Arts and Crafts Center and Abstract Group of Pittsburgh, December 20–January 11, 1948.

1948

"Hans Hofmann," Addison Gallery of American Art, Phillips Academy, Andover, Massachusetts, January 2–February 22.

1949

"Hans Hofmann," Galerie Maeght, Paris, January.

"Hans Hofmann: Recent Paintings," Kootz Gallery, New York, November 15–December 5.

1950

"Hans Hofmann: New Paintings," Kootz Gallery, New York, October 24–November 13.

1951

"Hans Hofmann: New Paintings," Kootz Gallery, New York, November 13–December 1.

1952

"Hans Hofmann," Kootz Gallery, New York, October 28–November 22.

1953

"Hans Hofmann: Landscapes, 1936–39," Kootz Gallery, New York, April 27–May 30.

"Hans Hofmann," Kootz Gallery, Provincetown, Massachusetts, summer.

"Hans Hofmann: New Paintings," Kootz Gallery, New York, November 16–December 12.

1954

"Hans Hofmann," Kootz Gallery, Provincetown, summer.

"Paintings by Hans Hofmann," The Baltimore Museum of Art, October 5–November 21.

"Hans Hofmann: New Paintings," Kootz Gallery, New York, November 15–December 11.

1955

"Hans Hofmann," Bennington College, Bennington, Vermont, May.

"Hans Hofmann," Kootz Gallery, New York, November 7–December 3.

1956

"Hans Hofmann," Art Alliance, Philadelphia, March.

1957

"Hans Hofmann: New Paintings," Kootz Gallery, New York, January 7–26.

"Hans Hofmann Retrospective Exhibition," Whitney Museum of American Art, New York, April 24–June 15, in association with the Art Galleries of the University of California, Los Angeles (traveled).

1958

"Hans Hofmann: New Paintings," Kootz Gallery, New York, January 7–25.

1959

"Hans Hofmann: Paintings of 1958," Kootz Gallery, New York, January 6–17.

"Hans Hofmann: Early Paintings," Kootz Gallery, New York, January 20–31.

1960

"Hans Hofmann: Paintings of 1959," Kootz Gallery, New York, January 5–23.

1961

"Hans Hofmann," Kootz Gallery, New York, March 7–25.

1962

"Hans Hofmann: New Paintings," Kootz Gallery, New York, January 2–20.

"Hans Hofmann," Frankische Galerie am Marientor, Nuremberg, March (traveled).

"Oils on Paper, 1961–1962," Neue Galerie im Künstlerhaus, Munich, March.

"Paintings by Hans Hofmann," Hopkins Center, Dartmouth College, Hanover, New Hampshire, November 8–30.

1963

"Paintings by Hans Hofmann," Santa Barbara Museum of Art, California, February 1–24.

"Hans Hofmann: New Paintings," Kootz Gallery, New York, March 5–23.

"Oils on Paper," Galerie Anderson-Mayer, Paris, April 23–May 18.

"Hans Hofmann," The Museum of Modern Art, New York, September 11–November 28 (traveled).

1964

"Hans Hofmann: Paintings, 1963," Kootz Gallery, New York, February 18–March 7.

"Hans Hofmann: Oils," American Art Gallery, Copenhagen, April 18–May 9.

"Recent Gifts and Loans of Paintings by Hans Hofmann," Worth Ryder Art Gallery, University of California, Berkeley, May 11–June 7.

1965

"Hans Hofmann, 85th Anniversary: Paintings of 1964," Kootz Gallery, New York, February 16–March 6.

1966

"Hans Hofmann," Kootz Gallery, New York, February 1–26.

"Hans Hofmann: 21 Paintings," Stanford Art Museum, Stanford University, June 22–August 17.

1967

"Hans Hofmann," André Emmerich Gallery, New York, January 21–February 9.

1968

"Hans Hofmann," André Emmerich Gallery, New York, January 6–31.

"Hans Hofmann: Paintings," Richard Gray Gallery, Chicago, January 31–March 2.

"21 Hofmanns from Berkeley," Honolulu Academy of the Arts, March 29–May 5.

"Paintings by Hans Hofmann," La Jolla Museum of Art, La Jolla, California, May 25–June 30.

1969

"Hans Hofmann: Ten Major Works," André Emmerich Gallery, New York, January 11–30.

"Hans Hofmann," David Mirvish Gallery, Toronto, March 22–April 15.

1970

"Hans Hofmann: Paintings of the 40s, 50s and 60s," André Emmerich Gallery, New York, January 3–22.

"Hans Hofmann: Paintings," Waddington Galleries II, London, June 9–July 4.

1971

"Hans Hofmann," André Emmerich Gallery, New York, January 9–February 3.

1972

"Hans Hofmann," André Emmerich Gallery, New York, January 8–27.

"Hans Hofmann: Paintings," Richard Gray Gallery, Chicago, February.

"Hans Hofmann," David Mirvish Gallery, Toronto, spring.

"Hans Hofmann: The Renate Series," The Metropolitan Museum of Art, New York, October 16–December 31.

"Hans Hofmann," Janie C. Lee Gallery, Dallas, December.

1973

"Hans Hofmann: 10 Major Works," André Emmerich Gallery, New York, January 6–24.

"Hans Hofmann: Works on Paper," David Mirvish Gallery, Toronto, January 13–February 10.

"Hans Hofmann: Works on Paper," André Emmerich Gallery, New York, September 15–October 11.

"Hans Hofmann: 52 Works on Paper," circulated by the International Exhibitions Foundation, October 1973–December 1975.

1974

"Hans Hofmann: Paintings, 1936–1940," André Emmerich Gallery, New York, January 5–24.

"Hans Hofmann: A Colorist in Black and White," circulated in the United States by the International Exhibitions Foundation, October 1974–1977.

1975

"Hans Hofmann: 108 Works," Bowers Museum, Santa Ana, California, April 15–May 15.

"Hans Hofmann: A Selection of Late Paintings," André Emmerich Gallery, New York, May 17–June 17.

1976

"Hans Hofmann: The Years 1947–1952," André Emmerich Gallery, New York, April.

"Hans Hofmann: A Retrospective Exhibition," Hirshhorn Museum and Sculpture Garden, Smithsonian Institution, Washington, D.C., October 14–January 2, 1977, and The Museum of Fine Arts, Houston, February 4–April 2, 1977.

1977

"Provincetown Landscapes," André Emmerich Gallery, New York, January 8–26.

"Hans Hofmann." David Mirvish Gallery, Toronto.

1978

"Hans Hofmann: Drawings, 1930–1944," André Emmerich Gallery, New York, December 10–January 11, 1979.

1979

"Hans Hofmann: Provincetown Landscapes, 1941–1943," André Emmerich Gallery, New York, January 6–31.

"Hans Hofmann Drawings," Harriman College, Harriman, New York, April 25–May 1.

"Hans Hofmann: Works on Paper," Marianne Friedland Gallery, Toronto, November 3–24.

1980

"Hans Hofmann: Private-Scale Paintings," André Emmerich Gallery, New York, January 12–February 6.

"Hans Hofmann: Provincetown Scenes" (shown jointly with "Hans Hofmann as Teacher: Drawings by His Students"), Provincetown Art Association, Provincetown, Massachusetts, August 1–October 12.

"Hans Hofmann: The Renate Series," The Metropolitan Museum of Art, New York, December 2–January 31, 1981.

"Hans Hofmann, Centennial Celebration, Part I: Major Paintings," André Emmerich Gallery, New York, December 13–January 13, 1981.

1981

"Hans Hofmann, Centennial Celebration, Part II: Works on Paper," André Emmerich Gallery, New York, January 17–February 14.

"Hans Hofmann: Major Paintings and Works on Paper," Marianne Friedland Gallery, Toronto, April.

1982

"Hans Hofmann: The Late Small Paintings," André Emmerich Gallery, New York, January 7–January 30.

"The Drawings of Hans Hofmann," Marianne Friedland Gallery, Toronto, March 6–30.

"Hans Hofmann, 1880–1966: An Introduction to His Paintings," The Edmonton Art Gallery, Alberta, July 9–September 5.

1983

"Hans Hofmann: Paintings on Paper, 1958–1965," André Emmerich Gallery, New York, January 6–29.

1984

"Hans Hofmann: Explorations of Major Themes: Pictures on Paper, 1940–1950," André Emmerich Gallery, New York, January 7–February 4.

"Hans Hofmann: The Early Interiors, the Late Abstractions, Major Paintings," Marianne Friedland Gallery, Toronto, March 31–May 5.

1985

"Major Paintings," André Emmerich Gallery, New York, January 5–26.

"Hans Hofmann" and "Hans Hofmann: The Renate Series," Fort Worth Art Museum, September 15–November 17.

1986

"Hans Hofmann: Pictures of Summer, Provincetown 1941–42," André Emmerich Gallery, New York, January 8–February 8.

1987

"Hans Hofmann: The Pre-War Years in America," André Emmerich Gallery, New York, January 9–February 7.

"Hans Hofmann: The Push and Pull of Cubism," André Emmerich Gallery, New York, December 23–January 23, 1988.

1988

"Hans Hofmann: Late Paintings," The Tate Gallery, London, March 2–May 1.

1989

"Hans Hofmann: The Post-War Years, 1945–1949," André Emmerich Gallery, New York, January 12–February 18.

Selected Bibliography

Interviews, Statements, and Writings

The Search for the Real and Other Essays, eds. Bartlett H. Hayes, Jr., and Sara T. Weeks. Andover, Massachusetts: Addison Gallery of American Art, 1948. Reprint, Cambridge: The MIT Press, 1967. Includes "The Search for the Real in the Visual Arts," pp. 46–54; "Sculpture," pp. 55–59; "Painting and Culture," pp. 60–64; excerpts from the teachings of Hans Hofmann adapted from his essays "On the Aims of Art" and "Plastic Creation," pp. 65–76; "Terms," pp. 76–78.

Hofmann, Hans. "Art in America." *Art Digest,* 4 (August 1930), p. 27.

———. "Creation in Form and Color: A Textbook for Instruction in Art." Written in German at the University of California, Berkeley, 1931. Translated by Glenn Wessels. Typescript, estate of the artist.

———. Statement in *Daily Californian,* June 25, 1931.

———. "Painting and Culture." *Fortnightly* (Campbell, California), 1 (September 11, 1931), pp. 5–7.

———. "On the Aims of Art." Translated by Ernst Stolz and Glenn Wessels. *Fortnightly* (Campbell, California), 1 (February 26, 1932), pp. 7–11.

———. "Plastic Creation." *The League,* 5 (Winter 1932–33), pp. 11–15, 21.

———. Statement in *Hans Hofmann: Recent Paintings,* exhibition announcement. New York: Kootz Gallery, 1949.

———. "Space Pictorially Realized Through the Intrinsic Faculty of the Colors to Express Volume." In *Hans Hofmann: New Paintings,* exhibition catalogue. New York: Kootz Gallery, 1951.

———. Statement in *Hans Hofmann,* exhibition catalogue. New York: Kootz Gallery, 1952.

———. "The Mystery of Creative Relations." *New Ventures* (July 1953), pp. 22–23.

———. "The Resurrection of the Plastic Arts." *New Ventures* (July 1953), pp. 20–23. Reprinted in *Hans Hofmann: New Paintings,* exhibition catalogue. New York: Kootz Gallery, 1954.

———. "The Color Problem in Pure Painting: Its Creative Origin." In *Hans Hofmann,* exhibition calatogue. New York: Kootz Gallery, 1955. Reprinted in *Arts and Architecture,* 73 (February 1956), pp. 14–15, and in Sam Hunter, *Hans Hofmann,* New York: Harry N. Abrams, 1963.

———. "Nature and Art: Controversy and Misconceptions." In *Hans Hofmann: New Paintings,* exhibition catalogue. New York: Kootz Gallery, 1958.

———. Statement in *It Is,* 3 (Winter 1958–Spring 1959), p. 10.

———. "Space and Pictorial Life." *It Is,* 4 (Autumn 1959), p. 10.

———. "Hans Hofmann on Art." *Art Journal,* 22 (Spring 1963), pp. 180, 182. Speech delivered at the inauguration of Hopkins Center, Dartmouth College, November 17, 1962.

———. "The Painter and His Problems: A Manual Dedicated to Painting." Typescript, March 21, 1963. Library, The Museum of Modern Art, New York.

———. "Selected Writings on Art." Typescript compiled by William Seitz, 1963. Library, The Museum of Modern Art, New York.

Jaffe, Irma. "A Conversation with Hans Hofmann." *Artforum,* 9 (January 1971), pp. 34–39.

Kuh, Katharine. *The Artist's Voice: Talks with Seventeen Artists.* New York: Harper and Row, 1962, pp. 118–29.

van Okker, William H. "Visit with a Villager: Hans Hofmann." *Villager* (New York), March 18, 1965.

Wolf, Ben. "The Digest Interviews Hans Hofmann." *Art Digest,* 19 (April 1, 1945), p. 52.

Monographs and One-Artist Exhibition Catalogues

Bannard, Walter Darby. *Hans Hofmann: A Retrospective Exhibition,* exhibition catalogue. Washington, D.C.: Hirshhorn Museum and Sculpture Garden, Smithsonian Institution; Houston: The Museum of Fine Arts, 1976.

Geldzahler, Henry. *Hans Hofmann: The Renate Series,* exhibition catalogue. New York: The Metropolitan Museum of Art, 1972.

Goodman, Cynthia. *Hans Hofmann as Teacher: Drawings by His Students, Hans Hofmann: Provincetown Scenes,* exhibition catalogue. Provincetown, Massachusetts: Provincetown Art Association, 1980.

_____. *Hans Hofmann, Centennial Celebration, Part I: Major Paintings,* exhibition catalogue. New York: André Emmerich Gallery, 1980.

_____. "The Hans Hofmann School and Hofmann's Transmission of European Modernist Aesthetics to America." Ph.D. dissertation. Philadelphia: University of Pennsylvania, 1982.

_____. *Hans Hofmann.* New York: Abbeville Press, 1986.

Greenberg, Clement. *Hans Hofmann.* Paris: Éditions Georges Fall, 1961.

Hunter, Sam. *Hans Hofmann.* New York: Harry N. Abrams, 1963.

Loran, Erle. *Recent Gifts and Loans of Paintings by Hans Hofmann: Hans Hofmann and His Work,* exhibition catalogue. Berkeley: Worth Ryder Art Gallery, University of California, 1964.

Rose, Barbara. *Hans Hofmann: Drawings, 1930–1944,* exhibition catalogue. New York: André Emmerich Gallery, 1978.

Sandler, Irving. *Hans Hofmann: The Years 1947–1952,* exhibition catalogue. New York: André Emmerich Gallery, 1976. Reprinted as "Hans Hofmann and the Challenge of Synthetic Cubism," *Arts Magazine,* 50 (April 1976), pp. 103–05.

Seitz, William. *Hans Hofmann,* exhibition catalogue. New York: The Museum of Modern Art, 1963.

Varley, Christopher. *Hans Hofmann, 1880–1966: An Introduction to His Paintings,* exhibition catalogue. Edmonton, Canada: The Edmonton Art Gallery, 1982.

Wight, Frederick S. *Hans Hofmann,* exhibition catalogue. New York: Whitney Museum of American Art; Los Angeles: Art Galleries of the University of California, 1957.

Periodicals, Books, and Group-Exhibition Catalogues

Abbey, R.D. "Color: Man and Nature." *Art Journal,* 31 (Fall 1971), pp. 110–12.

"Art for the Office Lobby: Mosaic Elevator Shaft." *Interiors,* 116 (February 1957), p. 85.

Ashton, Dore. "Hans Hofmann: An Appreciation." *Cimaise,* 6 (January–March 1959), pp. 38–45.

_____. *The New York School: A Cultural Reckoning.* New York: The Viking Press, 1972.

Baker, Elizabeth C. "Tales of Hofmann: The 'Renate Series.'" *Art News,* 71 (November 1972), pp. 39–41.

Bannard, Walter Darby. "Hofmann's Rectangles." *Artforum,* 7 (Summer 1969), pp. 38–41.

_____. "Notes on an Auction." *Artforum,* 9 (September 1970), pp. 62–64.

Bayl, Friedrich. "Hans Hofmann in Deutschland." *Art International,* 6 (September 1962), pp. 38–44. Reprint of catalogue essay for 1962 exhibition at the Neue Galerie im Künstlerhaus, Munich.

Bell, Tiffany. *After Matisse,* exhibition catalogue. New York: Independent Curators Incorporated, 1986.

Bird, Paul. "Hofmann Profile." *Art Digest,* 25 (May 15, 1951), pp. 6–7.

Bultman, Fritz. "The Achievement of Hans Hofmann." *Art News,* 62 (September 1963), pp. 43–45, 54–55.

_____. "Hofmann's Modernism." *Art/World,* 5 (December 18, 1980–January 15, 1981), pp. 1, 9.

Burckhardt, Rudolph. "Repertory of Means: *Bald Eagle* by Hans Hofmann." *Location,* 1 (Spring 1963), pp. 67–72.

Cheney, Sheldon. *Expressionism in Art.* 2d rev. ed. New York: Tudor Publishing, 1948.

Coates, Robert M. "A Hans Hofmann Retrospective." *The New Yorker,* May 11, 1957, pp. 104–06.

de Kooning, Elaine. "Hans Hofmann Paints a Picture." *Art News,* 48 (February 1950), pp. 38–41, 58–59.

Devree, Howard. "A Veteran Surprises." *The New York Times,* May 3, 1953, section 2, p. 8.

Europa/Amerika: Die Geschichte einer künstlerischen Faszination seit 1940, exhibition catalogue. Cologne: Museum Ludwig, 1986. Essays by Cynthia Goodman et al.

Ellsworth, Paul. "Hans Hofmann: Reply to Questionnaire and Comments on Recent Exhibition." *Arts and Architecture,* 66 (November 1949), p. 46.

Fitzsimmons, James. "Hans Hofmann." *Everyday Art Quarterly,* 28 (1953), pp. 23–26.

Forgey, Benjamin. "The Restless Experiments of Hans Hofmann." *Art News,* 75 (February 1977), pp. 62–63.

Geldzahler, Henry. *New York Painting and Sculpture, 1940–1970,* exhibition catalogue. New York: The Metropolitan Museum of Art, 1969.

Genauer, Emily. "One-Man Movement in U.S. Art. Hofmann Solo at Whitney Museum, Abstract Annual." *New York Herald Tribune,* April 28, 1957, section 6, p. 14.

_____. "Hans Hofmann—Medium Plus Message." *World Journal Tribune,* January 29, 1967, p. 35.

Goodman, Cynthia. "Hans Hofmann as Teacher." *Arts Magazine,* 53 (April 1979), pp. 22–28.

_____. *Hans Hofmann and His Legacy,* exhibition catalogue. New York: Lever/Meyerson Gallery, 1986.

Gouk, Alan. "Essay on Painting." *Studio International,* 180 (October 1970), pp. 145–49.

Greenberg, Clement. "Art." *The Nation*, April 21, 1945, p. 469.

_____. "The Present Prospects of American Painting and Sculpture." *Horizon* (October 1947), pp. 20–30.

_____. "American-Type Painting." *Partisan Review*, 22 (Spring 1955), pp. 179–96.

_____. "Hans Hofmann: Grand Old Rebel." *Art News*, 57 (January 1959), pp. 26–29, 64.

_____. *Art and Culture*. Boston: Beacon Press, 1961.

Gruen, John. "The Creative Fountain of Youth." *New York Herald Tribune*, March 1, 1964, p. 34.

"Hans Hofmann Continues Despite War." *Art Digest*, 16 (May 15, 1942), p. 29.

Hans Hofmann: Derrière le Miroir, 16 (January 1949). Includes Charles Estienne, "Hofmann ou la lumière américaine"; Weldon Kees, "A Salvo by Hans Hofmann"; Peter Neagoe, "Hans Hofmann"; Tennessee Williams, "An Appreciation."

"Hans Hofmann: 1880–1966." *Newsweek*, February 28, 1966, p. 85.

"Hans Hofmann Gift to University of California at Berkeley." *Art Journal*, 23 (Summer 1964), p. 291.

Hess, Thomas B. "Hans Hofmann." *Art News*, 45 (March 1946), p. 53.

_____. "*Art News* Visits the Art Schools: Three in Provincetown." *Art News*, 45 (June 1946), pp. 12–13.

_____. "U.S. Painting: Some Recent Directions." *Art News Annual* (1956), pp. 75–98.

_____. "The Mystery of Hans Hofmann." *Art News*, 63 (February 1965), pp. 39, 54–55.

"Hofmann at Chouinard." *Art Digest*, 5 (February 15, 1931), p. 29.

Irving, Carl. "Regents Okay Berkeley Art Gallery. Hans Hofmann Paintings Will Form Nucleus." *Oakland Tribune*, February 20, 1964, pp. 1, 3.

Jewell, Edward Allen. Review of exhibition at Betty Parsons Gallery. *The New York Times*, March 30, 1947, section 2, p. 10.

Kaprow, Allan. "Effect of Recent Art upon the Teaching of Art." *Art Journal*, 23 (Winter 1963–64), pp. 136–39.

_____. "Hans Hofmann." *The Village Voice*, February 24, 1966, pp. 1–2.

Kepes, Gyorgy. "Hans Hofmann: *Search for The Real.*" *Magazine of Art*, 45 (March 1952), pp. 136–37.

Kootz, Samuel M. "Credibility of Color: Hans Hofmann." *Arts Magazine*, 41 (February 1967), pp. 37–39.

Kramer, Hilton. "Symbol of Change: Hofmann, Teacher, Theorist, and Artist, Codified and Passed on Modern Legacy." *The New York Times*, February 18, 1966, p. 33.

_____. "Hofmann in Perspective." *The New York Times*, January 29, 1967, section 2, p. 25.

[Kroll, Jack.] "Old Man Crazy about Painting." *Newsweek*, September 16, 1963, pp. 88, 90.

Landau, Ellen G. "The French Sources for Hans Hofmann's Ideas on the Dynamics of Color-Created Space." *Arts Magazine*, 51 (October 1976), pp. 76–81.

Lane, John R., and Susan C. Larsen, eds. *Abstract Painting and Sculpture in America 1927–1944*, exhibition catalogue. Pittsburgh: The Museum of Art, Carnegie Institute, 1983.

Lawson, J. H. "Hans Hofmann." *Arts and Architecture*, 61 (March 1944), p. 23.

Loran, Erle. "Hans Hofmann and His Work." *Artforum*, 2 (May 1964), pp. 32–35.

Louden, Lynn M. "Apollo and Dionysius in Contemporary Art." *Arts Magazine*, 45 (December 1970), pp. 20–23.

"Master Teacher." *Life*, April 8, 1957, pp. 70–72.

Matter, Mercedes. "Hans Hofmann." *Arts and Architecture*, 63 (May 1946), pp. 26–28.

Messer, Thomas. "Kandinsky en Amérique." *XXe Siècle*, 28 (December 1966), pp. 111–17.

Millard, Charles W. "Hans Hofmann." *Hudson Review*, 30 (Autumn 1977), pp. 404–08.

Moffett, Kenworth. "Exhibition at André Emmerich Gallery." *Moffett's Art Letter* (February 1987), p. 1.

Morse, J. D. "Artist in America: He Paints Big." *Art in America*, 48 (Summer 1960), pp. 76–79.

O'Doherty, Brian. "Art: Profound Changes. Hofmann Display at Kootz Shows He Has Cast His Work into the Melting Pot Again." *The New York Times*, January 4, 1962, p. 27.

_____. "Hans Hofmann: A Style of Old Age." *The New York Times*, September 15, 1963, section 2, p. 23.

Plaskett, J. "Some New Canadian Painters and Their Debt to Hans Hofmann." *Canadian Art*, 10 (Winter 1953), pp. 59–63.

Pollet, Elizabeth. " Hans Hofmann." *Arts Magazine*, 31 (May 1957), pp. 30–33.

"Push Answers Pull." *Time*, March 17, 1961, pp. 78–81.

Riley, Maude. "Hans Hofmann: Teacher-Artist." *Art Digest*, 18 (March 15, 1944), p. 13.

Rosenberg, Harold. "Hans Hofmann: Nature into Action." *Art News*, 56 (May 1957), pp. 34–36.

———. "Tenth St.: A Geography of Modern Art." *Art News Annual* (1959), pp. 120–43, 184–92.

———. "Hans Hofmann's 'Life' Class." *Portfolio and Art News Annual*, 6 (Autumn 1962), pp. 16–31, 110–15.

———. "Hans Hofmann and the Stability of the New." *The New Yorker*, November 2, 1963, pp. 100, 103–05, 108–10.

———. "Hans Hofmann." *Vogue*, 145 (May 1965), pp. 192–95, 236.

———. "Editorial." *Art News*, 65 (April 1966), p. 21.

———. "Homage to Hans Hofmann." *Art News*, 65 (January 1967), p. 49.

———. "Teaching of Hans Hofmann." *Arts Magazine*, 45 (December 1970), pp. 17–19.

———. "Hofmann Unforgettable as Artist, Teacher." *Advocate Summer Guide* (Provincetown, Massachusetts), August 7, 1980, pp. 3–25.

Sandler, Irving. *The Triumph of American Painting: A History of Abstract Expressionism*. New York: Praeger Publishers, 1970.

———. "Hans Hofmann at Emmerich." *Art in America*, 60 (March 1972), pp. 118–19.

———. "Hans Hofmann: The Peda-gogical Master." *Art in America*, 61 (May 1973), pp. 48–57.

Schimmel, Paul. *The Interpretive Link: Abstract Surrealism into Abstract Expressionism. Works on Paper 1938–1948*, exhibition catalogue. Newport Beach, California: Newport Harbor Art Museum, 1986.

Seckler, Dorothy. "Can Painting Be Taught?" *Art News*, 50 (March 1951), pp. 39–40, 63–64.

Seitz, William C. *Abstract Expressionist Painting in America*. Cambridge, Massachusetts, and London: Harvard University Press, 1983.

Tillim, Sidney. "Report on the Venice Biennale." *Arts Magazine*, 35 (October 1960), pp. 28–35.

"Trapezoids and Empathy." *Time*, December 3, 1951, p. 72.

Tuchman, Maurice, ed. *New York School — The First Generation: Paintings of the 1940s and 1950s*, exhibition catalogue. Los Angeles: Los Angeles County Museum of Art, 1965.

Willard, Charlotte. "Living in a Painting." *Look*, July 28, 1953, pp. 52–55.

Wolf, Ben. "Space and Rhythm." *Art Digest*, 20 (March 15, 1946), p. 15.

Chronology

A World War I class at the Hans Hofmann Schule für Bildende Kunst, Munich.

1880

March 21, Johann Georg Albert (Hans) Hofmann born in Weissenburg, Germany, to Theodor and Franziska Hofmann.

1886

Family moves to Munich, where Hans shows particular aptitude in science, mathematics, and music and begins drawing.

1896

Hans becomes assistant to the director of public works of Bavaria. Invents an electromagnetic comptometer, a radar device for ships, a sensitized light bulb, and a portable freezer unit.

1898

Enrolls at Moritz Heymann's Munich art school. Subsequently studies with various teachers, including Willi Schwarz, who introduces him to Impressionism. Visits the Secession Gallery in Munich and becomes increasingly aware of contemporary art movements.

1900

Meets Maria (Miz) Wolfegg, his future wife.

1903

Meets department store owner and art collector Phillip Freudenberg, who becomes his patron and gives him the funds that enable him to go to Paris.

1904–08

In Paris, attends evening sketch classes at the Académie Colarossi and the Académie de la Grande Chaumière, where Matisse is also studying. Frequents the Café du Dôme, a favorite nightspot for artists and writers. Meets Jules Pascin and Robert Delaunay, with whom he becomes particularly good friends. Also meets Léger, Braque, Picasso, Arthur B. Carles, and Leo Stein. Paints still lifes, landscapes in the Luxembourg Gardens, and figurative pieces. Miz and Hans design patterns for Sonia Delaunay's fashions.

1908

Included in group exhibition at the New Secession, Berlin (again in 1909).

1910

First one-man exhibition at Paul Cassirer Gallery, Berlin.

1914

Caught in Germany when World War I breaks out. Disqualified from military service because of a lung condition.

Hans and Miz Hofmann with Tristan Forster, John Haley, and Joan Hein at Kreuzeck in the German Alps, February 1928.

Hofmann in Munich, 1920s.

1915

Opens the Hans Hofmann Schule für Bildende Kunst at 40 Georgenstrasse in Schwabing, the Bohemian district of Munich.

1918–29

During the war, school enrollment is small and students are primarily women. After the war, the school begins to attract foreign students, including Worth Ryder, Glenn Wessels, Carl Holty, Louise Nevelson, Vaclav Vytlacil, Alfred Jensen, and Ludwig Sander. Although running the school leaves Hofmann little time to paint, he draws continuously.

1929

Marries Miz Wolfegg. Reproduces a group of his drawings as *Lichtdrucke,* a photographic process.

1930

Worth Ryder, chairman of the department of art, University of California, Berkeley, invites Hofmann to teach in the summer session. Glenn Wessels travels to America with Hofmann. They stop in various cities, including Chicago and Minneapolis, with Wessels acting as Hofmann's guide and interpreter.
Executes a series of drawings of the American landscape in various places, including Lake Tahoe and Richmond, California. In the winter, returns to Munich.

1931

Teaches in the spring at Chouinard School of Art, Los Angeles. In the summer, returns to Berkeley for a second term. While there writes "Creation in Form and Color: A Textbook for Instruction in Art," his major (unpublished) treatise on art.

1932

Moves to New York, where he lives in the Barbizon Plaza Hotel. Begins teaching at the Art Students League; among his first students are Burgoyne Diller, Ray Eames, Harry Holtzman, Lillian Kiesler, Mercedes Carles Matter, George McNeil, and Irene Rice Pereira.

1933

In the summer, teaches as guest instructor at the Thurn School of Art, Gloucester, Massachusetts. (Ernest Thurn had been his student in Munich.) In the fall, opens his own school at 444 Madison Avenue.

1934

Goes to Bermuda for a few months and returns with a permanent visa. Teaches again in the summer at the Thurn School. In the fall, opens the Hans Hofmann School of Fine Arts at 137 East 57th Street, New York.

1935

Opens his summer school in Provincetown, Massachusetts. Starts to paint regularly again.

The Hofmanns' Munich apartment, maintained by Miz Hofmann, c. 1938.

Hans and Miz Hofmann in their Provincetown house, 1940s.

1936

Moves his school to 52 West 9th Street. Regularly attends gallery and museum exhibitions.

1938–39

School moves to its permanent location at 52 West 8th Street. Hofmann presents a lecture series at the school.

1939

Miz Hofmann comes to the United States, bringing with her some of her husband's works, some Biedermeier furniture, and works they own by other artists, including Miró, Braque, and Louis Vivin.

1941

Becomes US citizen. Delivers address during annual meeting of the American Abstract Artists at the Riverside Museum.

1942

Lee Krasner, formerly a Hofmann student, introduces Hofmann to Jackson Pollock.

1944

First one-man New York exhibition held at Peggy Guggenheim's Art of This Century. (Pollock is instrumental in encouraging Guggenheim to give Hofmann this show.) Meets critic Clement Greenberg. Begins working almost exclusively indoors after a hernia operation. He and Miz move into a one-room fifth floor walk-up apartment on 14th Street.

1945

Included in "Annual Exhibition: Contemporary American Painting" at the Whitney Museum of American Art, New York.

Hofmann in New York, 1940s.

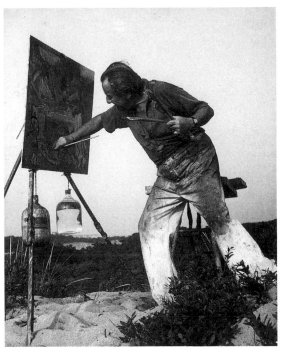

Hofmann painting on the dunes in Provincetown, 1939–40.

1947

Addison Gallery of American Art, Andover, Massachusetts, acquires *Black Demon*. First exhibition at Kootz Gallery, New York, where he is to show until his death.

1948

Large retrospective organized by the Addison Gallery, the first major one-man exhibition given by a museum to an Abstract Expressionist. *The Search for the Real and Other Essays* is published in conjunction with this exhibition.

1949

January, travels to Paris for his one-man exhibition at Galerie Maeght; visits studios of Picasso, Braque, Brancusi, and Miró.
Participates in and helps organize "Forum 49," a summerlong series of lectures, panels, and exhibitions in Provincetown at the Gallery 200.

1950

April, participates in three-day symposium at Studio 35 with William Baziotes, James Brooks, Willem de Kooning, Herbert Ferber, Theodoros Stamos, David Smith, and Bradley Walker Tomlin. Joins the so-called Irascibles (Baziotes, de Kooning, Adolph Gottlieb, Robert Motherwell, Barnett Newman, Pollock, Richard Pousette-Dart, Ad Reinhardt, Mark Rothko, Clyfford Still, and Tomlin) in writing an open letter to Roland Redmond, president of The Metropolitan Museum of Art, protesting the exclusion of the avant-garde from a large exhibition of American art.

1951

October, juries "60th Annual American Exhibition," The Art Institute of Chicago, with Aline Louchheim and Peter Blume.

1955

Small retrospective exhibition, selected by Clement Greenberg, held at Bennington College, Vermont.

1956

Designs mosaic mural for the lobby of 711 Third Avenue, New York.

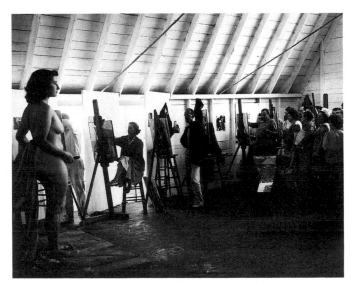

Hofmann in his Provincetown school, correcting a students drawing.

Hofmann painting *Fruit Bowl: Transubstantiation No. 1,* 1950. Photograph by Rudolph Burckhardt.

1957

Retrospective exhibition at the Whitney Museum of American Art, organized by Frederick Wight, in association with the Art Galleries of the University of California, Los Angeles.

1958

Closes his schools after forty-three consecutive years of teaching to devote full time to painting. Moves his studio to the school quarters at 52 West 8th Street. Designs mosaic murals for the exterior of the New York School of Printing, 439 West 49th Street.

1960

Represented in "XXX Venice Biennale." Travels to Europe.

1962

Receives honorary degree from Dartmouth College, Hanover, New Hampshire, and delivers address at the commencement ceremony.

1963

Spring, Miz Hofmann dies.
Major exhibition, organized by William Seitz, held at The Museum of Modern Art, New York, which also circulates "Hans Hofmann and His Students" (1963–65).

1964

Marries Renate Schmitz. She is the inspiration for *The Renate Series*.

1966

February 17, Hofmann dies in New York.

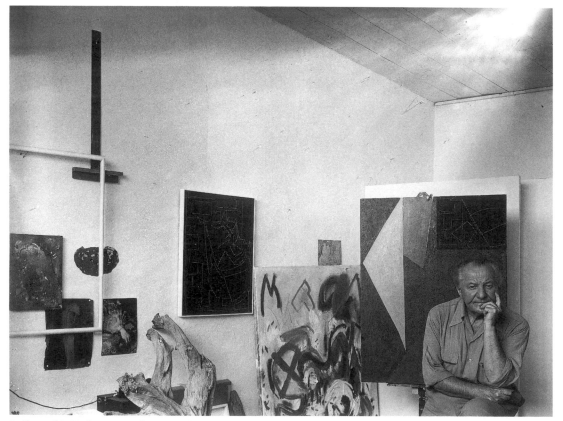

Driftwood in Hofmann's studio, 1952. Photograph by Arnold Newman.

190

Hofmann in Provincetown, 1956. Photograph by Arnold Newman.

Index of Illustrations

Works in the Exhibition

Dimensions are in inches, followed by centimeters; height precedes width. The titles of works are Hofmann's own and his spelling has been retained. In the case of some early untitled works, parenthetical descriptions of the subject matter have been added for purposes of identification; numbers in parentheses at the end of an entry are Hofmann estate numbers.

Untitled (Figure Study), c. 1898
Ink on paper, 10⅛ × 8¾ (25.7 × 22.2)
Estate of the artist; courtesy André Emmerich Gallery, New York (M-1398-2)

Untitled (Figure Study), c. 1898
Pencil on paper, 11½ × 8 (29.2 × 20.3)
Estate of the artist; courtesy André Emmerich Gallery, New York (M-1398-7)

Untitled (Figure Study), c. 1898
Pencil on paper, 11⁹⁄₁₆ × 8¹⁄₁₆ (29.4 × 20.5)
Estate of the artist; courtesy André Emmerich Gallery, New York (M-1398-25)

Untitled (Figure Study), c. 1898
Pencil on paper, 11⁹⁄₁₆ × 8³⁄₁₆ (29.4 × 21)
Estate of the artist; courtesy André Emmerich Gallery, New York (M-1398-31)

Untitled (Standing Youth), c. 1898
Pencil on paper, 6⅜ × 4¹⁄₁₆ (16.2 × 10.3)
Estate of the artist; courtesy André Emmerich Gallery, New York (U-48)

Untitled (Portrait of Maria Wolfegg), c. 1901
Oil on academy board mounted on masonite, 27½ × 19½ (69.9 × 49.5)
Estate of the artist; courtesy André Emmerich Gallery, New York (M-1314)

Self-Portrait, 1902 (recto)
Untitled (Still Life), 1902 (verso)
Oil on composition board, 16½ × 20¼ (41.9 × 51.4)
Estate of the artist; courtesy André Emmerich Gallery, New York (U-42)

Untitled (Portrait of a Woman), 1902
Oil on canvas mounted on canvas, 16 × 15 (40.6 × 38.1)
Estate of the artist; courtesy André Emmerich Gallery, New York (M-1319)

Untitled (Cityscape), c. 1914
Watercolor on paper, 8¼ × 10½ (21 × 26.7)
Estate of the artist; courtesy André Emmerich Gallery, New York (M-1400-5)

Untitled (Landscape), c. 1914
Watercolor and pencil on paper, 8 × 10½ (20.3 × 26.7)
Estate of the artist; courtesy André Emmerich Gallery, New York (M-1400-2)

Untitled (Landscape), c. 1914
Watercolor and pencil on paper, 6¾ × 8¾ (17.1 × 22.2)
Estate of the artist; courtesy André Emmerich Gallery, New York (M-1400-6)

Untitled (Landscape), c. 1914
Watercolor on paper, 8 × 10½ (20.3 × 26.7)
Estate of the artist; courtesy André Emmerich Gallery, New York (M-1400-7)

Untitled (Study for Ceiling Design), c. 1914
Pencil, watercolor, and tape on paper, 8¼ × 10¾ (21 × 27.3)
Estate of the artist; courtesy André Emmerich Gallery, New York (M-1400-4)

Untitled (Landscape), 1917 (originally recto of *Study for Landscape*, c. 1917)
Watercolor and pastel on paper, 8 × 10 (20.3 × 25.4)
New Orleans Museum of Art; The Muriel Bultman Francis Collection

Study for Landscape, c. 1917 (originally verso of *Untitled [Landscape]*, 1917)
Pencil on paper, 6¾ × 9½ (17.5 × 24.1)
New Orleans Museum of Art; The Muriel Bultman Francis Collection

Green Bottle, 1921
Oil on canvas, 17¾ × 22¾ (45.1 × 57.8)
Museum of Fine Arts, Boston; Gift of William H. and Saundra B. Lane

Student with Spectacles, c. 1926
Ink on paper, 13¾ × 11 (34.9 × 27.9)
Estate of the artist; courtesy André Emmerich Gallery, New York

Untitled (St. Tropez), 1928
Ink on paper, 9 × 12 (22.9 × 30.5)
Estate of the artist; courtesy André Emmerich Gallery, New York (M-1399-26)

Untitled (St. Tropez), 1928
Ink on paper, 9¾ × 12⅞ (24.8 × 32.7)
Estate of the artist; courtesy André Emmerich Gallery, New York (M-1399-28)

St. Tropez vue sur les montagnes de St. Raphael, 1929
Ink and pencil on paper, 10½ × 13⅞ (26.7 × 35.2)
Estate of the artist; courtesy André Emmerich Gallery, New York

Untitled (St. Tropez), 1929
Ink on paper, 10½ × 13½ (26.7 × 34.3)
Estate of the artist; courtesy André
Emmerich Gallery, New York (M-1399-2)

Untitled (Portrait of a Woman), c. 1929
Ink on paper, 13¹⁵⁄₁₆ × 10¹⁵⁄₁₆ (35.4 × 27.8)
Estate of the artist; courtesy André
Emmerich Gallery, New York (M-1397-8)

Untitled (Portrait Study), 1930
Ink and collage on paper, 15 × 12½
(38.1 × 31.8)
Collection of Jeanne Bultman

Untitled (California Oil Field), c. 1930
Ink on paper, 8¹⁵⁄₁₆ × 10⅞ (22.7 × 27.6)
Estate of the artist; courtesy André
Emmerich Gallery, New York (C-355)

Untitled (California Oil Field), c. 1930
Ink on paper, 8⁷⁄₁₆ × 10¹⁵⁄₁₆ (21.4 × 27.8)
Estate of the artist; courtesy André
Emmerich Gallery, New York (M-933)

Apples, c. 1932
Oil on composition board, 25 × 30
(63.5 × 76.2)
Private collection

Bouquet, c. 1932
Gouache on paper, 15¾ × 11½ (40 × 29.2)
Private collection

Still Life, c. 1932
Oil on board, 25 × 30 (63.5 × 76.2)
Collection of Michael Diamond

Untitled (Still Life), c. 1932
Watercolor on paper, 19½ × 24½
(49.5 × 62.2)
Private collection

Jeannette Carles (Mercedes Carles Matter), 1934
Oil on plywood, 54½ × 40½
(138.2 × 102.9)
Collection of Mr. and Mrs. Jeffrey Glick

Landscape, 1935
Casein on plywood, 25 × 30 (63.5 × 76.2)
Private collection

Reclining Nude, 1935
Ink on paper, 8½ × 11 (21.6 × 27.9)
The Museum of Modern Art, New York;
Gift of Philip Isles

Untitled (Figure Study), c. 1935
Ink on paper, 11 × 8½ (27.9 × 21.6)
Estate of the artist; courtesy André
Emmerich Gallery, New York
(M-933-418)

Untitled (Provincetown Seascape), c. 1935
Ink on paper, 8½ × 11 (21.6 × 27.9)
Estate of the artist; courtesy André
Emmerich Gallery, New York
(M-933-203)

Pilgrim Hights Vue, 1936
Oil on board, 25 × 30 (63.5 × 76.2)
Collection of Mr. and Mrs. Miles
Q. Fiterman

Untitled (Yellow Table on Green), 1936
Oil on board, 60 × 44½ (152.4 × 113)
Collection of Howard E. Rachofsky

Landscape, c. 1936
Oil on board, 30 × 36 (76.2 × 91.4)
Collection of Mr. and Mrs. Kenneth
N. Dayton

Untitled No. 4, c. 1936
Oil on plywood, 52½ × 38½ (133.4 × 97.8)
Estate of the artist; courtesy André
Emmerich Gallery, New York (M-178)

Truro, Evening in the Harbor, 1938
Oil on board, 24 × 30 (61 × 76.2)
Private collection

Untitled, 1939
Watercolor on paper, 17¾ × 24 (45.1 × 61)
Private collection

Untitled (Still Life), c. 1940
Ink on paper, 8¼ × 10¾ (21 × 27.3)
Estate of the artist; courtesy André
Emmerich Gallery, New York
(M-933-134)

Self-Portrait with Brushes, 1942
Casein on plywood, 30 × 25 (76.2 × 63.5)
Estate of the artist; courtesy André
Emmerich Gallery, New York

Untitled, VII. 16. 42, 1942
Ink and crayon on paper, 14 × 16¹⁵⁄₁₆
(35.6 × 43)
Hirshhorn Museum and Sculpture
Garden, Smithsonian Institution,
Washington, D.C.; Museum Purchase,
1977

Untitled (Self-Portrait), c. 1942
Oil and ink on paper, 10¹⁵⁄₁₆ × 8½
(27.8 × 21.6)
Estate of the artist; courtesy André
Emmerich Gallery, New York (M-938-9)

Untitled (Self-Portrait), c. 1942
Oil and ink on paper, 10¹⁵⁄₁₆ × 8½
(27.8 × 21.6)
Estate of the artist; courtesy André
Emmerich Gallery, New York (M-938-12)

Untitled (Self-Portrait), c. 1942
Oil and ink on paper, 10¹⁵⁄₁₆ × 8⅝
(27.8 × 21.9)
Collection of Dr. Harold and
Elaine L. Levin

Color Intervals at Provincetown, 1943
Ink and crayon on paper, 17½ × 24
(44.5 × 61)
Addison Gallery of American Art, Phillips
Academy, Andover, Massachusetts

Untitled, 1943
Gouache on paper, 17½ × 24 (44.5 × 61)
Collection of Mr. and Mrs. Orin
S. Neiman

Spring, 1944–45 (dated 1940)
Oil on panel, 11¼ × 14⅛ (28.6 × 35.9)
The Museum of Modern Art, New York;
Gift of Mr. and Mrs. Peter A. Rübel

The Wind, c. 1944 (dated 1942)
Oil, Duco paint, gouache, and ink on
poster board, 43⅞ × 27¾ (111.4 × 70.5)
University Art Museum, University of
California, Berkeley; Gift of the artist

Cataclysm (Homage to Howard Putzel), 1945
Casein on gesso on board, 51¾ × 48 (131.4 × 121.9)
Collection of Lee and Gilbert Bachman

Intoxication, 1945
Gouache on paper, 28⅞ × 22⅞ (73.3 × 58.1)
Collection of Herta and Samuel Seidman

Midnight Glow, 1945
Gouache on paper, 28⅞ × 22⅞ (73.3 × 58.1)
Collection of Mrs. G. N. Bearden

Untitled, 1945
Gouache and watercolor on paper, 28¾ × 23 (73 × 58.4)
Collection of Beth and Steven Lever

Bacchanale, 1946
Oil on composition board, 64 × 48 (162.6 × 121.9)
Collection of Robert and Alice Galoob

Red Shapes, 1946
Oil on cardboard, 32½ × 28 (82.6 × 71.1)
Collection of Sally Sirkin Lewis and Bernard Lewis

Untitled, c. 1946
Gouache on paper, 28¾ × 23⅛ (73 × 58.7)
Private collection

Gestation, 1947
Oil on canvas, 60 × 48 (152.4 × 121.9)
Collection of Frank Stella

Blue Rhythm, 1950
Oil on canvas, 48 × 36 (121.9 × 91.4)
The Art Institute of Chicago; Gift of the Society for Contemporary Art

Magenta and Blue, 1950
Oil on canvas, 48 × 58 (121.9 × 147.3)
Whitney Museum of American Art, New York; Purchase 50.20

Persian Phantasy, 1953
Oil on plywood, 23 × 32 (58.4 × 81.3)
Estate of the artist; courtesy André Emmerich Gallery, New York

Liebesbaum, 1954
Oil on panel, 60 × 48 (152.4 × 121.9)
Estate of the artist; courtesy André Emmerich Gallery, New York

Studio No. 2 in Blue, 1954
Oil on canvas, 48 × 84 (121.9 × 213.4)
Collection of Mr. and Mrs. Gerhard Andlinger

A Lovely Day, 1955
Oil on canvas, 20 × 24 (50.8 × 61)
Private collection

Blue on Gray, 1956
Oil on canvas, 50 × 84 (127 × 213.4)
Collection of Mr. and Mrs. Clifford M. Sobel

Circles, 1956
Oil on cardboard, 12 × 31 (30.5 × 78.7)
Private collection; courtesy André Emmerich Gallery, New York

Fragrance, 1956
Oil on canvas, 60 × 48 (152.4 × 121.9)
Honolulu Academy of Arts; Purchase, 1968

Yellow Burst, 1956
Oil on canvas, 48 × 60 (121.9 × 152.4)
Collection of Berthe and Oscar Kolin

Golden Splendor, 1957
Oil on canvas, 84 × 50 (213.4 × 127)
Private collection

Equipoise, 1958
Oil on canvas, 60 × 52 (121.9 × 132.1)
Collection of Marcia S. Weisman

Pastorale, 1958
Oil on canvas, 60 × 48 (152.4 × 121.9)
Private collection

The Pond, 1958
Oil on canvas, 40 × 50 (101.6 × 127)
Collection of Richard Brown Baker

Towering Clouds, 1958
Oil on canvas, 50 × 84 (127 × 213.4)
Private collection

Cathedral, 1959
Oil on canvas, 74¼ × 48¼ (188.6 × 122.6)
Private collection

Chimera, 1959
Oil on canvas, 60 × 52 (152.4 × 132.1)
Collection of Thomas Marc Futter

Festive Pink, 1959
Oil on canvas, 60 × 72 (152.4 × 182.9)
Collection of Mr. and Mrs. Kenneth N. Dayton

Jardin d'Amour, 1959
Oil on canvas, 60 × 72 (152.4 × 182.9)
Private collection

Smaragd, Red, and Germinating Yellow, 1959
Oil on canvas, 55 × 40 (139.7 × 101.6)
The Cleveland Museum of Art; Contemporary Collection

Voices of Spring, 1959
Oil on canvas, 74 × 48 (188 × 121.9)
Collection of Mr. and Mrs. Gilbert H. Kinney

Lava, 1960
Oil on canvas, 72 × 60 (182.9 × 152.4)
Private collection

Agrigento, 1961
Oil on canvas, 84½ × 72 (214.6 × 182.9)
University Art Museum, University of California, Berkeley; Gift of the artist

Cap Cod–Its Eboulliency of Sumer, 1961
Oil on canvas, 60 × 48 (152.4 × 121.9)
Private collection

Image of Cape Cod: The Pond Country, Wellfleet, 1961
Oil on canvas, 70 × 61 (177.8 × 154.9)
Collection of Dr. William C. Janss, Jr.

Leise zieht durch mein Gemüht liebliches Geläute, 1961
Oil on canvas, 74 × 48 (188 × 121.9)
Collection of Mrs. Jan Cowles

Moonshine Sonata, 1961
Oil on canvas, 78⅛ × 84⅛ (198.4 × 213.7)
IBM Corporation, Armonk, New York

Summer Night's Bliss, 1961
Oil on canvas, 84 × 78 (213.4 × 198.1)
The Baltimore Museum of Art; Gift of the
artist

Wild Vine, 1961
Oil on canvas, 72 × 60 (182.9 × 152.4)
Collection of Mr. and Mrs. Harold Price

Memoria in Aeternum, 1962
Oil on canvas, 84 × 72⅛ (213.4 × 183.2)
The Museum of Modern Art, New York;
Gift of the artist

Sic Itur Ad Astra, 1962
Oil on canvas, 60 × 72 (152.4 × 182.9)
Private collection

Elyseum II, 1963
Oil on canvas, 60 × 52 (152.4 × 132.1)
Collection of Mr. and Mrs. C. Bagley
Wright

Fiat Lux, 1963
Oil on canvas, 72 × 60 (182.9 × 152.4)
The Museum of Fine Arts, Houston; Gift
of Mrs. William Stamps Farish, by
exchange

Ora Pro Nobis, 1964
Oil on canvas, 60 × 48 (152.4 × 121.9)
Private collection

Song of the Nightingale, 1964
Oil on canvas, 70 × 61 (177.8 × 154.9)
Collection of Barbara and Eugene
M. Schwartz

Sun in the Foliage, 1964
Oil on canvas, 84 × 72 (213.4 × 182.9)
Collection of Mr. and Mrs. Graham
Gund

Te Deum, 1964
Oil on canvas, 52 × 60 (132.1 × 152.4)
Private collection

To Miz – Pax Vobiscum, 1964
Oil on canvas, 78 × 84 (198.1 × 213.4)
Modern Art Museum of Fort Worth;
Museum Purchase

Flaming Lava, 1965
Oil on canvas, 72 × 60 (182.9 × 152.4)
Private collection

In Sober Ecstasy, 1965
Oil on canvas, 72 × 60 (182.9 × 152.4)
Private collection

Joy Sparks of the Gods, 1965
Oil on canvas, 84 × 78 (213.4 × 198.1)
Estate of the artist; courtesy André
Emmerich Gallery, New York

Lonely Journey, 1965
Oil on canvas, 50 × 40¼ (127 × 102.2)
The Metropolitan Museum of Art, New
York; Gift of Renate Hofmann, 1989

Lust and Delight, 1965
Oil on canvas, 84½ × 60¼ (214 × 153)
The Metropolitan Museum of Art, New
York; Promised gift of Renate Hofmann,
1975

Pendulare Swing, 1965
Oil on canvas, 60 × 52 (152.4 × 132.1)
Private collection

Rapturious Smile, 1965
Oil on canvas, 84 × 60 (213.4 × 152.4)
Private collection

Trustees

National Committee Members

Mr. and Mrs. Anthony Ames

Mr. and Mrs. Donald Brown

Mr. and Mrs. Martin S. Brown

Mr. and Mrs. Sydney F. Biddle

The Honorable Anne Cox Chambers

Mr. and Mrs. Thomas B. Coleman

Dr. and Mrs. David R. Davis

Mr. and Mrs. James S. DeSilva, Jr.

Mr. and Mrs. Rene di Rosa

Mr. and Mrs. Thomas Dittmer

Mr. and Mrs. Peter H. Dominick, Jr.

Ms. Laura Donnelley

Mr. and Mrs. Walter B. Ford II

Mr. and Mrs. Brendan Gill

Mr. and Mrs. Gerald Greene

Mr. and Mrs. Graham Gund

Mr. and Mrs. William A. Hall

Mr. and Mrs. Gordon Hanes

Mr. and Mrs. S. Roger Horchow

Mr. and Mrs. Edward R. Hudson, Jr.

Mr. and Mrs. William C. Janss

Mr. and Mrs. Herbert E. Jones, Jr.

Mr. and Mrs. R. Crosby Kemper

Mr. and Mrs. Robert P. Kogod

Mr. and Mrs. Leonard A. Lauder

Mr. and Mrs. Sydney Lewis

Mrs. Robert B. Mayer

Mr. Byron R. Meyer

Mr. and Mrs. Robert E. Meyerhoff

Mr. and Mrs. Nicholas Millhouse

Mr. and Mrs. A. J. F. O'Reilly

Mr. and Mrs. H. Charles Price

Mr. and Mrs. Harold C. Price

Mr. and Mrs. C. Lawson Reed

Mr. and Mrs. Paul C. Schorr III

Mr. and Mrs. Donald Scutchfield

Rev. and Mrs. Alfred R. Shands III

Ms. Marion Stroud

Mrs. Nellie Taft

Mr. and Mrs. A. Alfred Taubman

Mr. and Mrs. Thurston Twigg-Smith

Mr. and Mrs. Jack W. Warner

Mrs. Paul Wattis

Mr. Leslie Wexner

Mr. and Mrs. Cornelius Vanderbilt Whitney

Mr. and Mrs. David M. Winton

Mr. and Mrs. Robert Woods

Mr. and Mrs. William S. Woodside

This publication was organized at the Whitney Museum of American Art by Doris Palca, Head, Publications and Sales; Sheila Schwartz, Editor; Madeleine Nicklin, Associate Editor; Martha Lee, Production Assistant, and Aprile Gallant, Assistant.

Typeset by Typodata GmbH, Munich
Offset lithography by Repro Dörfel, Munich
Printed by Karl Wenschow-Franzis Druck GmbH, Munich
Bound by R. Oldenbourg, Graphische Betriebe, Heimstetten

Photograph Credits

Benjamin Blackwell: pp. 39, 55, 76, 100, 151
Steve Bratman: p. 108
Geoffrey Clements: p. 145
Tibor Franyo: p. 133
Greg Heins: p. 155
Paul Hester: pp. 148, 153
George Holmes: p. 119
Robert Mates: pp. 24 (bottom), 37 (top), 38 (top), 60, 88, 122, 154, 160
Herbert Matter: p. 189 (top right)
Ken McKnight: p. 101
Tom Milius: p. 189 (bottom)
Kevin Ryan: pp. 12, 13, 14, 16, 17, 18, 19, 20, 21, 24 (top), 25, 26, 29, 33, 35, 37 (bottom), 43, 45, 46, 47, 49, 65, 85, 87, 104, 105, 107, 115, 135
William Thornton: p. 74
Wendy Vail: p. 52
Malcolm Varon: pp. 73, 142, 147, 159
John Webb: p. 157
Bill Witt: p. 188